P9-DEW-761

creative solutions for
UNUSUAL PROJECTS

creative solutions for

unusuaL PRojects

Includes: Templates Formats Guidelines

HOW
DESIGN
BOOKS
CINCINNATI, OH
www.howdesign.com

Creative Solutions for Unusual Projects. Copyright ©
2001 by Design Press Books. Manufactured in Singapore.
All rights reserved. No other part of this book may be
reproduced in any form or by any electronic or mechan-
ical means including information storage and retrieval
systems without permission in writing from the pub-
lisher, except by a reviewer, who may quote brief pas-
sages in a review. Published by HOW Design Books, an
imprint of F&W Publications, Inc., 1507 Dana Avenue,
Cincinnati, Ohio 45207. (800) 221-5831. First edition.

Visit www.howdesign.com for information on more
resources for graphic designers. Other fine HOW Design
Books are available from your local bookstore, art supply
store or direct from the publisher.

05 04 03 02 01 5 4 3 2 1

Library of Congress Cataloging-in-Publication Data
Boylston, Scott
 Creative solutions for unusual projects / Scott Boylston.
 p. cm.
 Includes index.
 ISBN 1-58180-120-3 (pb w/flaps : alk. paper)
 1. Computer graphics. I. Title.

T385 .B72 2001
741.6—dc21 00-143892

Editor: Clare Warmke
Liaison from Design Press: Janice Shay
Interior Designer: Scott Boylston
Interior Production: Kathy Gardner
Cover Designers: Camille Ideis and Matthew DeRhodes
Production Coordinator: John Peavler

The permissions on page 191 constitute an extension of
this copyright page.

 This book was a joint
collaboration between
HOW Design Books
and Design Press, a
division of the
Savannah College of
Art and Design.

acknowledgments

Developing a book project is akin to setting out on a thrilling adventure, and as with any excursion, the companions you travel with will determine the quality of that journey. My thanks go to the three fine women at Design Press for their hard work and insight, especially Janice Shay. Janice, along with Winslett Long and Cameron Spencer—and Star Kotowski in campus photography—were companions of the first rate, always willing to share their sizable expertise and their good humor. I am grateful, too, to Clare Warmke at HOW Design Books for her dedication and zeal. She was always very close with her guidance and encouragement regardless of the actual miles between us.

I am grateful to the many graphic designers who have contributed their exceptional creations, and thanks in particularly to the talented students and faculty at the Savannah College of Art and Design for contributing such fine works of design, illustration, furniture design and jewelry design. Their tireless efforts have made my job of seeking out the best design work a pleasant task. All the people at both HOW Design Books and the Savannah College of Art and Design have helped make this job a passionate pursuit.

Special thanks to my wife—silly Kristin—for her bottomless reserve of encouragement and patience, and to my family, on both sides of the marital fence, for their love, friendship and caring.

contents

introduction

GRAPHIC DESIGN. TWO WORDS HAVE RARELY ENCOMPASSED SO MUCH YET defined so little. The question *What is graphic design?* cannot be answered in a way in which many designers prefer things; that is, in a clearly defined and orderly manner. When we think of ourselves as graphic designers, most of us like to imagine that our skills are as diverse as that term entails. But today it is nearly impossible to be a designer who is capable of performing in all the various media available. The technical demands alone force designers to commit themselves to specific areas of the field in order to insure their status as experts. This is not to say that designers armed with a solid understanding of typography and composition cannot learn to apply their hard-earned knowledge. In fact, it should be the goal of every designer to become a contemporary Renaissance person, capable of applying expertise across a wide range of project demands.

How do you take what you already know about design and apply it in a knowledgeable manner to new challenges? This book provides a one-stop shop for such occasions.

This book focuses on a diverse array of challenging print-related formats. Despite what some have said, print is not dead. It is alive and well. The digital luminescence of the computer screen certainly has its place, but it will not replace print. Just as the onslaught of video stores has not replaced the allure of movie theaters, and the omnipresence of e-mail has not replaced verbal communication, so digital media will surely prosper but will not lead to the obliteration of print design.

You're a designer. Maybe you're a seasoned professional in a certain area of the business, or maybe you're just breaking into the field. Then a client comes to you and asks if you would be willing or able to design a print project that may be outside your realm of experience. Where do you go for specifics on that particular format? How do you take what you already know about design and apply it in a knowledgeable manner to new challenges? This book provides a one-stop shop for such occasions.

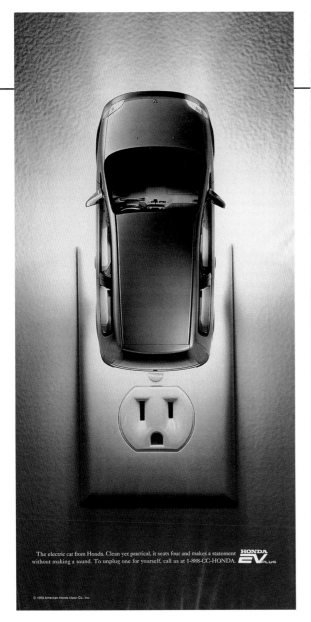

The electric car from Honda. Clean yet practical, it seats four and makes a statement without making a sound. To unplug one for yourself, call us at 1-888-CC-HONDA. **HONDA** *EV PLUS*

© 1998 American Honda Motor Co., Inc.

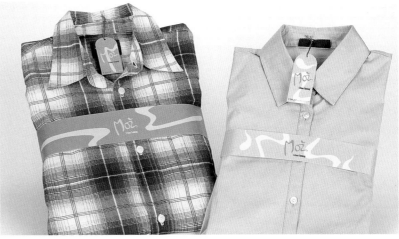

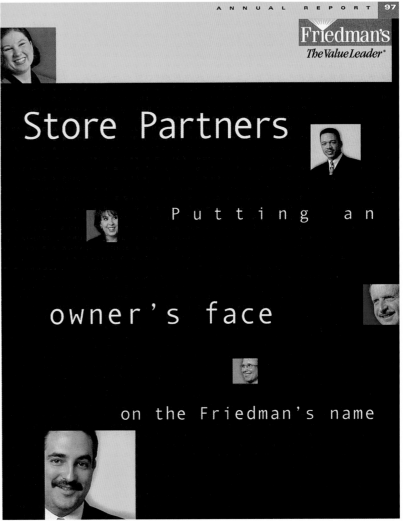

Friedman's
The Value Leader

Store Partners

Putting an

owner's face

on the Friedman's name

The old adage that if you give someone a fish he will eat for a day, but if you teach him how to fish he will eat for a lifetime applies to the objectives of this book. It offers more than a single solution, and it attempts to avoid a cookie-cutter approach to design. The varied examples throughout each chapter provide the designer with distinct options in all facets of design—from font choice to format to use of negative space—while the many captions call attention to these distinctions.

While presenting so-called quick solutions to design problems, this book focuses on what could be called time-tested or "classic" design ideas. Although adapting to trends is an important ability for any designer, a firm understanding of design basics is paramount to success in the field. Accordingly, the last section focuses on general design considerations that must always be at the forefront of the designer's mind. Good

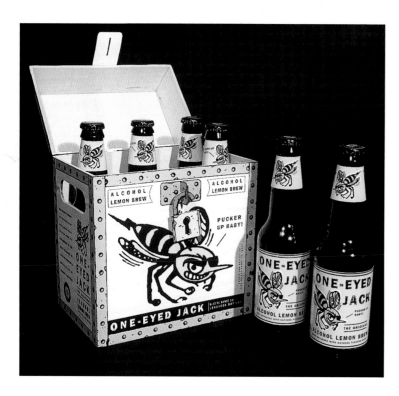

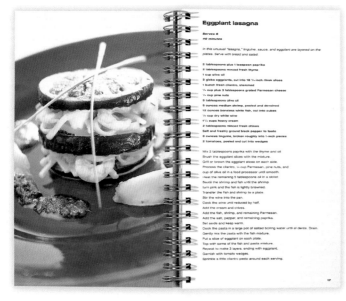

designers will consistently refer to such information throughout the duration of their careers.

The text is broken down into two sections for each chapter. The first section, called *Groundwork,* offers helpful suggestions and industry tips concerning the challenges inherent in each of the specific design problems. These tips include everything from paper stock concerns and production considerations to specific questions for the client that should be asked at the first meeting in order to insure clear communication throughout the process.

The second section, *Design,* includes important typographic and compositional considerations that are unique to the problem at hand. Each of these projects presents the designer with a set of its own challenges, and each of these challenges is addressed in quick, easy-to-read paragraphs. There are sidebars interspersed throughout the book that offer detailed information on related design considerations for each of the projects. There are also many illustrations that present an in-depth analysis of any specialized considerations.

Think of this book as a graphic designer's crisis kit. All professionals—from physicians and attorneys to police and firefighters—at times find themselves confronted by an unfamiliar situation or one with which they feel less than completely confident. In such emergencies, fast, clear information on how best to proceed is crucial. This book offers the graphic designer vital information, professional advice, and step-by-step guidance to lead him through the intricacies of 26 new projects—from order forms, invitations, and annual reports to wine labels, CD covers, trade show signage and buttons. Novice and veteran designer alike will find valuable counsel and aid in *Creative Solutions for Unusual Projects.*

BROchures

catalogs

order forms

menus

annual reports

catalogs

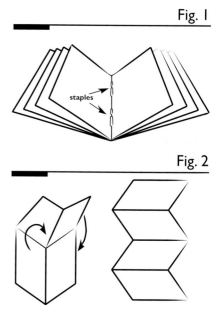

Fig. 1

Fig. 2

GROUNDWORK

CATALOGS COME IN ALL SHAPES AND SIZES. THE first order of business when designing one is to determine just how much information is being presented. Is it a catalog for a large department store or one for a small, run-at-home business? Also make sure to consider the overall size; catalogs are often delivered through the mail, so it would be wise to design it to conform to postal standards or with standard envelope sizes in mind. Visit your post office for information on acceptable sizes before you meet with your client so that you are ready to address this concern.

If the catalog is relatively small, it may be wise to avoid the issue of binding completely and instead use a scored format that unfolds. A bound catalog is most inexpensively done as a saddle stitch (Fig. 1), whereas a scored or folded catalog could be opened in numerous ways (Fig. 2). This second option works nicely in a 5″ × 7″ (12.70cm × 17.78cm) format due to its mail-friendly proportions.

Because catalogs deal with the sale of products that the consumer may have never yet seen, photography is extremely important. Find out from your client who will be responsible for this part of the project. If you are responsible, your first step is to procure an experienced studio photographer. A photo shoot is a huge undertaking that requires a lot of time and coordination. Just making sure the products themselves (in all their colors, shapes and sizes), the photographer, the models (if needed) and the client are all under one roof at the same time can be a major undertaking in itself.

Clients can be picky when it comes to showing their products in the best light, and it must be decided early whether the products will be shown on their own or in conjunction with live models. Photo shoots are successful only with the patient teamwork of everyone involved. Work out all the billing hours beforehand so that there are no misunderstandings that might disrupt valuable studio time, and always make sure to account for unforeseen complications.

Clarify with your client before you begin

+ **What is the overall size, and will it be bound or folded?**
+ **Who is responsible for the photography?**
+ **Is the copy written, and is it in digital form?**
+ **How much is the client willing to pay for paper stock?**
+ **Will an order form be inserted, or will it be a part of the catalog?**

FUNCTIONAL FOLLIES

20 ARCHITECTURAL OBJECTS OF DELIGHT

SAVANNAH COLLEGE of ART and DESIGN

Catalog covers work nicely when they portray one or more of the items included within it. The example above shows cropped images of each of the architectural studies that are featured within the catalog.

DESIGN If the client is supplying the photography, then you can move on to the issue of layout. Acquire the photographs—along with the accompanying text, prices and catalog numbers—immediately, and talk to your client regarding the emphasis he or she would like to place on the photography. A catalog should be an organized visual treat that presents the products clearly while leaving the typographic information as a secondary—but no less important—visual element. In the case of catalogs, photographs are indeed worth a thousand words: they may sell a product on first sight.

A grid is a must for catalogs for consistency from page to page and ease of use on the consumer's part. It is a good idea to present the photography in consistent places throughout the piece, so set a standard treatment at the outset and stick with it all the way through. Predictability may be a liability in other categories of design, but in this case it is your best friend; if a consumer knows where to find information from one page to the next, he or she is likely to spend more time shopping

Make shopping easy. Do not design to show off your design prowess; design to show off the quality of your client's products.

and less time figuring out where to look. Make shopping easy. Do not design to show off your design prowess; design to show off the quality of your client's products.

Page numbers are an important issue inasmuch as many order forms request them so as to to limit mistakes. The page numbers must be placed consistently from page to page. They should be unobtrusive but clearly visible. If there are various kinds of products (men's clothing and women's clothing, or kitchenware and bedroom accessories), color coding a design element that occurs on every page can be helpful. This could be as simple as a color bar that runs horizontally across the top or a vertical bar that runs down the side of the page.

Fig. 3
silhouette

Wood Magnet Steel Chair
This postmodern interpretation of a classic offers a dramatic study in line and color. Designed by Rebecca Fox, this chair will enhance any room in the house with its bold contrasts and curvatures. Hand built in the United States.
22" × 31" × 42" H #34256-01
$98.00 Set of four $350

Tulip Lamp
Designed by Michael Brady, this elegant lamp is made from brushed stainless steel and hand-blown glass, With a total height of just over three feet, it will brighten any room and can be used as a floor lamp or a table lamp.
42" H #61834-01 $170

Fig. 4
vignette

Wood Magnet Steel Chair
This postmodern interpretation of a classic offers a dramatic study in line and color. Designed by Rebecca Fox, this chair will enhance any room in the house with its bold contrasts and curvatures. Hand built in the United States.
22" × 31" × 42" H
#34256-01
$98.00 Set of four $350

Tulip Lamp
Designed by Michael Brady, this elegant lamp is made from brushed stainless steel and hand-blown glass. With a total height of just over three feet, it will brighten any room and can be used as a floor lamp or a table lamp.
42" H
#61834-01
$170

Fig. 5
frame

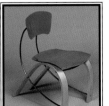

Wood Magnet Steel Chair
This postmodern interpretation of a classic offers a dramatic study in line and color. Designed by Rebecca Fox, this chair will enhance any room in the house with its bold contrasts and curvatures. Hand built in the United States.
22" × 31" × 42" H #34256-01
$98.00 Set of four $350

Tulip Lamp
Designed by Michael Brady, this elegant lamp is made from brushed stainless steel and hand-blown glass, With a total height of just over three feet, it will brighten any room and can be used as a floor lamp or a table lamp.
42" H #61834-01 $170

There are three basic ways to present photography as a design element in a layout: silhouetted, vignetted, or framed. Silhouetting products (using the edge of the product itself to separate it from the background) requires more design time and a more forceful hand at structuring the page (Fig. 3). Vignetting is a looser form of silhouetting, where the background of a photograph slowly fades to the color of the page (Fig. 4). Both of these techniques require more up-front work on the photographs themselves than does using a standard framed picture. They also provide the designer with more freedom in terms of type wraps, as seen in the example to the left.

Because the edges and irregular shapes will be inconsistent as a matter of course, they result in elements that are less willing to cooperate with the underlying structure of your grid. Framing the photographs in a consistent square or rectangular block (Fig. 5) goes a long way in creating the necessary visual structure. This way the products are contained in a clean-edged form that can easily be incorporated into any grid.

If you are confident in your design skills, it is possible to create a catalog that takes advantage of the unique attributes of each of these on the same page. This technique provides plenty of visual diversity but can be confusing and disorienting if not treated with expert care.

Some catalogs perform double duty as brochures. With business-to-business catalogs information about the company itself is as important as the products. This straightforward example makes use of illustrations for products that are difficult to reproduce with photography. As a money-saving measure, this catalog has also been printed with only two colors. The background blueprint has been added to convey a sense of precision.

Since there will always be consumers who have a question about a price, a color, or a mailing option, it can be very helpful to allow room for a phone number and an e-mail address on every page for easy reference. Treat this element consistently on every page so the consumer knows where to look.

Along with a clearly presented caption and description, include the order number (SKU number). Present this in a consistent spot each time, and allow some space around it so consumers can find it quickly. Many catalogs like to show off their bargain prices by printing a regular price beside their specially discounted price. The special price is often in a bold typeface or a different color as a way to highlight it.

Coated paper stocks are more appropriate for catalogs because the reflective surface of the page gives a crisper and more brilliant finish to the photographs. An 80-lb. coated stock works nicely.

Early in the layout process determine how diverse the featured products are in terms of overall proportions. There are long, skinny products and short fat ones. There are square and round products, and all of these must be presented in a way that will allow maximum clarity. The job of cropping photographs to better fit is a serious consideration that must not be overlooked.

Often with catalogs the designer is forced to fit a lot of information into a small format. The example shown here uses an accordion fold that collapses into a 5″ × 7″ (12.70cm × 17.78cm) self-mailer. Captions, photographs and graphic illustrations are used to organize the page and break up the copy into easily digestible paragraphs.

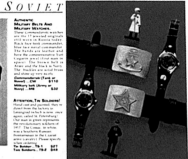

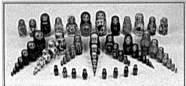
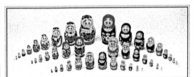

CLASSIC SOVIET

IMPORTED FROM RUSSIA

MATRYOSKI DOLLS — CHARMING AND COLLECTIBLE

UNIQUE !!!

Big Red Star, Inc
309 Fifth Ave. Ste. 256
Brooklyn, NY 11215
1-800-892-6009

With such a self-mailer, make sure to take into account postal requirements for mailing. Also look into bulk mailing rates before submitting your design to the printer. Including your bulk-postage account number is imperative. More information on self-mailers can be found in the direct-mail section of this book.

RUSSIAN FAIRY TALES TOLD ON LACQUER MINIATURES

ORDERS MEDALS & PINS

AUTHENTIC MILITARY DECORATIONS

RED

RUSSIAN CONSTRUCTIVIST POSTER ART — ON T-SHIRTS

Orders received by December 20, 1992 are guaranteed by Xmas!

organizing the page

There are many easy ways of organizing the page once a grid is established. The use of graphic rules is especially helpful in clearly dividing the page. When in doubt, keep it clean and straightforward (Fig. 6). If you choose to use graphic rules, do not be too heavy-handed; an excessive amount of these will clog up the page, and rules that are too thick have a similar effect.

Also, make sure to create a consistent language when using them. A series of thin vertical lines will often work well, but so can an L-shaped bracket with a variation in line thickness (Fig. 7). Using a modular grid of horizontal and vertical areas (Fig. 8) can work, but if not done properly, it becomes too overpowering and tends to choke the page and confuse the consumer.

The text does not always need to be directly beside the actual object it is describing. Using alphabetic markings is a good alternative (Fig. 9). In this case, as long as the letters for both the copy and the photograph are clearly visible, any consumer can match them up. Use a bold typeface or a second color for the captions to help them stand out.

Use color sparingly as a way to emphasize things like sale prices or new items. Using too much color in the layout will detract from the products themselves. Notice that all the examples on this spread use only black and a second color. This second color could be taken from the client's logo.

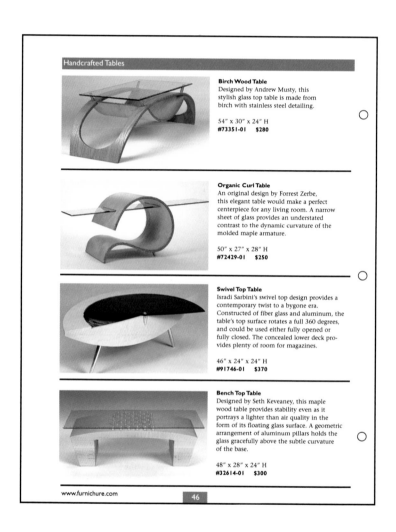

Fig. 6

When in doubt, keep it simple, and let the products speak for themselves. Use graphic rules to clearly define your areas, but do not overuse them. For in-store use, a three-ring binder catalog works nicely. It allows for flexibility in merchandise selection. Some pages might feature products that are available year-round, while other pages might feature limited-edition work. For a changing inventory, single pages could be added or taken out rather than reprinting the entire catalog.

Fig. 7

A surefire way of keeping your page organized is to use text boxes and picture boxes that are exactly the same. Although this structures the page nicely, it puts more demands on the person who must crop the photographs because each box is the same proportion regardless of the shape of the product.

Broach Set Designer: Daphne Dowling
Sterling silver & brass.
Reg. 130.⁰⁰ Special 105.⁰⁰ Item #3425

Opal Pendant Designer: Chin-Hao Chung
Sterling silver w/ opal.
Reg. 160.⁰⁰ Special 145.⁰⁰ Item #2583

Floral Charm and Necklace Designer: Mia Habib
Sterling silver.
Reg. 100.⁰⁰ Special 85.⁰⁰ Item #1817

Pendant & Earring Set Designer: Liang-Chung
Yen Sterling silver.
Reg. 90.⁰⁰ Special 75.⁰⁰ Item #2312

Precious Stone Broach Designer: Pei-Jung Chen
Sterling silver & stone.
Reg. 110.⁰⁰ Special 98.⁰⁰ Item #1968

Floral Globe Ring Designer: Aomporn Phonlabutr
Sterling silver, copper & pearl.
Reg. 170.⁰⁰ Special 158.⁰⁰ Item #2881

Pea Pod Ring Designer: Aomporn Phonlabutr
Sterling silver.
Reg. 100.⁰⁰ Special 88.⁰⁰ Item #3912

Pendant Set Designer: Chin-Hao
Chong Sterling silver.
Reg. 110.⁰⁰ Special 95.⁰⁰ Item #2768

Dancing Pendant
Sterling silver
Reg. 70.⁰⁰
Special 55.⁰⁰
Item #3386

Designer:
Chin-Hao
Chong

Floral Charm and Necklace
Sterling silver
Reg. 100.⁰⁰
Special 85.⁰⁰
Item #1851

Designer:
Mia Hebib

Peapod Ring
Sterling silver & aluminum.
Reg. 110.⁰⁰
Special 95.⁰⁰
Item #1748

Designer:
Aomporn
Phanlabutr

Scroll Pattern Ring
Sterling silver & aluminum.
Reg. 110.⁰⁰
Special 95.⁰⁰
Item #1748

Designer:
Shannon Mathis

Enamel Pendant Set
Sterling silver & enamel
Reg. 160.⁰⁰
Special 145.⁰⁰
Item #1851

Designer:
Daphne Dowling

Sapphire Pendant with Necklace
Sterling silver & sapphire
Reg. 150.⁰⁰ **Special 135.⁰⁰**
Item #3425

Designer: Ulrika Moats

Scroll Pattern Ring
Sterling silver & aluminum.
Reg. 110.⁰⁰ **Special 95.⁰⁰**
Item #1748
Designer: Shannon Mathis

Enamel Pendant Set
Sterling silver & enamel
Reg. 150.⁰⁰ **Special 125.⁰⁰**
Item #2276
Designer: Alex Cutris

Fig. 8

Using graphic rules to contain the products and their descriptions allows for a more modular approach. The example below uses a three-column grid. It also uses two typefaces—a serif and a bold sans serif—to create an emphasis on important information.

A. Modern Swing Lamp
Designed by Korpon Leopairote, and made from maple and steel, this movable swing lamp provides halogen light with a flair. For office or home use. 20" H
#32718-01 $120

B. Birch Wood Coffee Table
Designed by Andrew Musty, this stylish coffee table is made from birch with stainless steel detailing. 54" x 30" x 24" H
#73351-01 $280

C. Side Cabinet
This gracefully curved, three door cabinet was designed by Wesley Crosby and is made of maple and aluminum. The elongated drawers are spacious enough for a wide variety of items, whether it be used in the bedroom, the den or the office. 12" x 25" x 34" H
#61834-01 $210

D. Oak and Stainless Steel Stand
Paul Troy designed this regal oak stand as a multipurpose table. Black enamel paint enhances the upward motion of this piece and contrasts nicely with the stainless steel lag caps. 14" x 14" x 40" H
#26421-01 $190

E. Wall Cabinet
Another Andrew Musty design, this walnut, maple and steel wall cabinet can serve a utilitarian purpose, or simply add to the aesthetics of any household. 7" x 22" x 30" H
#61834-01 $160

F. Leather and Stainless Steel Love Seat
A rare and dynamic design by Anna Troupe will make anyone who sits in this chair feel like a master of the new millennium. 42" x 40" x 45" H
#32781-01 $260

G. Tulip Lamp
Designed by Michael Brady, this elegant lamp is made from brushed stainless steel and hand-blown glass. With a total height of just over three feet, it will brighten any room, and can be used as a floor lamp or a table lamp. 42" H
#61834-01 $170

PG 46

Fig. 9

Using alphabetic tags allows more freedom in altering the size, proportion and placement of the photographs. Allow for a clear column of type and large enough letters on both the text and the photograph. Also make sure that the sequence of the photographs follows the general eye flow across the page.

inserts & order forms

Inserts for seasonal sales are somewhat common in catalogs. Because they are good only for short periods of time, they are often printed on lesser quality paper and sometimes even in black and white. They can be a smaller format than the catalog as well and should be only large enough to fit the required information. This are often stapled into the binding so they can easily be torn out, and they often include their own order form and envelope.

Order forms are an extremely important element in any catalog for obvious reasons. They can either be part of the catalog itself, with a perforation mark to show the consumer where they should be torn from the catalog, or become a separate sheet that is folded and adhered or stapled to the catalog. This second option allows for more flexibility in light of unforeseen changes, and to save costs it can be printed in one color. For more recommendations on design order forms, see chapter two.

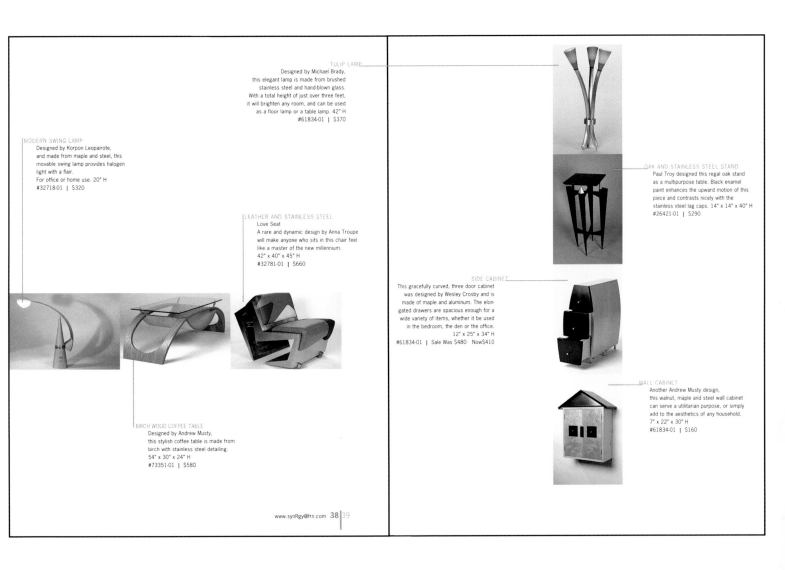

TULIP LAMP
Designed by Michael Brady,
this elegant lamp is made from brushed
stainless steel and hand-blown glass.
With a total height of just over three feet,
it will brighten any room, and can be used
as a floor lamp or a table lamp. 42" H
#61834-01 | $370

MODERN SWING LAMP
Designed by Korpon Leopairote,
and made from maple and steel, this
movable swing lamp provides halogen
light with a flair.
For office or home use. 20" H
#32718-01 | $320

OAK AND STAINLESS STEEL STAND
Paul Troy designed this regal oak stand
as a multipurpose table. Black enamel
paint enhances the upward motion of this
piece and contrasts nicely with the
stainless steel lag caps. 14" x 14" x 40" H
#26421-01 | $290

LEATHER AND STAINLESS STEEL
Love Seat
A rare and dynamic design by Anna Troupe
will make anyone who sits in this chair feel
like a master of the new millennium.
42" x 40" x 45" H
#32781-01 | $660

SIDE CABINET
This gracefully curved, three door cabinet
was designed by Wesley Crosby and is
made of maple and aluminum. The elon-
gated drawers are spacious enough for a
wide variety of items, whether it be used
in the bedroom, the den or the office.
12" x 25" x 34" H
#61834-01 | Sale Was $480 Now $410

WALL CABINET
Another Andrew Musty design,
this walnut, maple and steel wall cabinet
can serve a utilitarian purpose, or simply
add to the aesthetics of any household.
7" x 22" x 30" H
#61834-01 | $160

BIRCH WOOD COFFEE TABLE
Designed by Andrew Musty,
this stylish coffee table is made from
birch with stainless steel detailing.
54" x 30" x 24" H
#73351-01 | $580

All too often when designing a catalog, space is at a premium due to the costs associated with printing. On the rare occasion you are given a lot of space to work with, be sure to take advantage of it. Using large photographs is always an option, but a more understated approach would be to allow the negative spaces on the page to breath and define the design style of the products themselves. The layout should represent the company's philosophy in the same way the actual products do.

2 *order forms*

GROUNDWORK

FORMATS FOR ORDER FORMS CAN BE DIVIDED INTO BASICALLY TWO CATEGORIES: Forms printed on standard, letter-sized paper, and forms designed to work directly with a catalog. The letter-sized form is popular for in-store purchasing because the size is convenient for on-site printing and filing. Catalog order forms can be designed either as single sheets that fold to fit an enclosed postage-paid envelope or as a section of a self-mailer that can be torn or cut off.

Once it is determined how these forms will be used, the issue of paper stock should be discussed. Order forms serve a very specific function. A customer fills one out, then sends it along, either through the mail or over the counter. Inasmuch as no one holds on to the form for a long period of time, it has a short shelf life in an office environment.

Although the design must be strong, the paper stock does not need to be of the highest quality. This is a good place to save a little money on your printing costs. However, remember that the paper stock must be easy to write on with different sorts of pens and inks; therefore, coated papers are unusable. There are several uncoated papers available that are less expensive alternatives. The paperstock for an order form differs greatly from that for a catalog, which is something that may sit on a coffee table or office desk for months. It may also be passed from friend to friend. Unlike the order form the catalog is the company's silent ambassador, and spending extra money here for high-quality paper is a wise investment.

Ask your client how many carbon copies, if any, are required. The most common sizes for carbon copy forms are 5″ × 7″ (12.70cm × 17.78cm) and 8½″ × 11″ (21.59cm × 27.94cm). If these are used, the client can save money (and the printing turnaround is usually shorter) rather than pay extra for a custom-sized page. Find out ahead of time how much more money (and time) is required for special sizes, and be prepared to offer this estimate if your client asks for it.

It is also very easy to have these carbon forms numbered consecutively, although the typographic treatment is rather generic and may not go along with the rest of your design. If your client chooses not to use the generic numbering, make sure to add a space dedicated to this information in your design.

Ask the client if there is any other information required for these forms. If a return policy is required, for instance, it will need to be considered in the early stages of design work.

Clarify with your client before you begin

+ **How many carbon copies are required?**
+ **What is the overall format (size and proportion)?**
+ **Approximately how many items does a person usually order at once?**
+ **How much space is required for item descriptions?**
+ **How many colors is the client willing to pay for?**

Give ample space to the logo. Also make sure to use the typeface from the logo in the order form, as well as any particular design attributes that the logo might have.

Direct marketing makes use of mailing lists of specific target audiences. Leave room for computer outputs of these addresses and code numbers. They may not always print in the exact same location.

With a one-color job, take advantage of tints. Using them wisely (and not too often), will give your work a clear sense of structure and visual hierarchy.

torque

133 Summer Winds Drive
Savannah, Georgia 31410

1.800.090.0909

Ordered By: Your order will be shipped to the below address unless otherwise indicated at the right. Please provide a local delivery address if a P.O. box is shown below.

CODE: 976uyoih867

SCOTT BOYLSTON
133 SUMMER WINDS DRIVE
SAVANNAH, GA 31410

To order by phone call **1.800.090.0909**
To order by fax: **1.912.897.4626**

Please print

Name	
c/o	
Street	
City	
State/Zip code	

page	qty.	item #	description	size	color (& second color choice)	price	total

Handling & Shipping Charges

Purchase Amout	
Up to $20	$4.95
$21-$35	$5.95
$36-$50	$6.95
$51-80	$8.95
$81-$100	$10.95
Over $100	10% of order

Rush Deliveries
For Second Day delivery
add $10
For Overnight delivery
add $17
*Overnight cannot be assured in certain ares. Call for information.

Total Cost for Goods

Shipping (See table to the left)

Rush Delivery (See charges to the left)

Sales Tax Please add local and state tax for merchandise & shipping on orders delivered to AL, CA, CO, CT, DC, DE, GA, IL, IN, KY, MD, MI, MN, NC, NJ, OH, PA, TX, VA, and WA.

Total Amount Due (No cash or COD please)

Method of Payment ☐ American Express ☐ MasterCard ☐ Visa
☐ Discover ☐ Check ☐ Extended payment

Account Number (Please include all the numbers on your credit card)

Expiration Date

Month Year

Name (Please PRINT exactly as it appears on your card)

Signature

Fig. 10

Do not overcrowd the area reserved for orders. Remember that people need to write in these areas. Forcing the consumer to scribble will wreak havoc on both ends; a frustrated consumer with a cramped hand, and a frustrated service representative with a headache from trying to read scribbles.

Do as much of the math as possible for the consumer. Ease of use makes for happy customers, and happy customers mean return business.

The above example would work nicely as a tear-out section from a catalog. The horizontal layout allows enough room for handwritten entries. Using an uncoated stock and a perforated edge for easy removal from the catalog will enhance ease of use on the consumer's part.

DESIGN Since details included on these forms can change from time to time, and in-store forms can be discarded due to mistakes, many order forms are designed to work as a one-color design. Even when the clients ask for a multicolor job, you would be wise to show them how your design works in black and white. These forms are often machine copied on the spot or faxed, so the information should not have to rely on color as a chief organizing element.

Whatever the format, there is a

When picking typefaces, work with the font the client uses on his or her letterhead. This will ensure a consistent presentation.

list of necessary entries on any order form. First and foremost are the company logo and address. The logo could be presented along the top of the form with the company address, or it could be enlarged and printed as a light tint in the background.

The bill-to address, ship-to address, personal customer information, shipping instructions and method of payment are often placed on top of the page or in a position that the customer will find easily. More specific information, such as item descriptions and number, quantity, color, cost per unit and total cost must be clearly labeled and

quickly understood by the customer.

An order form is the last place you want someone to be confused. Structure the page clearly, and be obvious about this structure. Allow for signature space, credit card numbers, and special delivery requests (two-day, overnight, and so forth), as well as tax and liability information.

Remember to keep the type at a highly readable point size. When picking typefaces, work with the font the client uses on his or her letterhead. This will ensure a consistent presentation. Straightforward typefaces are the best solution, and your creativity should be focused on clarity of message.

When it comes to design elements, there are times to use rules (graphic lines) in order to break up your page and organize information into different segments, and there are times not to. An order form is as good a time as any to use these design elements. Using two different weights for these rules helps organize information even further.

A good way to utilize a one-color job in a way that takes full advantage of that color for organizational purposes is to use a tint of that color in certain areas. Medium tints (40–70 percent) in bands can efficiently divide the page into clearly marked areas without interfering with the overall hierarchy (Fig. 10). With the darker tints, you can either drop out type in the band or print it black, and with the lighter tints you can print black type in it.

HausWerks

318 WEST ST. JULIAN
SAVANNAH GEORGIA 31401

VOX 912.236.4676
FAX 912.236.4671

Order No.

Date

SOLD TO

ADDRESS

SHIP TO

ADDRESS

SALESPERSON	SHIP VIA	WHEN	TERMS	F.O.B.

RETURN POLICY: An item may be returned within 21 days provided it is in the original condition and packaging as purchased. Special orders may not be cancelled and, once received, are non-returnable. On all discounted items, sales are final. Other policies not stated above may apply.

Fig. 11

The company's logo can be presented in its entirety, or it can be broken up into separate elements. The example to the left shows the logotype on top and the tinted symbol behind the rest of the information. This sample also includes the company's return policy to ensure there is no confusion regarding this important matter.

Fig. 12

Using captions that reflect the nature of the company or the products it sells can personalize the order form and further the image. The example to the right is an order form for Russian memorabilia using the bold declarative elements of Constructivist design.

THIS IS WHERE WE FIND YOU

Name
Address
City ___ State ___ Zip ___

It is mandatory FOR UPS DELIVERY that no P.O. Boxes are used. Can we deliver your goods to your office or elsewhere?

THIS IS HOW WE REACH YOU

It is very important that we be able to reach you by phone or fax. We don't plan to have to call or fax, but if we must, we will. Please leave your number(s) in this space.

Evening phone ___
Day phone ___
Fax (Day or Night?) ___

METHOD OF PAYMENT

CHECK (personal or business) MONEY ORDER (postal, bank or other)
Make checks and money orders payable to BIG RED STAR, INC. VISA / MASTERCARD

Acct. No. ___ Signature ___
Expiration Date ___

ITEM #	DESCRIPTION (SIZE/COLOR)	QUANTITY	PRICE PER	TOTAL

GIFT ORDER *continue in next section if necessary*

Name ___
Address ___
City ___ State ___ Zip ___

WE WILL PROVIDE AN APPROPRIATE GIFT CARD IF NECESSARY.
GREETING:

GIFT ORDER

Name ___
Address ___
City ___ State ___ Zip ___

WE WILL PROVIDE AN APPROPRIATE GIFT CARD IF NECESSARY.
GREETING:

SHIPPING & INSURANCE CHARGES

If your order totals	Add
$50.00 or less	$5.00
$51.00-$100.00	$6.50
$101.00-$150.00	$7.25
$150.01-$250.00	$9.00
$251.00 and above	$11.50

International Orders: add $10.00 to Shipping & Insurance Charge.
•SECOND DAY UPS AIR or US Mail: add $9.00
•NEXT DAY UPS AIR or US Mail add $15.00 •C.O.D. (US Mail or UPS) add $5.00

Thank you for your order!

SUB TOTAL

N.Y. STATE SALES TAX (N.Y. Residents only)	
SHIPPING & INSURANCE (see chart)	
$5.00 EACH ADDT'L ADDRESS	

TOTAL

Call if you have any questions: (800) 892-6009 All credit card orders shipped within 48 hours unless you deem otherwise.

3 menus

THE FIRST TWO PHASES OF YOUR WORK HAVE LITTLE TO DO WITH DESIGN AND everything to do with discipline and organization. Because a menu plays an important role in a much larger environment (the restaurant itself), you as the designer must be very familiar with that particular environment. Keep in mind the special needs of your client and the clientele. Visit the restaurant during all hours of operation. If they serve breakfast, lunch and dinner, be sure to visit at each serving. Be a keen observer and miss nothing. What kind of tablecloths do they use? How does the wait staff dress? Be on the lookout for any patterns, motifs or color schemes that exist in the dining space.

GROUNDWORK

Also look around the building itself—inside and out—for any unique features that might provide you with inspiration or a rationale for your work (floors, walls, light fixtures, window treatments, the list is endless!). If a logo for the restaurant already exists, attempt to incorporate any font, symbol or design nuance within that logo as an element in your menu design. Think of unique ways to incorporate all these elements. During the thumbnail stage every possibility should be explored.

The second phase is to make sure you have familiarized yourself with existing menu designs. Observe how others have approached the challenging task of laying out a menu, and make sure to pay special attention to restaurants of similar caliber and cuisine. Also, clarify with your client whether or not photographic images of the food will be required. This is not a common request, but you should be clear on it from the beginning, because someone will be responsible for taking those photographs, and a photo shoot of that type can be complex and expensive.

Before actual design work can begin, there is also the issue of format to consider. What size and proportion would your clients like to work with? Talk to your clients about this; before you begin to paint, you have to know what size and shape your canvas is. Ask them if they have a particular format in mind. If they are open to suggestions, be ready to offer several choices. Take a little time before the meeting to fold up several sheets of clean white paper in various formats so that they can see their options in the round and hold them in their hands. (Page 29 offers several industry standards.)

Clarify with your client before you begin

- ✦ **What is the overall format (size and proportion)?**
- ✦ **Are there other inserts (drink menu, dessert menu, etc.)?**
- ✦ **Does the client require a take-out menu?**
- ✦ **How would the client like to handle daily specials?**
- ✦ **How many colors is the client willing to pay for?**
- ✦ **How much more is the client willing to pay for lamination?**

As the proportions of your page will dictate a wide range of design decisions, it is important to work this out early. If you decide to work with a tri-fold, then the progression in which the information is presented is extremely important; the diner will open one side and then the other, so the placement of information must follow this progression.

Because the customer is already seated within the restaurant, there is no need for an overly loud
cover design for the menu. Instead, it should reflect the sensibilities and decor of the restaurant. This example uses
embossed and stamped typography along with an elegant stylized photograph and a lot of negative space.

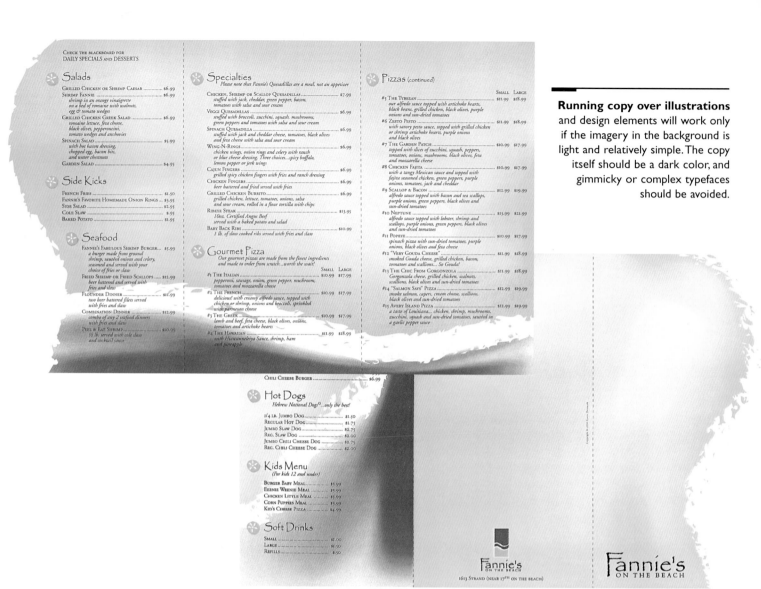

Running copy over illustrations and design elements will work only if the imagery in the background is light and relatively simple. The copy itself should be a dark color, and gimmicky or complex typefaces should be avoided.

DESIGN

When you approach the typographic information—and this should be your first design consideration—make sure to break it into subcategories. Captions that clarify the different types of food (e.g., *Appetizers, Soups and Salads, Poultry, Fish, Pasta*) should be easy to read at a glance. They should be a larger point size and treated differently from the rest of the type, or they should feature specialized symbols that identify the different categories.

It is important to treat all the headings in a similar fashion. If you squint your eyes and look at the menu, they should all stand out equally. Remember, visual structure allows for comfortable viewing, and there should be no confusion between menu items or menu groupings. Graphic elements like rules or bands of color (with the caption reversed out) are also options.

When it comes to the next subcategory—the actual menu items—visually group the words of each item so they can be easily distinguished from the items immediately surrounding them. Several examples of achieving this breathability can be seen on pages 32–33.

When determining the point size of the items, take into the account the ambience of the restaurant. If it is candlelit (or dimly lit), larger type or type with a relatively (continued on page 31)

menu formats

Because a menu is almost always held in the hand, it is important to design the format with comfort in mind. Many restaurants use cloth- or leather-bound bi-fold menus, in which case you are usually restricted to designing on standard 8½″ × 11″ (21.59cm × 27.94cm) sheets that will slip into a plastic sleeve or some other similar mechanism.

A tri-fold design is another popular format. If you choose to work with this format, make sure to consider the progression of information as each successive panel is pulled back. Make sure the dessert menu does not unintentionally come before the appetizer menu.

Consider other unique attributes of the menu in general, such as table display possibilities and options for take-out orders and deliveries. Should the take-out menu be the same as the sit-down menu? Should it be different in paper quality only? Or is another design solution required for the take-out menu? Much can be said about the spirit and the quality of a restaurant by a menu that finds itself in the hands of someone who has yet to go there.

Also, make sure you inquire as to whether the restaurant will need a separate drink menu, dessert menu, or insert for daily specials. Paper menus that are not protected by plastic sleeves should be laminated for protection against food and water stains. Talk to your printer to find out what kind of additional cost this will entail, and offer it to your client as an alternative.

A standard-sized menu holder (sometimes bound in leather) will allow for the inclusion of 8½″ × 11″ (21.59cm × 27.94cm) paper either slipped into corner notches, as above, or into clear-sleeved pages. On the right is an example of an accompanying wine list holder.

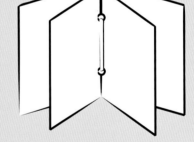

Certain details in a menu may change over time. Printing an outside cover in full color while printing the inside in black and white will allow for inexpensive alterations to the menu listings. These black-and-white inserts can be copied and put into the menu at a moment's notice.

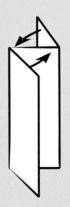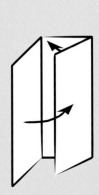

This accordion style tri-fold allows the menu to stand up nicely on a table, but the leaflet closure to the far right may be easier to handle. In any case, a tri-fold that is wider than 5″ (12.70cm) is difficult to hold in one hand.

Make sure the panel that closes inward first on the leaflet closure is slightly thinner than the other panels to prevent any binding of paper (¹⁄₁₆″ or 0.16cm difference is usually more than enough).

style samples

dealing with subcategories, prices and alignments

flush left alignment with prices in a secondary font **(Bodoni and Futura)**	Grilled filet of sole stuffed with shrimp tarragon, peppercorns and chopped parsley with wasabi leek sauce $17.50 Honey-painted pan-seared tuna with artichoke hearts, capers and white wine sauce over angel hair pasta $18.00
flush left alignment with indentation after the first line and price tabbed to the right **(Caecilia and Caecilia Bold)**	Grilled filet of sole stuffed with shrimp tarragon, peppercorns and chopped parsley with wasabi leek sauce $17.50 Honey-painted pan-seared tuna with artichoke hearts, capers and white wine sauce over angel hair pasta $18.00
enlarged and italicized first line with a dot leader to align the price **(Caslon 540 and Caslon 540 Italic)**	*Grilled filet of sole* stuffed with shrimp tarragon, peppercorns and chopped parsley with wasabi leek sauce $17.50 *Honey-painted pan-seared tuna* with artichoke hearts, capers and white wine sauce over angel hair pasta. $18.00
using large and small caps instead of italics on the first line is one of many variations of the above format **(Baskerville and Gill Sans)**	GRILLED FILET OF SOLE stuffed with shrimp tarragon, peppercorns and chopped parsley with wasabi leek sauce **$17.50** HONEY-PAINTED PAN-SEARED TUNA with artichoke hearts, capers and white wine sauce over angel hair pasta. **$18.00**
each of the above options can also be used with centered type	Grilled filet of sole stuffed with shrimp tarragon, peppercorns and chopped parsley with wasabi leek sauce **$17.50** *Grilled filet of sole* stuffed with shrimp tarragon, peppercorns and chopped parsley with wasabi leek sauce $17.50
or justified type	Grilled filet of sole stuffed with shrimp tarragon, peppercorns and chopped parsley with wasabi leek sauce. $17.50
since flush right can be difficult to read over long stretches, it should be used only in more playful or experimental designs **(Stone Serif and Gill Sans)**	GRILLED FILET OF SOLE stuffed with shrimp tarragon, peppercorns and chopped parsley with wasabi leek sauce **$17.50** HONEY-PAINTED PAN-SEARED TUNA with artichoke hearts, capers and white wine sauce over fried angel hair pasta **$18.00**

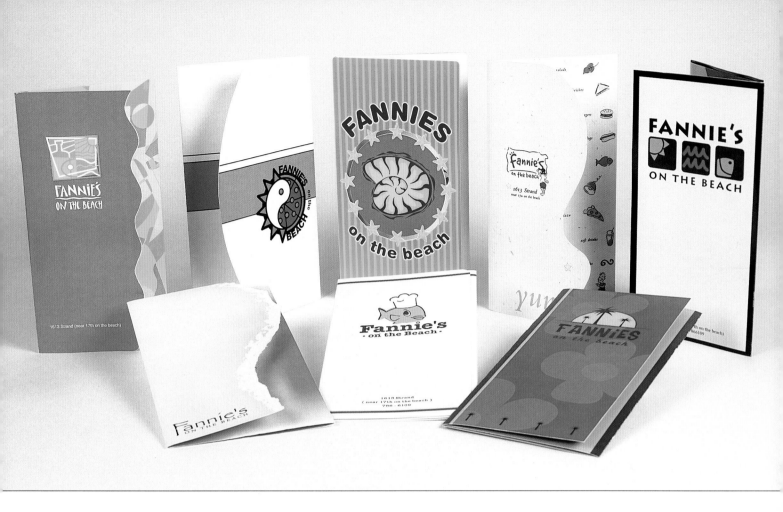

(continued from page 28) large x-height must be considered (see page 174 for more details on this). Also, if it is a restaurant that is frequented by older patrons, make sure the type is adequately sized.

The inclusion of prices is something that is relatively unique to menus, and their treatment must also be consistently addressed. Many people pay as much attention to the cost of the meal as they do to the meal itself, so if it is difficult to determine the price of an item, customers might assume that the restaurant is deliberately concealing the cost. Prices that are difficult to find or decipher can quickly turn a customer off.

Foremost among many important decisions, the issue of type alignment (centered type, flush left, flush right or justified) will have a significant impact on the overall structure.

Make sure your line breaks are in comfortable places. Avoid inserting a break between two-word items, such as "red onion," and do not leave single words stranded alone on the last line (widows).

Explore various design solutions.
Even though a restaurant may have a very specific feel to it, with a very specific clientele, there is always room for exploring different directions within the client's niche market.

Many people pay as much attention to the cost of the meal as they do to the meal itself, so if it is difficult to determine the price of an item, customers might assume that the restaurant is deliberately concealing the cost.

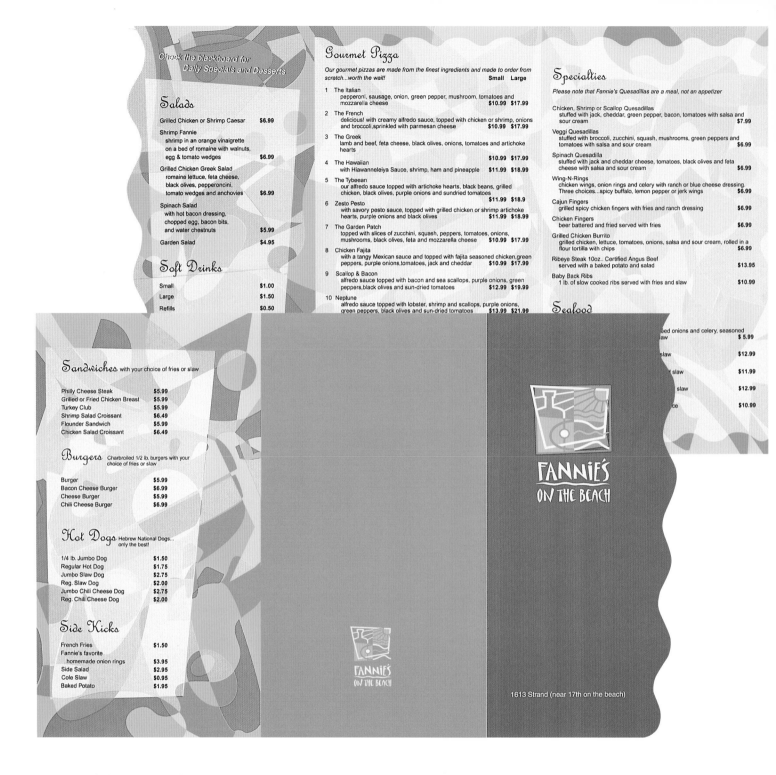

Check the blackboard for Daily Specials and Desserts

Salads

Grilled Chicken or Shrimp Caesar	$6.99
Shrimp Fannie shrimp in an orange vinaigrette on a bed of romaine with walnuts, egg & tomato wedges	$6.99
Grilled Chicken Greek Salad romaine lettuce, feta cheese, black olives, pepperoncini, tomato wedges and anchovies	$6.99
Spinach Salad with hot bacon dressing, chopped egg, bacon bits, and water chestnuts	$5.99
Garden Salad	$4.95

Soft Drinks

Small	$1.00
Large	$1.50
Refills	$0.50

Gourmet Pizza

Our gourmet pizzas are made from the finest ingredients and made to order from scratch...worth the wait!

		Small	Large
1	The Italian pepperoni, sausage, onion, green pepper, mushroom, tomatoes and mozzarella cheese	$10.99	$17.99
2	The French delicious! with creamy alfredo sauce, topped with chicken or shrimp, onions and broccoli, sprinkled with parmesan cheese	$10.99	$17.99
3	The Greek lamb and beef, feta cheese, black olives, onions, tomatoes and artichoke hearts	$10.99	$17.99
4	The Hawaiian with Hiawanneleiya Sauce, shrimp, ham and pineapple	$11.99	$18.99
5	The Tybeean our alfredo sauce topped with artichoke hearts, black beans, grilled chicken, black olives, purple onions and sundried tomatoes	$11.99	$18.9
6	Zesto Pesto with savory pesto sauce, topped with grilled chicken or shrimp artichoke hearts, purple onions and black olives	$11.99	$18.99
7	The Garden Patch topped with slices of zucchini, squash, peppers, tomatoes, onions, mushrooms, black olives, feta and mozzarella cheese	$10.99	$17.99
8	Chicken Fajita with a tangy Mexican sauce and topped with fajita seasoned chicken, green peppers, purple onions, tomatoes, jack and cheddar	$10.99	$17.99
9	Scallop & Bacon alfredo sauce topped with bacon and sea scallops, purple onions, green peppers, black olives and sun-dried tomatoes	$12.99	$19.99
10	Neptune alfredo sauce topped with lobster, shrimp and scallops, purple onions, green peppers, black olives and sun-dried tomatoes	$13.99	$21.99

Specialties

Please note that Fannie's Quesadillas are a meal, not an appetizer

Chicken, Shrimp or Scallop Quesadillas stuffed with jack, cheddar, green pepper, bacon, tomatoes with salsa and sour cream	$7.99
Veggi Quesadillas stuffed with broccoli, zucchini, squash, mushrooms, green peppers and tomatoes with salsa and sour cream	$6.99
Spinach Quesadilla stuffed with jack and cheddar cheese, tomatoes, black olives and feta cheese with salsa and sour cream	$6.99
Wing-N-Rings chicken wings, onion rings and celery with ranch or blue cheese dressing. Three choices...spicy buffalo, lemon pepper or jerk wings	$6.99
Cajun Fingers grilled spicy chicken fingers with fries and ranch dressing	$6.99
Chicken Fingers beer battered and fried served with fries	$6.99
Grilled Chicken Burrito grilled chicken, lettuce, tomatoes, onions, salsa and sour cream, rolled in a flour tortilla with chips	$6.99
Ribeye Steak 10oz.. Certified Angus Beef served with a baked potato and salad	$13.95
Baby Back Ribs 1 lb. of slow cooked ribs served with fries and slaw	$10.99

Seafood

...ed onions and celery, seasoned ...law	$5.99
...slaw	$12.99
...slaw	$11.99
...slaw	$12.99
...ce	$10.99

Sandwiches with your choice of fries or slaw

Philly Cheese Steak	$5.99
Grilled or Fried Chicken Breast	$5.99
Turkey Club	$5.99
Shrimp Salad Croissant	$6.49
Flounder Sandwich	$5.99
Chicken Salad Croissant	$6.49

Burgers Charbroiled 1/2 lb. burgers with your choice of fries or slaw

Burger	$5.99
Bacon Cheese Burger	$6.99
Cheese Burger	$5.99
Chili Cheese Burger	$6.99

Hot Dogs Hebrew National Dogs... only the best!

1/4 lb. Jumbo Dog	$1.50
Regular Hot Dog	$1.75
Jumbo Slaw Dog	$2.75
Reg. Slaw Dog	$2.00
Jumbo Chili Cheese Dog	$2.75
Reg. Chili Cheese Dog	$2.00

Side Kicks

French Fries	$1.50
Fannie's favorite homemade onion rings	$3.95
Side Salad	$2.95
Cole Slaw	$0.95
Baked Potato	$1.95

FANNIE'S ON THE BEACH

1613 Strand (near 17th on the beach)

The use of a die cut can make a menu much more inviting to the consumer. Before offering this as a possible option, make sure to check with your printer to find out how much of an additional expense it will be.

And, as always, when you are deciding on your grid (yes, of course, you should use a grid!), make sure to allow ample space in the gutters and around the margins.

The cover should convey the spirit of the restaurant. It can be photographic or illustrative (if so, who will be doing this work?), or it could be a simple typographic solution. Fancy restaurants may have bound menus with the name emblazoned in gold across the front. Ask beforehand what other information (address, telephone number, and so forth) your client may want on the cover.

Also, as menus have been known to change, designing a full-color cover with inserts that are black-and-white will allow the client to change the menu without significant additional costs.

Sample 1 (handwritten style menu)

Surf

Grilled filet of sole *stuffed with shrimp tarragon, black peppercorns and chopped parsley with wasabi leek sauce* — $17.50

Honey painted pan seared tuna *with artichoke hearts, capers and white wine sauce over fried angel hair pasta* — $18.00

Lobster stuffed with shrimp. *fried coconut and plantain in a spicy togarashi chili sauce*

Sesame crusted wahoo *with a tarragon brie sauce over couscous almondine*

Grilled mahi mahi *with crab cream sauce over pumpkin & chili pepper rice*

Pan seared cuttlefish *with shrimp, wild mushrooms & asparagus over wild rice pilaf in lemon, rosemary and garlic oil*

Turf

Chicken Mauna Kea *with bamboo shoots pineapple chunks and banana in ginger oyster sauce*

Grilled pork loin *stuffed with lump crab meat in a scallion papaya pork demi-glace*

Roasted leg of lamb *with sauteed rosemary kale and mixed vegetables*

Mustard glazed skillet fried chicken *cutlet with mango chutney, cashews and bok choy*

Prime rib *with mozzarella, prosciutto & blackened scallops over sauteed spinach*

Filet mignon & lobster tails *with tomato, cucumber & feta cheese*

Vegetarian

Grilled tofu *with garlic-sesame bok choy, eggplant & roasted red pepper*

Pan fried shitake mushrooms *with artichoke hearts, kumbu seaweed and togarashi chili sauce*

Sauteed spinach with wild mushrooms, *scallions & baked acorn squash in a roasted garlic and ginger sauce*

Polynesian eggplant stir-fry *with ginger, scallions, garlic, green chili peppers, red peppers & peanut honey lemon sauce*

Sample 2 (Art Deco style menu)

SURF

GRILLED FILET OF SOLE
STUFFED WITH SHRIMP TARRAGON,
BLACK PEPPERCORNS AND CHOPPED
PARSLEY WITH WASABI LEEK SAUCE
$17.50

HONEY PAINTED PAN SEARED TUNA
WITH ARTICHOKE HEARTS, CAPERS
AND WHITE WINE SAUCE OVER
FRIED ANGEL HAIR PASTA
$18.00

LOBSTER STUFFED WITH SHRIMP
WITH FRIED COCONUT AND PLANTAIN
IN A SPICY TOGARASHI CHILI SAUCE
$23.50

SESAME CRUSTED WAHOO
WITH A TARRAGON BRIE SAUCE OVER
COUSCOUS ALMONDINE
$18.50

GRILLED MAHI MAHI
WITH CRAB CREAM SAUCE OVER
PUMPKIN & CHILI PEPPER RICE
$18.00

PAN SEARED CUTTLEFISH
WITH SHRIMP, WILD MUSHROOMS
& ASPARAGUS OVER WILD RICE PILAF IN
LEMON, ROSEMARY AND GARLIC OIL
$18.50

TURF

MUSTARD GLAZED FRIED CHICKEN
CUTLET WITH MANGO CHUTNEY,
CASHEWS AND BOK CHOY
$15.50

ROASTED LEG OF LAMB
WITH SAUTEED ROSEMARY KALE
AND MIXED VEGETABLES
$16.50

GRILLED PORK LOIN
STUFFED WITH LUMP CRAB MEAT IN
A SCALLION PAPAYA PORK DEMI-GLACE
$17.50

FILET MIGNON & LOBSTER TAILS
WITH TOMATO, CUCUMBER & FETA CHEESE
$26.50

CHICKEN MAUNA KEA
WITH BAMBOO SHOOTS PINEAPPLE CHUNKS
AND BANANA IN GINGER OYSTER SAUCE
$16.00

PRIME RIB
WITH MOZZARELLA, PROSCIUTTO & ... ENED
SCALLOP...

Sample 3 (textured paper menu)

Surf

Grilled filet of sole stuffed with shrimp tarragon, black peppercorns and chopped parsley with wasabi leek sauce	$17.50
Honey painted pan seared tuna with artichoke hearts, capers and white wine sauce over fried angel hair pasta	$18.00
Lobster stuffed with shrimp, fried coconut and plantain in a spicy togarashi chili sauce	$23.50
Sesame crusted wahoo with a tarragon brie sauce over couscous almondine	$18.50
Grilled mahi mahi with crab cream sauce over pumpkin & chili pepper rice	$18.00
Pan seared cuttlefish with shrimp, wild mushrooms & asparagus over wild rice pilaf in lemon, rosemary and garlic oil	$18.50

Turf

Chicken Mauna Kea with bamboo shoots pineapple chunks and banana in ginger oyster sauce	$16.00
Grilled pork loin stuffed with lump crab meat in a scallion papaya pork demi-glace	$17.50
Roasted leg of lamb with sauteed rosemary kale and mixed vegetables	$16.50
Mustard glazed skillet fried chicken cutlet with mango chutney, cashews and bok choy	$15.50
Prime rib with mozzarella, prosciutto & blackened scallops over sauteed spinach	$19.50
Filet mignon & lobster tails with tomato, cucumber & feta cheese	$26.50

Vegetarian

Grilled tofu with garlic-sesame bok choy, eggplant & roasted red pepper	$12.50
Pan fried shitake mushrooms with artichoke hearts, kumbu seaweed and togarashi chili sauce	$15.50
Sauteed spinach with wild mushrooms scallions & baked acorn squash in a roasted garlic and ginger sauce	$14.50
Polynesian eggplant stir-fry with ginger, scallions, garlic, green chili peppers, red peppers & peanut honey lemon sauce	$15.00

Creating a strong contrast between the graphics and the typeface can be very effective. The first sample here uses a color scheme and a font that reflect the Art Deco style. Working with an eye toward recognizable styles can help identify a restaurant with eras of the past.

Working with colored or textured paper like the middle sample on this page can make a single-color print job look more elegant. Also the use of text figures (numbers that have ascenders and descenders) creates a classier feel.

To balance out this asymmetrical design the prices have been tabbed out to create a column of their own that offsets the design graphics. The type is set in the *flush and hung* manner of indenting everything but the first line of a section of copy.

4 *annual reports*

GROUNDWORK

AN ANNUAL REPORT IS A MAJOR UNDERTAKING, SO MAKE SURE YOU ARE WELL organized and have assessed your client's needs beforehand. Find out early who will be providing the photographs and whether or not the images will be in digital form. Many larger companies will either keep a photographic record of their endeavors or hire a photographer to catalog them. Before committing to an estimate, personally check their photo library to make sure there is enough high-quality work to choose from.

Working with stock photography is also an option, so try to keep several recent stock catalogs close at hand, or at the very least compile a list of stock image suppliers that you can call up at a moment's notice. There are also many options in the stock illustration market.

Talk to your printer immediately for an estimate, and keep in touch with him or her throughout the project to make sure that there are no budgetary deviances that will drastically affect your original estimate.

The first consideration is often paper stock. You must be aware of the price differences between various paper options. Usually, no expense is spared in the publication of an annual report. High-gloss papers or heavyweight matte stocks give the impression of durability, while the use of vellums can add a touch of class.

Some clients will also require that the printing go beyond the standard four-color process. They may request a spot color or a varnish for their logo, and these will increase the overall cost of the project. Do not wait until the client mentions the need for a specific Pantone color midway through the project. Ask up front whether or not this will need to be considered. An annual report is a tremendous undertaking, and approaching the project proactively in all matters is your surest path to success.

When it comes to all those statistics and numbers, consider presenting pie charts and/or graphs to dispense this information clearly and quickly. The financial information found in annual reports can be confusing, but a good chart or graph will go a long way in explaining that information in a clear and concise manner. Adobe Illustrator dedicates an entire toolbox to creating custom graphs.

If you are not capable of creating these visuals yourself, you may need to hire a freelancer, in which case you need to find out what the cost of that

Clarify with your client before you begin

- ✦ **Who will supply the imagery, and is it in digital format?**
- ✦ **Will there be any special printing requests, such as a spot color, a varnish, embossing or foil stamping?**
- ✦ **Is the client interested in special paper stocks, like vellum?**
- ✦ **How will the client want statistical information presented?**

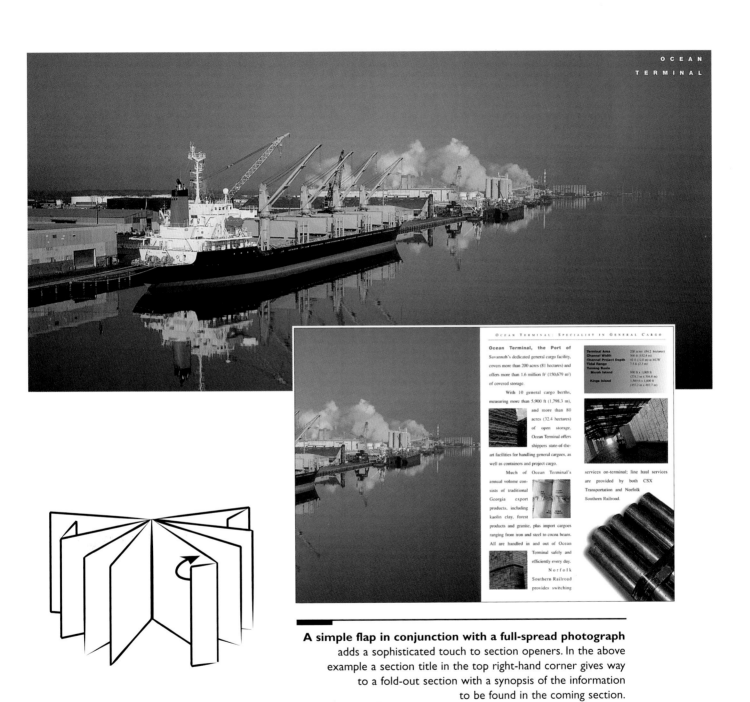

A simple flap in conjunction with a full-spread photograph adds a sophisticated touch to section openers. In the above example a section title in the top right-hand corner gives way to a fold-out section with a synopsis of the information to be found in the coming section.

work will be in order to include it in your estimate. With the inevitable last-minute changes inherent in such a project, do not underestimate the time and money needed to get it right.

DESIGN Regardless of the nature of the company requesting a design for an annual report, your work must be highly refined and professional. There may well be a big difference in style between a record company and a brokerage firm, but the bottom line is that the stockholders who read the annual report are looking for just that:

A feeling of balance, stability, and even a sense of history will put the investor at ease and build confidence in the company's business prowess.

the bottom line. Stockholders are business oriented. They want to know that their money is safe. They want to feel secure about their investments. For this reason content must drive design. Your efforts should portray elegance and subtlety and strive for a timeless and classic feel. This is no place to let your design work "shout"—less is often more. A feeling of balance, stability, and even a sense

of history will put the investor at ease and build confidence in the company's business prowess.

The use of a grid is essential for a consistent and unified presentation. The content of body copy will vary—with letters from the CEO to project descriptions to financial information—so there must be an underlying structural agent, and there is no better organizing agent than a grid.

A three- or four-column grid works well for annual reports, since each provides the designer with enough versatility to create interesting layouts and at the same time provides the reader with a clear and comfortable format. It also provides the designer with the option to leave large areas free of body copy altogether throughout the report in order to create a sense of openness.

As companies are willing to spend a lot of money on annual reports, this is a perfect opportunity to exploit your ability to work with white space; a well-designed clean and open page personifies elegance. When designing mailers, brochures, catalogs and the like, there is not always the luxury of working with white space because the client is concerned with fitting as much information onto a page as possible, so take advantage of this somewhat rare opportunity. Work with wide margins to enhance this open feel. A two-column grid can also

3 EQUIPMENT AND IMPROVEMENTS

Equipment and improvements, at cost, consist of the following:

(dollars in thousands)	September 30, 1997	1996
Store and office equipment	$20,261	$14,310
Leasehold improvements	17,267	14,141
Computer equipment and implementation costs	5,003	4,302
	42,531	32,753
Less accumulated depreciation and amortization	(13,151)	(9,272)
	$29,380	$23,481

4 PURCHASE OF TRADENAME

During 1997, the Company acquired all the rights of A.A. Friedman's Co., Inc. of Augusta, Georgia (AAFCO) to the "Friedman's Jewelers" tradename and AAFCO changed its corporate name to "Marks & Morgan." In connection with the tradename rights acquisition, the Company issued to AAFCO 250,000 shares of its Class A common stock on May 16, 1997. The shares were placed in escrow and became vested incrementally as AAFCO changed the names of its store locations between May 16, 1997 and September 30, 1997. The Company also agreed that for each share placed in escrow, the Company would pay AAFCO an amount by which the actual stock price at June 30, 1999 (the date of settlement for the escrow) is lower than a guaranteed stock price of $28.25 per share (guaranteed price). The Company has agreed to make certain advance payments to AAFCO of approximately $7 million through an escrow arrangement which would pre-fund the minimum sales proceeds. As of September 30, 1997, $4.0 million has been advanced to AAFCO under this arrangement. The Company recorded an asset related to the tradename rights acquisition of approximately $7.1 million (guaranteed amount) with additions to paid in capital of $4.2 million (which represents the quoted market price of the stock on the date of issue) and to a long-term obligation of $2.9 million. The $2.9 million obligation will be adjusted based on changes in the Company's stock price between the date of issuance, May 16, 1997, and the final settlement date, June 30, 1999. At June 30, 1999, any remaining amount of this obligation will be paid in cash by the Company.

5 ACCRUED AND OTHER LIABILITIES

Accrued and other liabilities consist of the following:

(dollars in thousands)	September 30, 1997	1996
Accrued compensation and related expenses	$2,271	$3,314
Sales taxes payable	1,592	1,614
Customer deposits for layaways	1,428	1,536
Accrued legal costs	107	1,139
Other	659	(395)
	$6,057	$7,208

Friedman's
The Value Leader

Store Partners

Putting an

owner's face

on the Friedman's name

"Everybody talks about *customer satisfaction*, but what attracted me to the Company is that **Friedman's Store Partners are obsessed with it.**"

Richard Ungaro, Incoming C.E.O.

"As a Store Partner, I have a genuine sense of ownership that promotes creativity, and a commitment that results in financial success."

Darrall Harper
Darrall Harper, Store Partner

"The Store Partner strategy enables me to give my customer a buying experience of unsurpassed selection and value, complemented by uncompromised customer service."

M. Carol Vina
Carol Vina, Store Partner

But just as we depend upon the entrepreneurial spirit of our Store Partners to generate the highest quality customer service, we also provide every possible resource necessary to make that happen. The confidence and respect we invest in our Store Partners is what really makes the difference. Those values resonate with the customers who, when they come into our stores, feel like they're dealing with the owner. That's what keeps satisfied customers coming back, again and again.

We also do everything possible to make Friedman's a company that our Store Partners are proud to represent as their own. Our Value Leader Guarantee gives them a solid expression of our customer service philosophy and enables them to consistently deliver the levels of satisfaction that distinguish us in the industry.

Ownership of Responsibility and Rewards
The level of responsibility for building customer satisfaction that we put on our Store Partners is tremendous, but so are the rewards. Backing up our ideals with the most tangible expression of our ownership philosophy, we encourage every member of the Friedman's Team to participate in our stock purchase plan. And through the stock options we grant to each of our store partners annually, we forge ever stronger bonds that link compensation and loyal, long-term partnership to stockholder returns. We believe we enjoy one of the highest percentages of employee stock ownership in our industry.

Partners to the Community Store Partners also play an essential role supporting our advertising and special promotions programs.

Percent of Store Partner Stockholders

6

7

A sense of unity is paramount when designing annual reports. Notice the background treatment of all the photography in the examples on this page. To ensure consistency, each of the photographs features a colorful background with a subtle drop shadow around the figure for a clean transition from foreground to background.

work well, but the designer must use it creatively or run the risk of designing a predictable and boring layout.

When choosing fonts, keep in mind that oldstyle fonts such as Caslon, Goudy and Garamond exude a sense of warmth, friendliness and romanticism and are considered classical, whereas transitional fonts such as Baskerville and Cochin have a rational and matter-of-fact feel to them. Modern fonts such as Bodoni and Iridium portray a certain sophistication and elegance. There is always room for *sans serif* fonts and more contemporary typefaces, but make sure to be very selective when using these. This is not the time to play with novelty fonts, nor is it the time to play with more than two fonts overall.

The binding and the outer surface of the annual report are two other variables with potential for unique design approaches. Although saddle stitching and perfect binding are the two most common types of binding for annual reports, spiral bindings or bindings that feature clasps or rivets can make an immediate impact, providing, of course, that there is a solid rationale for such an addition.

Covers are always important. Aside from the basic design work, which should include the company's name and the year of the annual report, more interactive features such as embossing, die-cut windows or edges, and wrapping paper or cardboard bands can add a nice interactive touch. Foil stamping and spot varnishes are also innovative and enticing options.

The day is past where an annual report must conform to standard paper formats. The above example makes use of a taller, more narrow paper size to make the report more comfortable to hold. It also makes creative use of a series of folds as a way to guide the reader through it. Also note the addition of photographs to the bar graphs as a way to liven the page.

charts & graphs
for financial information

Condensed Balance Sheet	2001	2000
Assets		
Current Assets	$5,467,944	$3,176,388
Property & Equipment	11,592,421	8,636,054
Investments, at fair value	8,151,897	4,965,368
Other assets	$3,060,374	$1,068,560
Total assets	$28,272,686	$17,846,370

Although presenting statistical information in a list (like the example to the left) is adequate, working with colored charts and graphs as supplements can liven up a page and break the monotony of too many type-oriented pages.

Below are several examples of how information can be arranged to emphasize different relationships. Each example uses the same information as the original listing to the left.

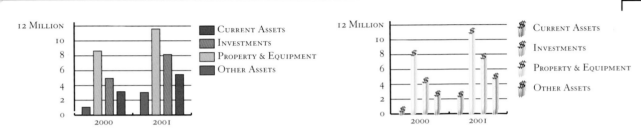

Both of these examples break down the information in a similar fashion as the original list. The years are broken up as well as each of the separate categories. The example to the right shows how graphics can be added to further spice up the presentation. Any icon can be used in place of the dollar sign; a logo or simple illustration would work just as well. Although this type of graph allows for a quick assessment of how each category has performed over the last two years, it does not present anything in the way of total assets combined.

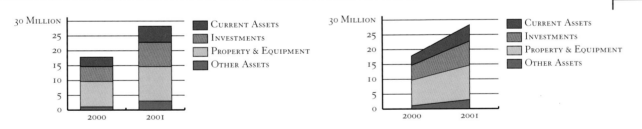

The above examples put special emphasis on the total assets combined but also offer a clear breakdown of each of the separate categories. The example to the right presents a more dramatic representation of the growth from one year to the next.

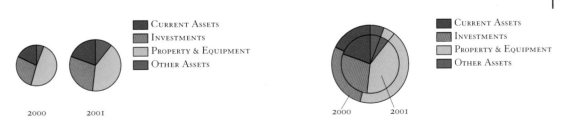

Pie charts present information that allows the viewer to see how each of the separate categories performs in relation to the whole. Both of these use a change in overall size of the pie to represent overall growth from one year to the next.

Attracting

business to

Savannah

is what we do

How we do it

is attracting

national

attention

Entrepreneurs for Growth

IN 1998, SEDA'S CLIENTS ANNOUNCED $127 MILLION IN INVESTMENT AND 2,454 NEW JOBS

It's what we do. And the key to doing it is this: In any project, don't be eliminated. That sounds deceptively simple until it becomes clear how many steps there are to the successful completion of a project:

► Identify a business beginning its relocation or expansion search. *Savannah must meet the criteria.*

► Research and assess the needs of the business and present the services, utilities, incentives, property or buildings that highlight the benefits of locating and operating here. *Savannah must be a rational choice.*

► Invite the decision-makers to the area, plan and host their visits, and provide data related to their specific interests. *Savannah must be the best business choice.*

► Close the deal. *Savannah must be the right choice.*

There are pitfalls in every step that can take us out of the game. The challenge is to execute these steps better than the competition.

HOW DOES SEDA DO IT BETTER THAN THE COMPETITION?

SEDA leads with strength to give Savannah maximum leverage. Unshackled by bureaucracy, SEDA is run like a profit-motivated company. Driven by an entrepreneurial spirit, SEDA approaches its mission with performance-oriented thinking. SEDA succeeds because we understand the concerns and opportunities confronting our clients.

SEDA operates on the rock-solid proposition that it's never too early to plant the seed of Savannah in the minds of prospects who will move or expand their operation next year, or in two years, or five years from now. The SEDA staff makes sure not to miss a single opportunity.

PATIENCE WITH PERSEVERANCE

The seed, once planted, must be cultivated with care and patience. Most companies considering relocation or expansion face a two-year-long process. SEDA's first objective is not to be eliminated. The odds aren't favorable: there may be as many as 90 competitors in as many as ten states. This is not a race for the easily intimidated.

When a search has finally been narrowed to between two and five communities, all objective criteria are relatively equal — to remain a contender at this point takes hard work, patience and steely nerves. Now is the time that perseverance and innovative salesmanship make the difference between success and failure. Success goes to the organization that responds most quickly, most accurately, most honestly and with sincere interest. SEDA is committed to delivering nothing less.

COMMUNITY BENEFITS WITHOUT TAXPAYER MONEY

All of SEDA's activities are financed by the Authority itself. In 1998 alone, it invested well over $1 million promoting the community. Though they occasionally partner with various allies in joint marketing activities, SEDA is unique in that it receives no operational funding from city, county, state or federal government. This allows SEDA to fairly represent the best interests of the community and the client. This is a unique advantage that allows SEDA to operate most effectively and responsively.

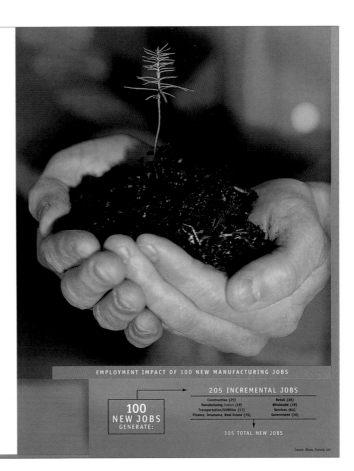

EMPLOYMENT IMPACT OF 100 NEW MANUFACTURING JOBS

	205 INCREMENTAL JOBS
100 NEW JOBS GENERATE:	Construction (25) • Retail (36) • Manufacturing (indirect) (19) • Wholesale (19) • Transportation/Utilities (11) • Services (64) • Finance, Insurance, Real Estate (15) • Government (16)
	305 TOTAL NEW JOBS

Source: Rome, Canada Ltd.

6

Photography is a key element in annual reports. Some companies have extensive photo archives, while others rely on stock photography. Whatever the case may be, use your images in a variety of ways. Bleeding them (as with the example above) breaks up the large amounts of copy that must be presented in annual reports. The faded picture on the left page is a nice echo of the photography on the cover.

CONDENSED FINANCIAL STATEMENTS

For the years ended December 31, 1998 and 1997

SAVANNAH ECONOMIC DEVELOPMENT AUTHORITY

	1998	1997
CONDENSED STATEMENT OF REVENUES, EXPENSES & CHANGES IN RETAINED EARNINGS:		
Operating revenues	$2,046,145	$2,010,181
Grant received	100,000	800,000
Operating expenses	(2,710,182)	1,893,683
Grant disbursed	(100,000)	(800,000)
Excess revenues (expenses)	(664,037)	116,498
Retained earnings - beginning of year, as previously stated	7,202,209	7,533,457
Effect of adoption of FASB 115		(447,746)
Retained earnings - beginning of year, as restated	7,202,209	7,085,711
Retained earnings - end of year	$6,538,172	$7,202,209

	1998	1997
CONDENSED STATEMENT OF CASH FLOWS:		
Excess revenues (expenses)	$(664,037)	$116,498
Adjustments to excess revenues (expenses):		
Depreciation	82,913	100,770
Gains on sales & settlement	(122,500)	(726,159)
Changes in operating assets and liabilities	952,903	(90,150)
Cash provided (used) by operating activities	249,279	(599,041)
Cash provided (used) by investing activities	(68,819)	772,725
Cash provided (used) by financing activities	(12,582)	108,936
Increase in cash and cash equivalents	167,878	282,620
Beginning cash and cash equivalents	436,885	154,265
Ending cash and cash equivalents	$604,763	$436,885

The condensed financial statements presented have been derived from financial statements audited by Burkett, Burkett & Burkett, CPAs, West Columbia, South Carolina. Copies of the complete audited financial statements may be obtained by contacting the Savannah Economic Development Authority office at (912)447-8450.

19

Financial information in annual reports must be clear and easy to understand. The example to the left presents it without the aid of any graphs or charts. If you plan to lay it out this way, leave a lot of white space between lines. Adding a little color in key places further organizes the page.

Cover design is important.
Dedicate a lot of time to generating many distinctly different solutions. Refine them thoroughly before you show the client, however. And select only the best solutions to present. Showing too many designs may confuse the client, and in which case it would be as bad as showing too few.

Don't be afraid to push
a particular concept to the limit in the early stages of design. Once you have determined the essence of your client's business philosophy, take time to develop an overriding theme. Then find imaginative and surprising ways to carry that theme throughout the entire annual report.

PAckaginG

compact discs

hangtags

beer & wine labels

polybags

video packaging

cassette packaging

5 compact discs

GROUNDWORK

THE APPROACH YOU TAKE WHEN DESIGNING A COMPACT DISC PACKAGE—FROM font choice to color scheme to the use of graphic elements or photographs—must relate directly to the style of music appearing on the CD (or movie on the DVD). More so here than with any other design project, you must be flexible and versatile in your abilities as a designer. A piano recital of Beethoven's sonatas will obviously be handled very differently from a CD of the most recent cutting-edge garage-rock band. But there are many other subtle differences in types of music, and the devotees vary from one style to the next. Never forget the target audience. Listen to the music. Listen to the music. Then, listen to the music.

If you are working through a record company or an agent for the band, do everything you can to get a chance to sit down and talk with the actual musicians. The band may have very different ideas from those of the record label when it comes to the overall design, so it is important to determine at the outset who holds the most influence over the decision-making process, and make sure you are clear on all their expectations. If the band has approached you personally, this part of the process will be a little easier, but be prepared for dissenting voices within the band itself, and be prepared to offer them several solutions that address the concerns of the band as a whole.

Due to the industry constraints of the standard jewel case, the overall size of the insert will remain constant at 4¾″ × 4¾″ (12.07cm × 12.07cm) unless your client wants a customized package construction. Then the standard size increases ½″ (1.27cm) horizontally to compensate for the jewel case's hinge. If a custom package is required, ask about what materials the client is interested in specifically. Because cost will vary, sometimes greatly, from custom package to custom package, it is important to have a general idea of the client's expectations from the outset so that your original estimate is reasonably accurate. **Note:** DVDs can be packaged in a standard jewel case as well, or, more typically, in a 11″ × 7½″ (27.94cm × 19.05cm) plastic case that can hold literature up to 7¼″ × 4¾″ (18.42cm × 12.08cm) at ¹⁄₁₆″ (0.16cm) thick.

Imagery is also important to discuss early. If photographs of the band are to be included in the design, then who will be taking them, and will they already be in digital form or will you be required to do the scanning along with the designing? If artwork is going to be used, does the client have an artist in mind, or is the client looking to you for that as well?

Another consideration is whether the lyrics of the songs will be included. If so, get them from your client before you begin. Songs vary in length, and the quantity of copy will always have a major influence on your design approach.

Clarify with your client before you begin

+ **Will a standard jewel case be used, or will a customized package be required?**
+ **Ultimately, who will be approving the design—an agent, a record company or the musicians themselves?**
+ **Will photography be used, and if so, who will supply it?**

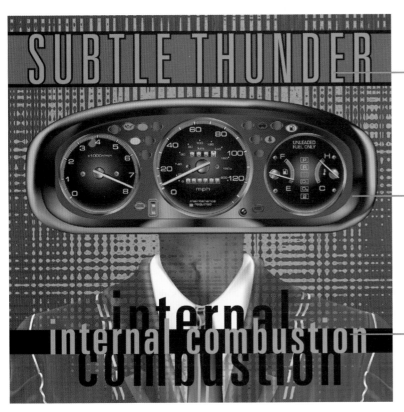

The name of the band should be the most prominent typographic element. Uppercase letters helps set this apart from the rest of the work, as do the black outline and the solid color band behind it.

Finding the right visual is extremely important. The image, whether an illustration or a photograph, should grab the consumer immediately, and it should exude a mood that reflects the nature of the music. The cover artwork should be the focal point. It is also used in marketing campaigns and posters.

The name of the album is set in all lowercase and placed in the lower half of the composition. All of the typography is set in clean horizontal lines in order to frame the artwork.

The band name as been copied from the front and placed vertically. The song titles are designed in the same manner as the name of the compact disc, complete with a black bar to separate the words from the background.

To carry through the design ideas established on the cover, the original background has been utilized in a slightly different manner for the back panel.

The back panel is a full half-inch (1.27cm) wider than the front. This is because the standard jewel case has a plastic hinge on the front but not on the back.

The two spines are printed on the same piece of paper stock as the back panel. The type on them should read facing the back panel as they do here.

Important information, such as a barcode and copyright notice, must be on the back cover. Make sure the area behind the barcode is one color and in high contrast to the barcode itself.

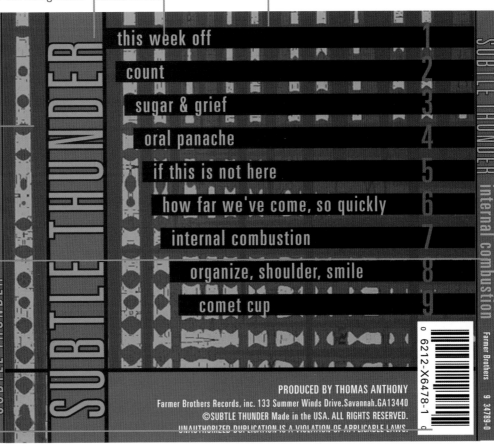

this week off — 1
count — 2
sugar & grief — 3
oral panache — 4
if this is not here — 5
how far we've come, so quickly — 6
internal combustion — 7
organize, shoulder, smile — 8
comet cup — 9

PRODUCED BY THOMAS ANTHONY
Farmer Brothers Records, inc. 133 Summer Winds Drive. Savannah. GA 13440
©SUBTLE THUNDER Made in the USA. ALL RIGHTS RESERVED.
UNAUTHORIZED DUPLICATION IS A VIOLATION OF APPLICABLE LAWS.

0 6212-X6478-1

DESIGN The cover is expected to be a work of art in its own right, as it is the first thing a consumer will see before actually purchasing the CD or DVD. Also, it is common to use the cover for poster designs or for advertisements. It should be distinctive enough to stand up on its own, but it must also work well with the entire insert. Consistency and unity are extremely important. When presenting your work to the client, it helps to show the cover at 200 percent (mount it neatly on presentation board) and use a color mock-up of the insert that the client can hold.

Working with a simple grid will allow for a more organized and consistent presentation, especially when dealing with lyrics. A single-column grid is often most effective, but by no means is it the only solution. When choosing a typeface, remember that the words will be small because the format itself is small, so do not pick anything overly ornate or a font that has a small x-height. Also, avoid using bold fonts at small sizes because the counters (negative spaces) may clog up in the printing process, creating legibility problems.

How many panels will the insert include? Will it be saddle stitched or folded up? If folding is the chosen option, then in what manner will it be folded? The opposite page shows several possible folding options.

Suzanne Corrigan

i will rest quietly

It is important that the design fit the style of music.
Everything from font choice to choice of imagery and use of white space was focused here to create a serene feeling in order to portray the type of music on the CD visually. Only a small section of the painting is shown on the front, whereas the entire painting is revealed on the back in order to provide a sense of progression from mystery to revelation. The front and back are laid out according to the same grid, and all copy is flush right. Credits for artwork can be included either on an inside panel or directly below the image, as done here.

i will rest quietly

1	The Same, So Different
2	Through Sunlit Blinds
3	Someone's Daughter's Ghost
4	I Will Rest Quietly
5	Whales
6	Orange Burgundy
7	Anyone Can Say Maybe
8	Bunnies Cannot Fly
9	My Lover's Name
10	The Opposite of Dark

I was father, mother, sister ©Randy Akers

J.HEIGHTS RECORDS~QUEENS, NEW YORK © 2000 SUZANNE CORRIGAN
MADE IN USA~ALL RIGHTS RESERVED~UNAUTHORIZED DUPLICATION
IS A VIOLATION OF APPLICABLE LAWS.

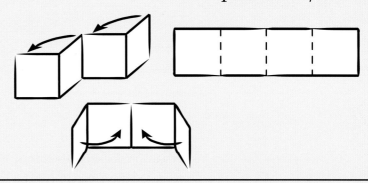

Even a simple four-panel straight fold can work in more ways than one. Both of the samples to the right come from the same folding piece of paper, but they are distinctly different from a designer's perspective. Each presents a unique format as far as how adjoining panels relate to one another, and each offers distinct folding sequences that will influence design decisions.

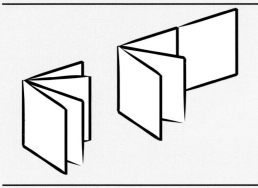

Staple-bound inserts can include as many pages as necessary. They can also incorporate extra fold-out sections at the beginning or the end, as seen in the second example. The major concern when laying out such a saddle stitch is designing it on the computer with the proper pagination in mind to insure trouble-free production.

Folding inserts like these can also have as few or as many panels as needed. Although the four-panel sample can be folded only one way, the sample with six panels could be folded a number of ways:

1. In half along the horizontal, then folded toward the center.
2. In half along the horizontal, then folded accordion style.
3. "Rolled" from one side to the other, then folded along the horizontal.
4. Both sides folded inward, then folded along the horizontal.

The inside surface of both of these can be used for a poster.

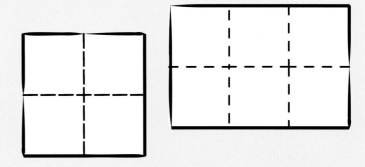

Beyond the parameters of a standard jewel case there are many possibilities for unique formats.

The first sample is constructed completely of card stock. It includes a sleeve for the CD that faces to the side so it cannot slip out inadvertently. If this is laid out properly, everything can be printed on one side of the card stock and glued back on itself.

The second sample still utilizes a plastic CD holder placed within a chipboard construction. The right panel can flip out to reveal lyrics, liner notes or photographs of the musicians.

The third sample features a sleeve for an accompanying booklet and a sleeve for the CD. Because the CD sleeve faces upward, a top flap must be used to assure it does not slip out of the top when the package is closed.

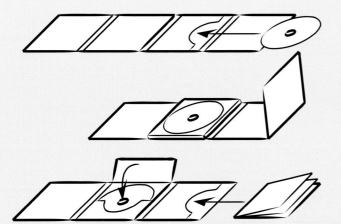

Because the sequencing of the song lyrics must follow the progression of songs as they appear on the CD, pay careful attention to how your insert folds up. This progression from one panel to the next must be an early consideration. If the package will be saddle stitched, this is simple enough, but if folding is required, be clear on the folding sequence in the beginning, because this will influence all design decisions. It would be a good idea to show your client a number of folding solutions early in the process.

When choosing a typeface, remember that the words will be small because the format itself is small, so do not pick anything overly ornate or a font that has a small x-height.

Layout options are many with such a package. Try photographs confined to picture boxes interspersed with the lyrics, but also try desaturating (fading out) the pictures and placing them behind the lyrics. Consistent type treatment is important. Using a larger point size and even a different font for the song titles is the first step in organizing your information in a way that can be easily and quickly digested. If song writing credits are to be listed underneath each song title, then the type treatment of these credits should be distinct from both the title and the lyrics. Find out if the length of

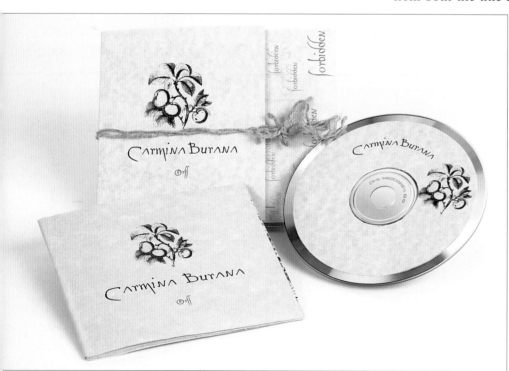

Custom paper and additions like a twine wrap-around can lend a design a certain amount of Old World elegance. It can be very beneficial to find the proper typeface as well, even if it means hunting around for a while.

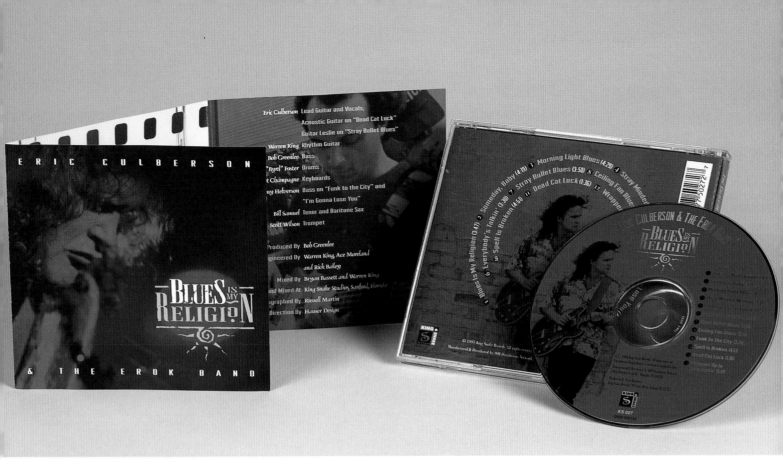

each track (in minutes) also needs to be included. Sticking with a single alignment through all the lyrics is not necessarily the only way, but it will lend the work the feeling of unity.

Do not neglect the back of the jewel case and the spine. The customer sees these before he or she sees the actual insert, so their impact cannot be underestimated. Also keep in mind the disc itself—any surface that can be printed on should be taken full advantage of.

Information that should be included on the inside includes acknowledgments and copyright information about the songs, a listing of band members and production notes. Get all of this information as soon as possible so it can be considered during the early stages of design.

Legal requirements such as a barcode, copyright warnings, and the record company logo and address should be acquired early. Most of this information will need to be placed on the outside of the package. It is most often placed on the back along with a listing of the song titles. This track listing is important to place on the outside of the package because some consumers are looking for a single song they once heard on the radio.

Color scheme and photographic treatment
can go a long way in unifying a compact disc case that makes use of several fonts and type alignments.

6 *hangtags*

HANGTAGS ARE USED FOR ANY PRODUCT THAT DOES NOT NECESSARILY HAVE a convenient surface to apply a label or that is not well suited for standard packaging. They are most often used for clothing and related items, but they can be used also for products and merchandise in lieu of an outer package altogether, as long as safety concerns are not an issue. Labels are most often affixed to the

GROUNDWORK product by means of a small plastic cord, but if the client is willing to spend a little extra money, using other materials such as ribbon or twine can add a unique touch to any hangtag.

First and foremost, determine what place the hangtags have in the overall scheme of the client's identity system. Will they be the sole identifier, or will they be supplemental information? The inclusion of a barcode for scanning and product identification must be addressed if the tags will be the only identifier on the product. In many cases the barcode is simply a sticker that is adhered to the back of the label. This offers the client a lot of flexibility. If this is the case, find out how large the barcode needs to be and leave enough space for it.

Find out how many items will require hangtags. Your work should be consistent from label to label despite any significant size differences in the products. Find out exactly how much information needs to be placed on the hangtags. If they are for food-related items, ingredient copy and nutrition information will need to be applied.

Clarify with your client before you begin

- ✦ **Are the hangtags the only identifier on the product?**
- ✦ **How many items in the product line require hangtags?**
- ✦ **Is there a budget for specialty papers and affixers, such as wire or twine?**
- ✦ **How important is durability?**

Finally, determine how creative you can get with the actual format of the label. Whether or not it will be a one-sided flat card, a two-sided flat card, a single-fold, or a booklet is often determined by how much money the client is willing to spend. Creative use of die cuts on a standard hangtag or tag shapes that are not simply rectangles or ovals are possibilities as long as they are not prone to tearing. Thicker paper stock will usually prevent tearing of any narrow sections of a tag. Wrap-around bands also work well for certain products.

DESIGN Because there are so many choices to begin with, determining the format of the hangtag is your first design issue. A long and skinny card can add a touch of elegance to the product, but it may also not be practical if the product is apt to be folded frequently and the tag is subjected to a lot of handling. Consider the overall shape and the design elements within the company's logo.

Since the front is mostly for display, make sure the logo is very prominent for brand identity purposes. The color scheme for the rest of the tag is taken directly from this logo.

Using simple words and phrases on the front of the tag provides consumers with a clue as to what type of merchandise they are looking at.

Not using an edge border on back allows for any slight misregistration that might occur during printing.

The pattern on the front is repeated on the back for consistency. The color change adds variety.

When choosing a secondary typeface, find one that is legible at small sizes. It should feel unified not only with the primary typeface but also with the overall design.

Use only one color behind the barcode so the scanner can read the encoded information. It is not necessary to make it black and white, but there must be significant contrast between the color of the code and the color of the background.

The hangtag construction can include a mechanism that attaches to the product, such as a slot and hole for wrapping around the neck of a bottle or an additional panel to slip into a pocket (like the top flap to the far right). Perforated edges can also come in handy for pricing information in the case of a potential gift item.

Find a shape that is practical but at the same time accentuates these logo attributes. As with many other projects in this book, the shape of your tag determines the proportions of your "canvas," and this must be determined early because all other design decisions are based upon it.

It is always a good idea to assign space for required elements (UPC code, logos, product names, legal listings, and so forth) at the very beginning. There is no way around these elements; they should be considered from the outset. Determine the necessary sizes for these and place them into your format immediately. Most tags should incorporate the company's logo, and so the typeface and color scheme must be carefully selected to work with this design element.

Hangtags often need to be quick reference guides to alert the consumer to differences in the products themselves, and color scheme is most often used for such distinctions; men's clothing versus women's clothing, sports items versus casual items versus formal items, spicy versus sweet, and so forth. With this fact in mind, design your work within a flexible framework. Offer several ways of distinguishing between separate products, and devise several color schemes that work well on their own but also make sense in the bigger picture.

When there is more than one product involved, begin the design process with the product that has the longest name. Designing a border treatment with the words Peach Jam, for example, will make it difficult to fit the words Strawberry Preserves in the same space.

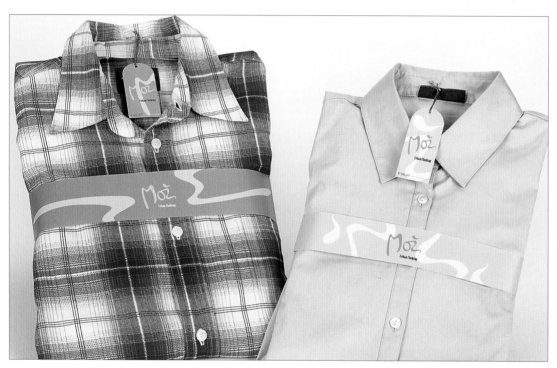

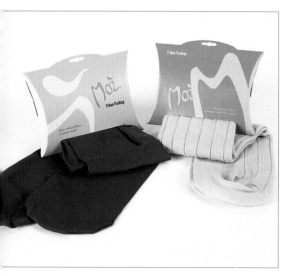

Hangtags need to be consistent with any other printed material that might appear on the merchandise. These are examples of different kinds of clothing identifiers. The top picture shows a standard hangtag attached to the collar as well as band tags that wrap around the product. These serve the dual purpose of identifying the product and containing it as well. The bottom picture shows how hangtags can be pushed more toward a packaging concept. Notice how color and imagery join together here to clearly define the difference between female products (beige) and male products (green).

Hangtags should reflect the nature of the product they are attached to. This includes obvious details such as appropriate choice of color scheme, typography, and imagery. But it also includes choice of paper stock and choice of binding material. This page features a number of hangtags that focus on the rugged nature of outdoor merchandise. Rough-hewn paper and twine add an outdoor flavor to the strong graphic images used. The hangtags open to reveal important information such as size and color and include a space for barcoded stickers on the backside. This information can help the consumer decide whether or not to purchase the item.

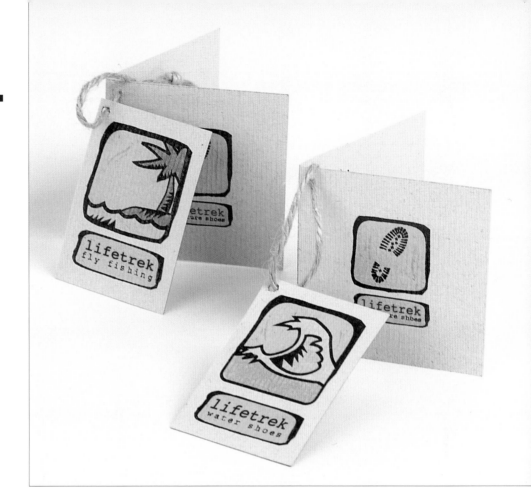

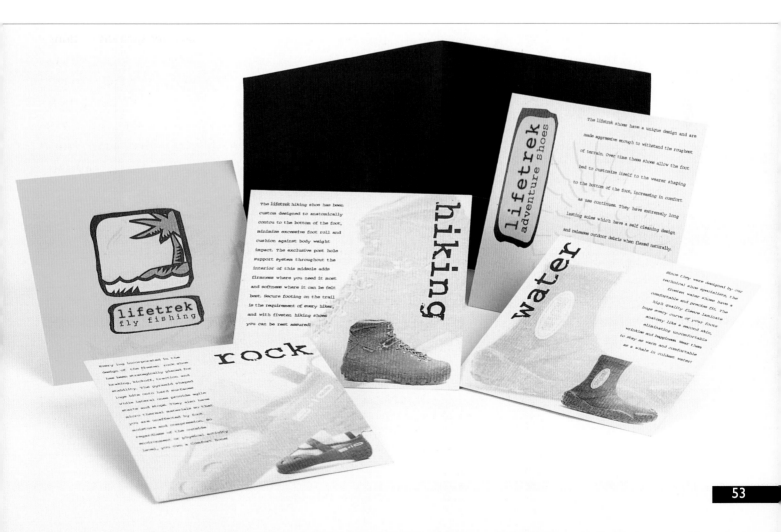

7

beer & wine labels

GROUNDWORK

At the risk of sounding too obvious, nothing should be done in the way of designing a beer or wine label before seeing the bottle on which the label will appear. The bottle shape and the color of the bottle's glass will have a direct bearing on your design approach. If you are fortunate enough to be involved with the early stages of the process, you may actually be asked to contribute your ideas regarding bottle form, but this is often carried out under the guidance of product designers on software that is specifically programmed to address issues of shaping as they apply to volume.

Beer bottles will most often contain 12 fluid ounces, whereas wine bottles will usually be 750 ml or 1.5 liters. Although these sizes are considered industry standards, the wide array of forms these volumes can be contained within requires a discerning eye in taking full advantage of what the shape has to offer when designing the label.

Glass color is also an important consideration. Although white wines are almost always packaged in light-colored or clear glass, red wines require glass that allows less light in from the outside in order to preserve the wine's delicate balance. Brown, red and green glass are the most frequently used. Beer has a little more flexibility, although specialized microbreweries also use darker glass for much the same reason. Because this color factor will have a significant bearing on some of your design decisions, find this out early.

Another major concern is the personality of the brewery or vineyard that has come to you for creative input. Vineyards so often in the past have been determined to present their products as vessels of refinement and elegance, but this is no longer always the case. Wine has become appealing to a much wider population than in the past, and vineyards are tapping into this younger generation. So find out the personality of the vineyard and to whom it most wants to appeal. It could be said that breweries, especially microbreweries, also have a niche market, but this niche market happens to be rather broad in its own right. Tongue-in-cheek humor and a more hearty image have always served this niche well.

Clarify with your client before you begin

✦ **What overall shape is the bottle and what color is the glass?**
✦ **Will you be responsible for a logo as well as the label?**
✦ **Will there be more than one product (Merlot, Chardonnay, amber ale, etc.)?**
✦ **For beer, will a six-pack container also need to be designed?**
✦ **Is the client interested in neck labels as well?**

Since there are several significant differences in how beer and wine labels should be approached, the labels have been divided into two separate sections on the following pages.

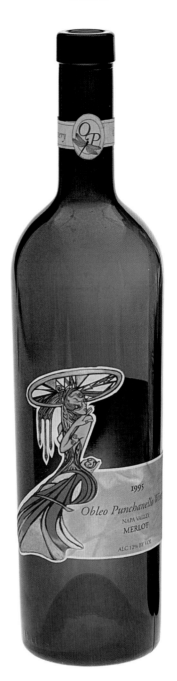
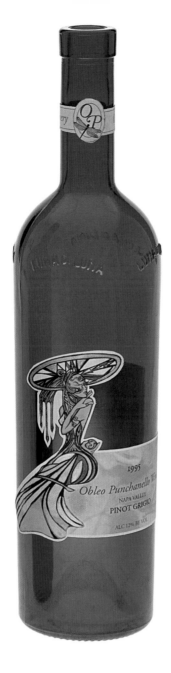

Illustration can successfully create a particular image for a winery. The examples to the left take full advantage of a dramatic illustration to attract the consumer's attention. Enlarging the image and die cutting around it further enhance the overall feel. The typographic information is presented in a clear and orderly fashion to prevent any clashing. The central image for a label can vary from grape to grape. Or, if the central figure is more closely tied to the winery's identity—as in this case— introducing different color schemes into the same image can be just as effective.

Many microbreweries have targeted a niche market that enjoys humor. The companies most often begin with a distinctive name capable of turning heads. For this reason the name itself is often the springboard for visuals and graphic treatment. Rather than carrying the dominant yellow over to the six pack carton, the more subtle colors of the label design are used here to create a sense of contrast.

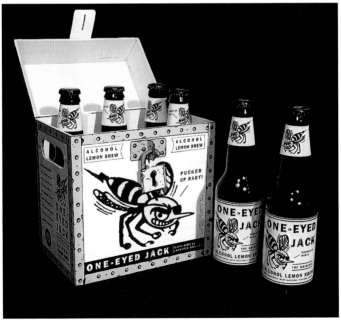

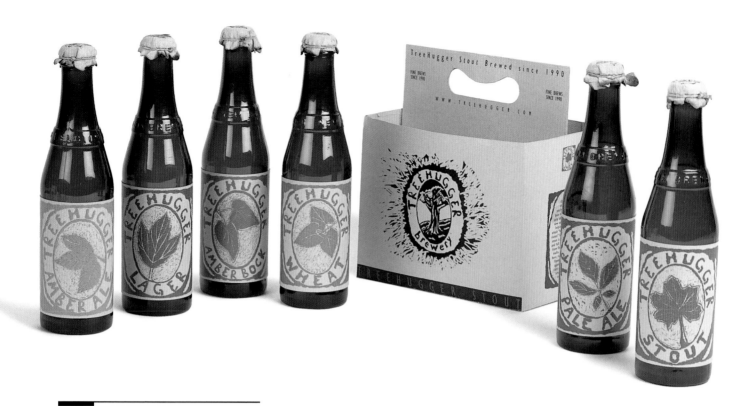

All elements of your work should reflect the nature of the brewery. The above photograph shows an entire line of select beers. Recycled paper is used on the labels and the carton to reflect the company's environmental views. The caps are covered with a paper wrap as a way to create an antique, backwoods feel. Notice how the Tree Hugger name remains the same, and the different brews are easily identifiable through the bold color schemes and the unique leaf designs.

When designing labels of different types of beer for the same brand, you should take advantage of all the design elements at your disposal. Where the brand name and logo should be consistent, color scheme and imagery should be different enough to be noticed from a distance. The color scheme should carry to the neck label and the bottle cap. Along with using the same logo for each, keeping the border treatment exactly the same for all variations of the beer helps to keep the brand easily identified. The names of the different beers should be consistently placed and large so that someone not yet familiar with the brand can determine which is ale, amber, and so forth. Government warnings should be in all capitals, and fluid ounces should be clearly visible.

beer labels

Beer bottles come in a relatively narrow range of shapes. All must contain 12 fluid ounces, and the largest variance usually occurs around the neck. There are long necks that are straight and long necks that are tapered; there are long necks with low shoulders and there are bulging necks (Fig. 13).

If a neck label is required, make sure to design it with a slight curve, which will allow it to wrap and still remain horizontal once it is adhered to the bottle. The easiest way to determine the amount of curvature to such a label (if you are not provided with a template) is to wrap a piece of paper around the neck and draw a horizontal line across it. When the paper is flattened, the slight arc in the line that results is the curvature of your label (Fig. 14). If your bottle neck is straight, there is no need for this. Because the body of most beer bottles is not tapered, using a simple rectangular shape for the body label works fine.

Determine how many different types of beer are involved at the outset (amber, ale, stout, and so forth). The labels should be consistent with one another for brand recognition but should still allow for easy determination between specific types. This can be accomplished by applying various color schemes and reserving a particular spot on the label for the different names. It's a good idea to design the type of beer with the longest name first in order to allow for enough space in all your label designs.

Many beer labels are printed on silver or gold stock paper to provide a luminescence that can compete with the shimmering quality of the glass. Pricing of reflective paper stock can vary, so if using it is an option, the additional cost should be reflected in your original estimate. Also make sure there is enough contrast between the edges of the label and the glass color of the bottle. Using a border around the edges that remains the same color from product to product will allow more freedom when dealing with the various color schemes.

Important legal matters include the incorporation of a barcode, the net weight, and a standard government warning that needs to be all capital letters and at least ¾₂″ (0.24cm) high. There should also be space provided for information regarding the particular brewery or the importer.

Keep in mind the bottle cap in furthering your design concept. And, because beer is most often sold in six-pack containers, always be thinking how your work will translate to such a package.

Fig. 13

Standard bottle shapes
A ~ Long, straight neck
B ~ Long, tapered neck
C ~ Regular, tapered neck

Customized bottle shapes
D ~ Long neck with low shoulders
E ~ Round neck

Fig. 14

Labels for round necks must not be too thick as they travel around the neck, or they will bind as they wrap around the bulbous section.

Labels for tapered necks must have a curve that works with the angle of the neck. Notice that the top curve remains the same (except for the last example, which shows a deliberate change from the horizontal).

Find a unique bottle shape to begin with.
On a shelf of standard bottles one with a long slender neck or a subtle curve to the bottle can attract immediate attention. The bottles on this page have been selected for their size as much as for their shape. They contain enough wine for two glasses, and the product line is geared toward special occasions for couples. Label shapes can either exaggerate the bottle's shape or contrast with it. In the sample on the right, the unique shapes of the body and neck label have been designed to contrast with the elegant shape of the bottle.

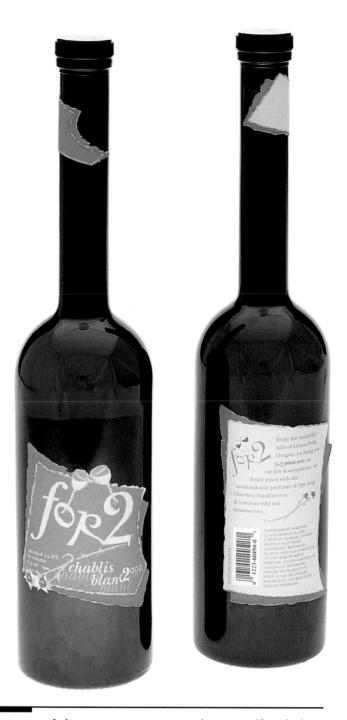

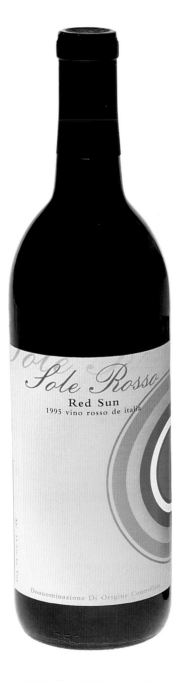

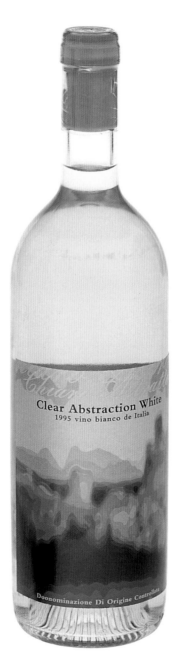

It is not necessary to restrict yourself to designs that are too similar. The bottles to the left rely on similar type treatment to make the connection. The imagery is less focused on contributing to an overall design approach and more concerned with a literal interpretation of the particular wine's name.

Note: Corks are often held in place by foil wraps.
Although these wraps can be ornately designed, the printing and wrapping processes for these are not always accurate, so it is usually a good idea to keep the design work simple and straightforward. The foil wrap also can be replaced by a clear plastic wrap that includes some kind of neck label.

Because a single vineyard may produce numerous wines, the original label design should be easily altered to accommodate the different wine varieties.

wine labels

Designing wine labels can be a little more involved than designing beer labels for a number of reasons. Bottle shapes for wine are much more diversified, and unlike beer bottles, the body as well as the neck can be tapered (Fig. 15). Inasmuch as there may be more focus on the elegance of the label—and because the bottle itself is larger than a beer bottle—it is not uncommon for vineyards to use a second label on the back to contain the more mundane information (barcode, government warning, vineyard information, and so forth).

Wine bottles are not necessarily restricted to a single front label either. Along with a neck label and a main body label, narrow hip labels can be used to present the specific vintage or grape (the vintage—or year the grape was harvested—is often a very important piece of information, and it should be treated as such). Lastly, as it is assumed that the percentage of alcohol by volume is nearly the same in beers (some imported beers have a higher percentage), the percentage is not required to be printed, but because alcohol by volume fluctuates in wines from grape to grape, the exact percentage must be presented on the front of the bottle.

With such a diverse array of potential shapes and combinations (Fig. 16), the creative process for designing wine labels begins long before the design of the surface graphics. You should present many early studies of label shapes, sizes and combinations to the client along with your two-dimensional design solutions.

Yet another factor when designing wine labels is the possibility of the label being used for both a 750 ml bottle and a 1.5 liter bottle. Find out early if both will be required and whether or not both sizes will be contained in the same shape bottle (this is usually the case).

Remember that white wines are often bottled in clear glass, whereas red wines are bottled in darker glass in order to protect the wine from the harmful effects of outside light. As with many beer labels, wine labels are often printed on gold, silver or other similarly reflective stock. Allowing the shiny paper to show along the border of the label is a very effective way of defining the label's edges and allowing it to stand out from the bottle itself, especially when the glass is a dark color.

Because a single vineyard may produce numerous wines, the original label design should be easily altered (either by color scheme or minor graphic treatment) to accommodate the different wine varieties. This can be more complex than it seems at first, because there could be a number of white wine labels that must work with light glass and a number of red wine labels that must work on darker glass.

Fig. 15

Wine bottles come in a multitude of shapes and sizes, offering the designer more of a challenge when designing labels than do beer bottles.

Fig. 16

Wine bottles often have more than a single label. A separate neck or hip label is a nice way to separate important information, such as the vintage of the wine or the grape that was used to make the wine.

8 *polybags*

POLYBAGS COME IN MORE SHAPES AND SIZES THAN YOU CAN IMAGINE. They come with resealable tops, permanently sealed tops and tops that have no seal whatsoever. They come in a wide array of thicknesses. They can be used to protect home-delivered newspapers, wrap candy, contain juice, and seal mailable samples, to name a few possible end uses. Rather than getting their

GROUNDWORK name from any particular function, polybags are named after the material from which they are made. Polyethylene is a lightweight, durable and flexible plastic. It can be molded into practically any shape, and it can be made in clear or any color. Plastic shopping bags—with or without die-cut handles—are made from polyethylene.

Polybags are an inexpensive yet effective way to seal and contain just about anything. When a client comes to you with a request for a polybag, first determine what the bag will be holding in terms of volume, proportions and perishability. Determining the actual size at the outset is very important, as is determining how much protection the merchandise requires.

Polybags are printed by means of flexography, which is a relief-based printing process that allows for a lot of—you guessed it—flexibility. The printer you use for regular paper stock print jobs may not be outfitted for such work. The offset printer cannot be adjusted to print on polyethylene, so you will need to find a printer who specializes in flexography. Luckily, this has become a much more common process in recent years and one that yields some very fine results in terms of resolution and quality.

If you have trouble locating a local provider, shop around for manufacturers of polybags on the Internet. In fact, it is very common to rely on a regional or national supplier for such a specialized job. Entering the word *polybag* or *polyethylene* into your internet search engine will access you to a virtual shopping center online for these products as well as to contact information for more details.

Unless you have worked with polyethylene before, or your client specifies a particular bag, contact a sales representative and explain exactly what your needs are. Many of these manufacturers either offer full printing services or work directly with a company that does. Ask for samples and advice on which thicknesses are best for particular products. Contact several companies and ask for estimates and samples of the bags they recommend for the job. If they understand

Clarify with your client before you begin

✦ **What are the proportions of the polybag itself, and what is the live print area?**

✦ **What is the exact volume of the merchandise to be held ?**

✦ **Will the polybag include promotional material such as samples or coupons?**

The electric car from Honda. Clean yet practical, it seats four and makes a statement without making a sound. To unplug one for yourself, call us at 1-888-CC-HONDA. **HONDA EV** PLUS

© 1998 American Honda Motor Co., Inc.

A form of advertising that has only recently become popular is the newspaper polybag. Originally designed to protect home-delivered newspapers from moisture, these bags provide a unique format for companies to advertise their merchandise. As with the best advertising campaigns, the information on these bags should be minimal while the impact should be strong. This example makes excellent use of imagery, without any need of typography for its immediate message.

the serious nature of your request and are eager for your business, they should have no problem delivering samples quickly so that you can show them to your client. Make sure the client has the product available to confirm the suitability of the sample polybags once you receive them.

DESIGN Although the process for printing on polyethylene has improved greatly over the years, there are still shortcomings in the production. The designer should design with these shortcomings in mind. For one, issues of trapping are important to consider. Unlike paper stocks, the polyethylene is often so thin that it allows light to permeate from behind, exposing some trapped colors in a way that makes the overprinted area look like an additional color. This can either look sloppy or, in the case of many small shapes or letters, be confusing and illegible.

If there is a lot of small copy, consider using a dark color for the copy and overprint all of it. In situations in which you are dropping copy out of a field of dark, adding a thin stroke of white to the copy will help prevent choking off the thinner strokes of the type. As long as the applied white stroke is thin enough, it will open the letter forms just enough to prevent the background color from filling in the thinner strokes and affecting the overall feel of the typeface. Using a bolder sans serif font will assure that this does not happen in the first place.

Yet another benefit to the newspaper polybag is the ability to include samples or coupons in a pouch on the bottom end of the bag. In order to catch the recipient's attention quickly—before the bag is tossed in the trash—the graphics should be bold and colorful, and every attempt should be made to call attention to the special offer in the polybag.

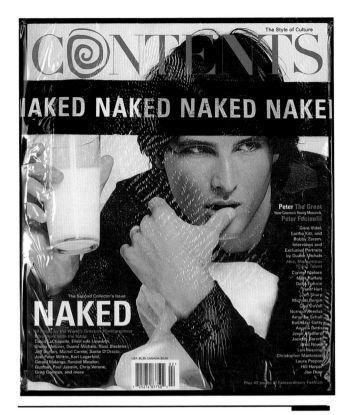

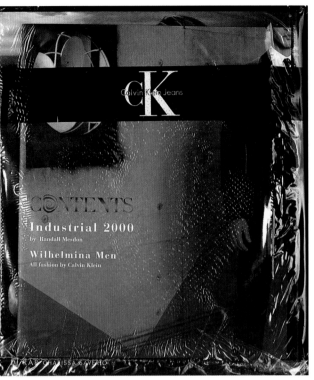

By definition, polybags are made to hold products.
Especially with clear plastics, the design on the polybag should work with the product it contains to reflect the style and enhance the overall compostion. The above example works with the same fonts as the cover design, and the black band that holds the word "naked" is placed in a way that does not intefere with the cover design. Instead, it highlights the magazine name and puts more focus on the model's eyes and hands. The logo of the major sponsor is printed on the back of the bag.

Along with the overall size of the bag, get the exact measurements of the printable area. Because of the flexible and sometimes awkward nature of a polybag, there are restrictions as to how much of the bag can be printed on. Some polybags offer small pouches that contain sample packets of the product that is being advertised. If this is the case with your job, ask for the sample packet. You will be designing it yourself, or the design may already be done. If it is already done, make sure to follow the design work in terms of color scheme and typographic treatment to assure a sense of unity.

Before finalizing the design, make sure you have the opportunity to fill your comp with the materials it will include once it is produced. What looks great as a flat design may actually not read clearly once it is placed on a three-dimensional surface. The outer edges—the areas most likely to be affected by this rounding out—need special attention.

Small details in these areas can get lost if you are not careful.

In a similar vein, make sure the color scheme does not get lost once it is placed in front of the products within the bag. Try to keep the design work cleanly organized and straightforward. Bold colors and shapes work best.

There are options available other than printing directly on the polybag. Some polybags are made so that they can be sealed only with the addition of a paper closure. Such tent-top labels can be printed on medium-weight cover stock, scored once for coverage on the front and back of the bag, and then adhered by way of glue or staples to the top of the polybag. Another option is a self-sealed bag with an adhesive label on front and, if needed, on back as well.

9 video packaging

GROUNDWORK

Okay, there may be a pattern emerging here. What is the first thing that should be done before beginning the design process for a video package? That's right: be familiar with the content of the tape. There are videos for all subjects and all purposes these days, not just for movies. Understand the content. Understand the rationale for the particular project. And be fully aware of whom the video is marketed toward. A self-help tape will be directed at an audience dramatically different from that for an instructional video on how to fly a plane.

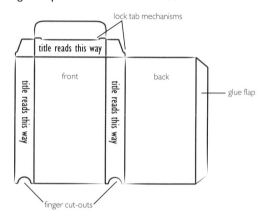

Fig. 17

Lay out your design work for a video box in its entirety so that the client will be able to see the complete design. Make sure all art work is reading in the proper direction, and make sure the glue flap is on the back of the box.

One thing that can be said about most video package designs, regardless of content, is the common use of imagery that appears to be taken directly from the video. Movies and exercise videos often make use of the faces of well-known actors or athletes, whereas instructional videos use images of the topic of instruction. Despite their appearance, however, these images are rarely taken directly from the video. Instead, still photography is used to insure the highest quality. Make sure your client understands how important the use of still photography is, and procure these images at the outset. If the client was hoping to use images directly from the video, alert him to the potential loss of quality, and explain how such a loss will affect the final design work. It does not matter how strong your design work is, with a pixilated image it will look amateurish.

The proportions of a standard, open-bottom video package are 4⅛″ (10.50cm) wide, 1⅛″ (2.86cm) thick and 7⅜″ (18.73cm) high. It also includes a glue flap on the back left side and an opening top panel with a lock tab (Fig. 17). Lay your work out to reflect this construction from the start, since any comp you show your client should be an accurate three-dimensional mock-up.

Clarify with your client before you begin

+ **Should the cover feature a prominent picture of a leading actor or actress in the picture?**
+ **Does the client have images that are not taken directly from the film or video?**
+ **Who is the target audience for the picture?**

Both side panels should present the movie title at a large enough size to be seen from three to five feet away. The left panel should face away from the front, as it does here, so it will read properly when the tape is placed on a table with the top facing up. Include the movie studio's name and logo and the catalog number.

Make sure to bleed the printed information onto the glue flap to insure full ink coverage on the exposed panels.

Using a faded image from the movie serves two purposes. It makes the panel much more interesting by introducing texture, and it provides more insight into the nature of the film.

Include a barcode and any other information regarding the copyright of technology used in the creation of the film.

WATER WE HAVE LIVED IN — SWIMMING PICTURES

67-9823-W

67-9823-W

WATER WE HAVE LIVED IN

WATER WE HAVE LIVED IN

WATER WE HAVE LIVED IN

WATER WE HAVE LIVED IN

Markus Renner
Janine Richards

"This movie will hold you and not let go..."

Jeffrey Kionet
JKZ Reviews

Daniel Hawthorne
Brett Shiver

SWIMMING PICTURES

DOLBY SURROUND
VHS hi-fi STEREO
ISBN 09-8767-889-76
Dolby and the Dolby DD are a trademark of Dolby Laboratories Licensing corporation
9796-34187-1 0

WATER WE HAVE LIVED IN

S et within the rolling hills and bucolic lakes of upstate New York, WATER WE HAVE LIVED IN explores the tempestuous life-long relationship between two would-be-lovers. Jake Sommers (*Markus Renner*) has been best friends with Laura Wilkens (*Janine Richards*) since youth. Jake has watched as Laura married the man of her dreams, Luke Myers, (*Daniel Hawthorne*) and the two of them built a small cottage on the side of a small lake. Several years later, Jake is there again at Laura's side, only this time he is there to help bury Luke after an a fluke accident on a frozen lake.

The story begins in Laura's cottage, several years after her husband's death. A snow storm during the coldest winter in recent memory keeps the two of them stuck in the small home with several other friends. In a thrilling cameo *Brett Shiver* plays Smitty, another life long friend of Jake's, who erupts in a fit of his own simmering passion.

SWIMMING PICTURES & JONAS STUDIOS present a WHIPPED TATER production a VINNY TONY KING film MARKUS RENNER, JANINE RICHARDS "WATER WE HAVE LIVED IN" DANIEL HAWTHORNE, BRETT SHIVER, SUE-ANN McGEE, TANYA WARST co-producers SAM TREB & GINA SIMMS music by TORPEDO HEAVEN production design WERNER KNAUSS edited by YAU MBUNA based on a short story by SCOTT BOYLSTON produced by KRISTIN CATAPANO

THIS FILM HAS BEEN MODIFIED FROM ITS ORIGINAL VERSION. IT HAS BEEN FORMATTED TO FIT YOUR TV

swimmingpictures.com
133 Summer Winds Drive
Savannah, GA 31420

"...a great one that will be remembered for a long time."

Toni James
MOVIE/SEE

SWIMMING PICTURES

The more popular the actors, the larger their names should be on the front. In many cases the person whose names are most prominent are also featured in the cover photograph. Secondary actors often get smaller billings, like the two on the blue band.

Most video boxes make use of photographs of the star actors in the movie. Single photographs can be used, but many times the designers create a softly blended collage in order to convey as much information as possible.

Blurbs from movie critics are extremely important. Try to fit two or three of the most flattering comments. Keep the quotes short, and make sure they speak directly to the consumer's tastes.

Notice how often the movie studio's name and logo appear on the video box. Name recognition is always an important consideration.

DESIGN **B**lank videotapes and head cleaners often slide out from the right side of the package while tapes that are sold for their content slide out from the bottom (Fig. 18). They slide out from the bottom for aesthetic reasons; when they stand up on a shelf, all of the exposed sides can carry design work. The blank tapes are not so concerned with offering this extra panel. In order to save a little money in production, they use a box that requires less card stock overall.

The importance of the back of the video box cannot be overstated. Watch people as they browse through video stores. They spin the box around instantaneously, and refer back to it continuously.

On a box where the tape slides out from the bottom, both sides are often treated with the same design elements for the sake of consistency. The left-hand side, like the spine on a book, should read properly when the cover is facing up on a flat surface. With the right-hand side there is more flexibility, although it is standard to have it read facing the front. That way it will go along with the top surface treatment, which should always read facing the front.

The front cover of a video package should feature the name of the video as well as any personalities who may be involved with the project. As with a book cover, the star power of the individuals involved will determine which typographic element receives more attention in the visual hierarchy. Be bold with your typography and, depending on the nature of the product, be willing to incorporate additional information onto the front, whether words of praise by critics or a subhead that defines the topic further.

Fig. 18

Video boxes are built differently depending on their end use. The example to the left shows how video boxes that do not contain movies (head cleaners, blank tapes, etc.) are made. The example to the right shows how boxes for movies are constructed. It is a little more expensive to do it this way, but the box provides two complete side panels for design work.

Video packages differ from books in that the margins on the front piece are usually very small on a video package, while on a book the edges are usually allowed some breathing room. This is one time when cramming information onto a surface is not necessarily a bad thing. This is not to say that the overall feeling should be cramped, only that it's more acceptable to place type closer to the edges on a video box than on other front covers.

The back of the carton must include a barcode. It must also include copyright information, running time of the tape, and studio credits. Other than that, the entire space is there for your designing pleasure. Once again, if you will be using photography, use still photography rather than footage taken from the video. Typographically, the more detailed information you provide on the back concerning the nature of the video's content, the better. Condensed fonts are frequently used to allow for more body copy.

The importance of the back cover cannot be overstated. Watch people as they browse through video stores. They spin the box around instantaneously and refer to it continuously. Each time they spin to the back they are looking for reasons either to put it down or to buy it. The copy must be informative and enticing. The imagery must follow suit. Do not cram too much information onto it, and do not reduce the typeface to a point that it is difficult to read. Whereas the cover is basically eye candy, the back cover is the sales pitch.

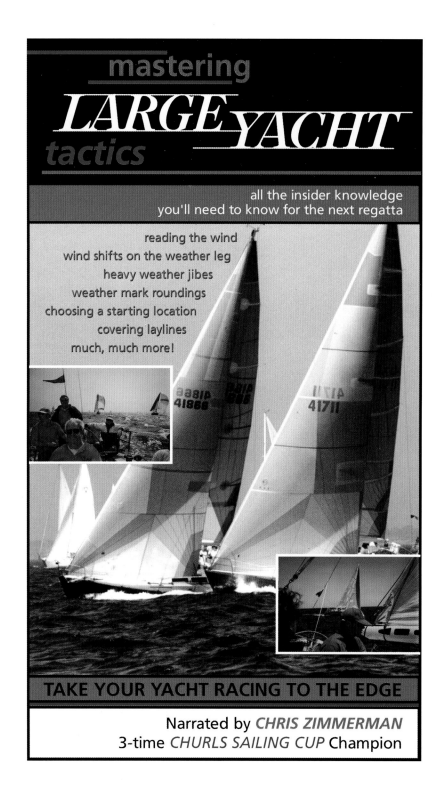

Instructional videos should not be shy about their subject.
Work with bold, easy-to-read fonts, and find at least one very strong image to use for the cover. All of your design elements should reflect the nature of the information on the tape. If celebrities are involved in any way, make sure to use their names as a way to interest consumers. Use a color scheme that relates directly to the topic at hand.

10 cassette packaging

As with compact discs, the approach you take when designing a cassette package—from font choice to color scheme to the use of graphic elements or photographs—must relate directly to the style of music appearing on the cassette. Listen to the music. Listen to the music. Then, listen to the music.

GROUNDWORK

It is also important to determine at the outset who holds the most influence over the decision-making process: the musicians themselves, the agent or the record label. Clarify this early so that time is not wasted exploring design ideas that in the end may not fly.

In most cases with cassette packaging, the designer is simply asked to take the preexisting compact disc design and apply it to the elongated format of a cassette holder. The only time this would not be true would be in the case of an amateur group in need of cassette packaging only. Because technology makes it cheaper and easier to record directly to CD, however, this is rarer today than it ever was. Find out early which you will be doing. Designing an entire cassette package is more labor intensive than applying an existing design to the same package.

Cassettes rarely come in customized packaging, with the exception of box sets (discussed later), so your design work must fit neatly into the industry format. This format allows for a front surface of 2½″ × 4″, a spine of ½″ × 4″ and a back panel of 1⅛″ × 4″ that is beveled to take into account the angles of the plastic case. Like a compact disc, there is the option of adding more than one panel to the front for inclusion of lyrics or images. The more panels you include, the more likely you will need to use a thinner paper stock to allow for clean scores and the added thickness that comes with overlapping. The issue of photographs and lyrics is touched on more extensively in the compact disc chapter. Determine whether a clear case or a case with a solid back (usually black or white) is preferred, and whether or not the cassette itself will be clear plastic.

Fig. 19

Like compact discs, cassette inserts can have as many extra panels on the inside as are needed. These are often used for the inclusion of lyrics, liner notes, images of the musicians, or any other information the client may want to include.

Clarify with your client before you begin

+ **Is there an original compact disc design, and if so, how faithful to that design must your work be?**
+ **Will it be printed on one side or both sides?**
+ **Will there be extra panels for lyrics or photographs?**
+ **If it is for a book on tape, how many tapes are involved?**

Books on tape have become very popular. These packages usually hold two, four or sometimes as many as eight cassettes. In this case, a box—often the same size as a video box—is used, and all the design work appears on this outside box. If you are involved in such a project, find out exactly how many cassettes will be involved. Also look into packaging options for the box. Is it a standard, bottom-release box in which the cassettes simply slide out, or does it open up like a book? With the second option, there are more surfaces to design, and your estimate should reflect that.

The spine of a cassette tape should carry the band name and the tape title as well as the music company's name, logo and stock number. It should read away from the front so when the cassette is placed on a table with the cover showing the information on the spine will read properly. Make sure the copy is large and easy to read since many people store tapes with only this surface showing.

The cover needs to clearly present the name of the band and the name of the tape. As with a compact disc, the cover artwork should be dramatic enough to catch anyone's eye.

The basic cassette insert has three panels as seen here. If the client is not willing to spend extra money for additional flaps or double-side printing, then all important information needs to fit into this small area. The back must incorporate a barcode, copyright information, and the music company's name and address. Even though the titles of the songs do not need to be placed on the back, it can be very helpful for a consumer who may not know what song is on which tape. Carrying design elements and typefaces that have been used on the front will make for a unified package.

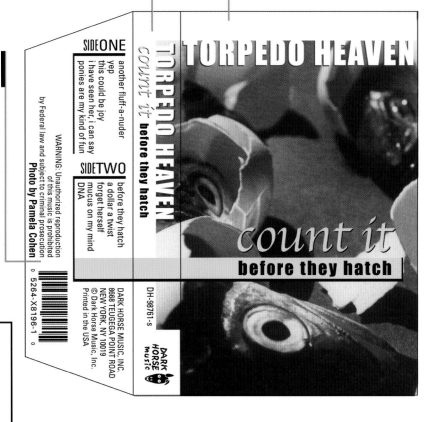

SIDE ONE
another fluff-a-nuder
yep
this could be joy
i have seen her, i can say
ponies are my kind of fun

SIDE TWO
before they hatch
a dollar a twist
forget herself
mucus on my mind
DNA

WARNING: Unauthorized reproduction of this music is prohibited by Federal law and subject to criminal prosecution

Photo by Pamela Cohen

0 5264-X8196-1 0

TORPEDO HEAVEN
count it **before they hatch**

DH-98761-s

DARK HORSE MUSIC, INC.
8668 TEUGEGA POINT ROAD
NEW YORK, NY 10019
© Dark Horse Music, Inc.
Printed in the USA

DARK HORSE Music

TORPEDO HEAVEN
count it
before they hatch

Suzanne Corrigan

i will rest quietly

1	The Same, So Different	
2	Through Sunlit Blinds	
3	Anyone Can Say Maybe	side one
4	I Will Rest Quietly	
5	Whales	
	6	Orange Burgundy
	7	Someone's Daughter's
		Gho
side two	8	Bunnies Cannot F
	9	My Lover's Nam
	10	The Opposite of Da

Suzanne Corrigan

i will rest quietly

Often the design of a cassette package is nothing more than an adjusted version of the original compact disc. The examples to the left show two ways of how a cassette cover can be designed to work with the original compact disc cover. The first example shows the cover as it appears on the compact disc with the remaining vertical space used to list the song titles. The second version shows how elements from the back of the compact disc (like the horizontal portrait) can be added as long as the feel replicates the original.

DESIGN

The cassette package is an even smaller format than a compact disc, so space is at a premium, and typographic choices must take into account the fact that everything will be printed small. If your job involves simply taking what is on an already existing CD, the standard approach is to take the cover artwork (square on a CD) and place it on the front of the cassette with either all of the additional lengthwise space added to the bottom, or else a narrow band added to the top with a slightly thicker band along the bottom. The change in color from the CD cover to the background is usually significant enough to let the consumer know that the original cover is indeed square.

The spine, like the spine of any book, must read right when the cassette box is placed with the front facing upward. As in dust jacket design, working in this limited space allows room for the musician's name, the name of the recording and the record company label. Since cassettes are often stored with only this surface showing, design simply and clearly on the spine.

If there are additional flaps on the insert (Fig. 19), make sure that each successive flap is slightly thinner than the last to allow for a clean closure without any binding ($\frac{1}{16}''$ or 0.16cm is more than enough). The decision to add extra flaps is usually based on whether or not lyrics, liner notes or photographs of the band will be incorporated. These, of course, will add to the total cost of the print job. It should also affect your original estimate, because adding such elements could easily double the time you spend on the job.

If there are no additional flaps and the insert is printed on one side only, your work becomes more difficult because everything must fit onto the small back panel. As an option, suggest that the back of the insert be printed as a one-color job. This allows for twice as much design space at a relatively low cost.

books on tape

Most books on tape are packaged in larger boxes (similar in size to video boxes). When there are only a few tapes, they can slide into the box as seen in the example to the right. For longer books there may be many tapes. In these cases take the extra space into account when doing your estimate because more surfaces mean more design work.

Although very different in many ways from music cassettes, books on tape are packaged with the same concerns in mind. They most likely have an already existing cover design that will be applied to the cassette package, so the design work usually falls into the realm of organizing information that is unique to the cassette format. There will be an author photograph, blurbs from other authors, and an author biography. There will be legal information, and if the package is the kind that opens like a book rather than a pull-out package, there may be additional information presented on the inside flaps. In any case, work with the fonts that have been used on the original cover design, or if there is a single font used, make sure that any additional font you choose works well with the original. The choice of color for the box should complement the overall color scheme of the original without overpowering it.

Designing the cover of a book on tape is very similar to designing an actual book cover. For more information regarding important considerations when designing book covers, see chapter 11.

pUblicAtıons

book covers

dust jackets

magazines

cookbooks

book covers & dust jackets

GROUNDWORK

BECAUSE BOOK COVERS SHOULD BE A CONCISE AND INFORMATIVE preview of the material contained within, it is important to be familiar with that material before you set out to design a cover for it. If the job has time constraints on it that do not allow you to read the entire book before beginning, then ask for a synopsis of the material.

Be fully aware of the target audience for the book, and find out where the book will be sold, as well as the retail price. Whereas products such as compact discs have an added benefit of the familiarity hearing a song on the radio will bring, books have no such calling card. People browse bookstores and are apt to pick up books that, barring any other variable, visually appeal to them and their personal tastes. A book with a picture of a clown on the cover may immediately either attract or repel them. The same can be said for a cover that holds nothing but a strong typographic treatment of the title. Knowing who the target audience is goes a long way in determining which direction you should take.

Also take time to get to know the author if you have the opportunity. There may be certain scenes in the story that are more relevant than others, and a visual depiction of that scene may be just the thing to summarize the entire story. Get any important information required for the job, including a photograph of the author, quotes of praise from other people that may be used on the back cover or the inside flaps, and and a biography of the author. Also find out how much synopsis copy will need to be included on the front inside flap. These elements are the building blocks of your dust jacket.

Make sure to ask for the exact size specifications for the finished product, including the spine thickness and the thickness of the cover board. Also find out the exact width of the inside panels of the dust jacket, as a lot of important information is usually presented there.

Gold stamping and embossing are two ways to make your dust jackets unique. Because both represent extra costs in production, it is a good idea to find out how much your client is willing to spend before you bring these up as possible alternatives.

Clarify with your client before you begin

✦ **Who is the targeted readership for the book?**
✦ **What are the key scenes or sentiments of the book?**
✦ **What are the exact size specifications of the book, the dust jacket and the inner panels of the jacket?**

PIKE PLACE

PUBLIC MARKET

AUGUST 7 · 1907

Seafood Cookbook

BRAIDEN REX-JOHNSON

Illustrated book covers can enhance the theme of the book in a very clear and straightforward manner. In such cases, however, do not take typography for granted. Typefaces that need to be placed upon a curve often have to be hand rendered or adjusted. This can be a time-consuming task and one that requires special attention to detail and letter form.

The spine is often a small working space, so the ability to work within confined areas is extremely important. This is chiefly an exercise in typographic refinement.

DESIGN

Like compact discs, dust jackets must work on several levels. Of course, the entire layout must be successful, but beyond that the cover must work successfully in its own right. The importance of the cover cannot be understated. It will be seen not only in stores but also in advertisements, and perhaps most significantly, it will be the only part of the book seen by potential Internet customers.

The two main typographic elements on a book cover—the author's name and the name of the book—are handled very differently, depending on how well the author is known by the general public. For first-time authors and authors who are not already celebrities in their own right, book covers give more prominence to the title of the book. With famous authors, however, the visual hierarchy changes dramatically. Because the author's name is now a major selling point, it must be displayed prominently for all to see. This hierarchy can be achieved by use of size, color, typeface or placement within the composition or any combination of these factors.

The two main typographic elements on a book cover—the author's name and the name of the book—are handled very differently, depending on how well the author is known by the general public.

As far as imagery is concerned, biographies and autobiographies usually take advantage of the subject's likeness on the cover, whether it is a photograph or an illustration. Books such as these will also often have a subtitle, something to solidify the subject's public persona. The imagery for other nonfiction books will vary, depending on the subject matter. Historical texts are often enhanced by the use of vintage photography or artwork, whereas self-help books and the like often take advantage of a more typographical approach, presenting as much detailed information as possible in order to clarify the topic covered within.

Works of fiction and poetry rely on the designer's ability to read and understand the text and subtext of the work. More so

than with other genres of books, the designer of fiction or poetry books must work hard to evoke visually the sentiments of the writing within. It is a matter of distilling the author's intention into a clear visual image.

Once in bookstores, some books (the fortunate few) are stacked with the cover facing outward for the customers to see. But in most cases, in order to save shelf space, books are presented with their spines facing outward. Therefore, it is important to take full advantage of what specific space the spine offers.

As with the cover, prominence will be given either to the title of the work or to the author's name, depending on the popularity of the author. Additionally, the imprint label must be presented. The spine is often a small working space, so the ability to work within confined areas is extremely important. This is chiefly an exercise in typographic refinement. Make sure the type reads right-side up if the book is lying flat with the front facing upward. The imprint label is most often run to read right when the book is standing.

The back cover is often used as a marketing tool, displaying words of praise from well-known authors or celebrities. A short biography of the author along with a photograph may also grace the back cover, but remember that there is always space on the inner panels of the dust *(continued on page 79)*

Written by
Paula S. Rowan

Illustrated by
Catherine Myler Fruisen

Children's books continue to grow in popularity.
When designing such a cover, allow the selected illustration to dominate the design. It is often the cover alone that attracts a child's attention. Typefaces can be fun and expressive, but they should also provide some contrast to the illustrative style and provide structure. This example also uses a red band along the left-hand side to introduce these elements.

Quotes from well-known authors or celebrities can help make a book that might be otherwise unknown more attractive to consumers. Be selective with these quotes, and if possible, make selections and order them so they tell a story of their own.

Make sure the names of the authors who have something to say about the book are clearly visible by using a different color, a different typeface, or both. Also isolate them visually from the rest of the copy.

This jacket uses three typefaces. Two are used throughout the entire jacket for more consistency, and a third (an italic) is used for the blurbs to give the impression of spoken words.

Author photographs are not always used. But at the very least, space must be allowed for a short author biography.

(CONTINUED FROM FRONT FLAP)

Before Smitty realizes it he finds himself an owner of a pawn shop gun, and he sets out to protect the few close friends he has.

Catapano has created a beautiful yet threatened world in *And The Surface Grew Seams*. With this moving work of fiction he has established himself as a writer of rare and raw courage who refuses to accept anything short of revelatory.

ABOUT THE AUTHOR

After publishing two critically acclaimed short story collections *Twirl*, *If It's Early Enough* and *Knocked Down By Breathing*, Frank Catapano explored prose poetry and published the award winning *Someone's Daughter's Ghost*. This is his first novel.

Jacket Design by Eli McLean
Jacket Photograph by Joanna Sit
Printed in the U.S.A.
© 2000 Gravity Torque Publishing

"*Pulled inexorably and against our wills into dilemmas ordinarily saved for troubled dream life,* And The Surface Grew Seams *exists in a kind of urban twilight of consciousness, a haunted place in every way.*"
DALE FENNELL

"*...a gun at the heart becomes the central, mysterious object as the inexplicable trajectories of violence are explored with subtlety and intelligence.*"
GLENN SWEAT

"*...a complicated and disturbing piece of work.*"
BRIAN SEAN

"And The Surface Grew Seams *is a story of moral gravity, of the sadness between brothers, and of the shadow of a father who presides with his haunting message of mercy, which is heard and acknowledged, but remains something that's been forgotten what to do with anymore.*"
DEIRDRE TAYLOR

"*This seemingly straightforward account, calmly told, filled with dread, chronicles actions which hover on the periphery of knowability, but never come any closer.*"
TRICIA ELIZABETH

5 217446 78-1
ISBN 0-194628-980

Artists' credits and copyright information should be clearly visible while remaining unobtrusive.

The secondary color (purple) has been taken directly from the cast shadows on the cover photograph.

Clarify the required size of the UPC and determine whether a second barcode (for chain bookstores) will be printed on the jacket or adhered by way of a label. Also allow ample room for the ISBN.

The spine should read right when the book is placed on a table with the cover facing up. It should present the title and the author's name clearly. Since many books are stacked on bookshelves with only this surface visible, the typography needs to be bold enough to be seen from a distance. The imprint label also needs to be printed here.

Find an image that is both eye-catching and relevant to the book's theme. The visual hierarchy should clearly favor either the author's name (if that person is a well-known individual) or the title of the book.

Retail prices are most frequently printed on the front inner flap, as done here. They can also be printed on the back cover or the back flap.

AND THE SURFACE GREW SEAMS

FRANK CATAPANO

AND THE SURFACE GREW SEAMS

A NOVEL

By FRANK CATAPANO

GRAVITY TORQUE PUBLISHING

U.S. $24.95
Can. $32.00

The author of two previous short story collections, *Twirl, If It's Early Enough* and *Knocked Down By Breathing*, has written a first novel that will disturb even as it enlightens. Things get strange for Michael "Smitty" Schmidt the day after he finds his ex-roomate has left a stash of bathtub toys under his bed upon leaving town in a hurry. Among the toys is a mother duckling that holds within it a hard object that rattles strangely inside the plastic duck. That night a burglar breaks into the apartment and proceeds to take all of the toys except the mother duckling. Michael places it in his shower and does not give it any more thought until several weeks later, when a new girlfriend of his is bathing with him.

What follows may not surprise Catapano's loyal readership, but it will be sure to shock anyone who reads it. Things change quickly in Michael's neighborhood, and he is unsure of the reasons for the seemingly random series of violent occurrences that seem to weave tighter and tighter around him.

(CONTINUED ON BACK FLAP)

The subtle checkerboard pattern and the graphic rules that bracket the body copy have been used to repeat the tile motif that exists on the cover photograph and to reflect the title of the book.

Better Homes and Gardens®

flea market decorating

creating style with vintage finds

Pictures are extremely important when designing covers for nonfiction books. Such books often have a very particular subject, and people interested in that subject will make a quick assessment of the book's worth depending on the nature of the photographs.

People may not judge a book by its cover, but the cover and the inner panels of the dust jacket are important in attracting buyers and helping them make a decision. Fiction books include a synopsis of the story and possibly an author photograph on the inner panels. Nonfiction books use photography of the subject along with a general synopsis on the inner panels.

(continued from page 75) jacket for this information.

Make sure the inside panels are wide enough to hold the jacket in place securely but not so long as to become cumbersome. At least two inches (5.08cm) should be given to these to allow for a decently sized column of type. The front inside panel is often used as an introduction or synopsis of the contents of the book, whereas the back inside panel is used for a short biography and photograph of the author. The price is often placed on the front inside panel for quick reference, and the publishing house's imprint label is on the back inside panel. Do not forget to include credits for any cover photography and design work (that would be your name!). Books have UPC labels that incorporate two barcodes. Although these can be placed on the inside panels, it is best to allow for easy use at the counter and place them on the back cover.

discover what antiques dealers and interior designers have known for decades: Shopping flea markets and antiques shows is fun. It's a treasure hunt for wonderful, one-of-a-kind items for the home. And when you add the satisfaction of finding new and unexpected uses for old objects, you have an approach to decorating that's endlessly creative and uniquely personal.

Because it's so individual, flea market decorating doesn't dictate a single look. In the first half of this book, eight homeowners from around the country share their homes, showing the range of styles possible—from classic to cottage, new country, eclectic, and modern. They also share practical advice on shopping for and decorating with secondhand treasures. While flea market decorating

can be a thrifty way to furnish your home, it's also a stylish means of expressing your interests and tastes. In the second half of the book, you'll find dozens of ideas for bringing focus, character, and humor to every room in the house.

Better Homes and Gardens® Flea Market Decorating isn't a price guide or an inventory of top collectibles. Rather, it's about looking at antique and secondhand objects with a fresh eye for new purposes they can serve. It also offers tips for evaluating the condition of pieces, advice on cleaning and care, and a list of recommended shows and flea markets.

For nearly 50 years, the home and family experts at Better Homes and Gardens® Books have offered inspiration and advice on decorating, using real homes to illustrate achievable results. Look for these and other decorating titles wherever quality books are sold.

$34.95

12 magazines

GROUNDWORK IF YOU ARE READING THIS, CHANCES ARE YOU ARE INTERESTED IN creating a new look for an already existing magazine, or else you have been asked to design a new magazine altogether, because designers are rarely asked to design a single magazine layout that is not already "plugged in" to a preexisting grid with preexisting standards, typefaces and basic design elements. If it is indeed your intent to design an entire magazine, then you most certainly have a large task ahead of you.

Magazine cover designs should retain enough structure from month to month in the use of typefaces, border treatments and design elements to give visual recognition on the newsstand. Other elements will change depending on the nature of the subject matter. In this cover example, the entire color scheme is dictated by the colors in the photograph.

Make sure to understand the range of the target audience and the proposed content and ideology of the publication. This is not a "one afternoon meeting with a client" assignment. This type of project requires a thorough absorption of the client's overriding philosophy. For brevity's sake, let's assume that the overall format (trim size and proportions) has been decided upon, as well as paper quality issues and specific production factors (these alone could fill an entire book). Let's also assume that the photography and the written elements have been supplied—monthly columns, letters to the editor, and so forth.

Determine whether or not you will be responsible for the creation of a standards manual. This manual should clarify the approved typefaces, color choices for graphics, graphics themselves, typographic treatment for the covers, table of contents, the incorporation of advertisement spaces, and standard treatment of half-page, quarter-page, and eight-page advertisements within the confines of the established grid.

Clarify with your client before you begin

+ **Who is the target audience for the magazine?**
+ **What is the primary purpose of the magazine (inform, entertain, shock, etc.)?**
+ **How many columns in the grid are they interested in?**
+ **Which present publications do the clients like, and which do they dislike, and for what reasons?**

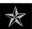
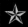

8TH ANNUAL TEXAS WILDLIFE EXPO EDITION

WWW.TPWMAGAZINE.COM ★ OCTOBER 1999

TEXAS

PARKS & WILDLIFE

The OUTDOOR MAGAZINE *of* TEXAS

GET GONE!

Where to hike, hide *and* float *in the* Texas wilds

$3.50

$3.50US

10>

0 14302 81334 3

DESIGN As with designing an annual report (see chapter four), a magazine needs a grid to enforce structure and a certain amount of predictability from one section to the next. Unity is paramount in magazine design, not just from page to page in a single issue but also from issue to issue. Many companies use certain visual cues in their advertising and marketing to help consumers identify them at a glimpse, and a magazine is no different; a consumer should be able to recognize the magazine within the span of a few seconds of seeing it, regardless of what page he or she might inadvertently see. This consistent presentation is the magazine's identifier, and it should welcome its readers as a soft and comfortable couch would.

Immediate considerations concerning the grid are the width of the margins, the number of columns, the alignment—or rag—that will be used for the body copy, as well as issues of tracking, leading and paragraph indentation. All these need to be consistent throughout. Another important matter that is sometimes ignored is the thickness of the alleys between columns and whether or not a thin rule will be used in these areas. All white spaces affect the overall design, and the alleys of white space that divide the columns are no exception.

Immediate considerations concerning the grid are the width of the margins, the number of columns, the alignment—or rag—that will be used for the body copy, as well as issues of tracking, leading and paragraph indentation. All these need to be consistent throughout.

Will versals (also called initial caps) be used, and if so, how often? (Versals are large letters used to denote the beginnings of different sections, as the capital *A* on this page is used.)

Magazines are perhaps one of the best measures of a designer's organizational abilities. Nowhere is the demand for typographic control more complex. The key to designing an effective editorial layout is developing a grid that offers enough visual stability and structure to insure a clean and orderly presentation yet at the same time allows the designer the flexibility to experiment and have some fun with the various design elements. The most important design principle to keep in mind when designing an editorial layout is a clear sense of emphasis (creating an unambiguous visual hierarchy) so that the viewer is led from one element to the next. It is up to you, the designer, to create this visual hierarchy.

A standard article begins with a heading that must call attention to itself and quickly explain the gist of the article. This is often followed by a subhead that clarifies the content of the article further and draws the reader into the body copy. There is body copy, which must be poured into a grid, and then there are the other typographic vari-

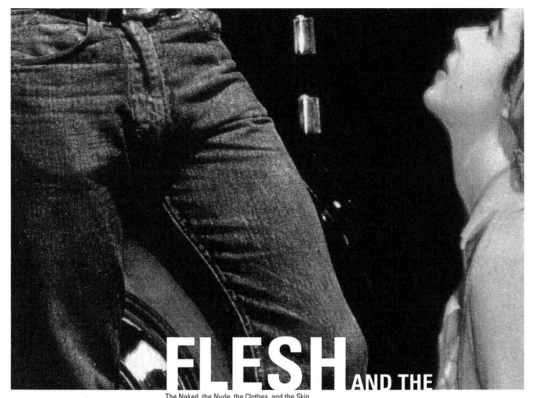

FLESH AND THE
The Naked, the Nude, the Clothes, and the Skin.

DEVIL

A minimalistic approach to design can be very effective if the designer is sensitive to subtle shifts of balance and has a keen appreciation for white space.

As a general rule, the less reliance a designer places on superfluous elements such as drop caps, pull quotes and graphic elements, the more demanding the job of creating an engaging layout will be. Each typographic element in this example serves an indisposable function to the success of the design as a whole.

White space (any negative space in a composition) is as integral a part of your work as any positive form. Whether it comes in a prominent or subtle form, its impact cannot be under-emphasized.

ables such as bylines, versals (or large caps), pull quotes, running feet or heads, and page numbers to consider.

Along with all of these disparate typographic elements, there are photographs to deal with and graphic rules, bars and shapes. There is also the issue of color as well as how all of this must fit into an overall framework so that, page after page, the viewer is intrigued by, but not lost in, the varied compositions. The introduction of white space throughout the design is important because white space pro-

vides the viewer with a calming influence. All these elements need to be maneuvered into place so that the whole of the page presents a clearly organized but interesting composition.

The opening spread also makes use of large images in a way that makes it easy for a person quickly flipping the pages to determine where the feature articles begin. Sometimes body copy is used sparingly on the opening spread, and sometimes it is not used at all.

Magazines are perhaps one of the best measures of a designer's organizational abilities. Nowhere is the demand for typographic control more complex.

10 WAYS TO SEE BETTER UNDER WATER

BY DR. SAMUEL SHELANSKI

IF SEEING IS BELIEVING, BELIEVE OUR DIVE DOC WHEN HE TELLS YOU THERE'S A WHOLE WORLD OF OPTIONS FOR SEEING BETTER BENEATH THE BOAT.

WHAT DO YOU REMEMBER MOST ABOUT YOUR LAST DIVE? IT'S PROBABLY something you saw. While all of the senses are involved in the enjoyment of a good dive, sight is the one we rely on the most.

But what if everything you saw was blurred and indistinct? Millions of divers wear glasses to see above water, and their need for visual correction does not disappear once they don scuba gear. But no matter what sort of vision problem you have topside, there's a way to correct for it under water. The options range from expensive surgery to inexpensive drop-in mask lenses. Before choosing a method, consult your doctor and consider budgetary and time constraints.

The opening spread of a feature article should clearly stand out from the rest of the article so that readers who are leafing quickly through the magazine can pinpoint the beginning with ease. Using a large, dramatic photograph as the major focus is important. The example on the previous page contains the opening photograph on a single page. The typographic elements are as follows: the heading (*Vision Quest*), the subhead (*10 Ways to See Better Under Water*), the byline (*by Dr. Samuel Shelanski*), a secondary subhead (directly below the byline), and a lead-in paragraph. The page number and running foot are also included.

Editorial design can be compared to the act of juggling—there are many design elements one must pay attention to, and when one element is shifted, other elements are affected. The example above shows excellent manipulation of spatial intervals, contrast (in value and size), and color in order to create a well-balanced layout. When dealing with so many variables, the designer must always strive for an overriding sense of unity.

This photo shows the art pictured on the previous page before the vandalism took place. A new management plan seeks to minimize damage by controlling the number of people who use the park.

these hunters drove herds of bison into the pass between North and West Mountains. Eventually these grasslands diminished, and the bison also receded. In the Archaic period (6000 B.C.–A.D. 200), small bands of hunter-gatherers lived in the area, pursuing a variety of plants and animals (rabbits composed 80 to 90 percent of their diets).

During the Formative period (A.D. 200-1450), activity increased. Around A.D. 1000, Casas Grandes people, practitioners of the Quetzalcoatl cult from the west coast of Mexico, began stopping at Hueco Tanks on their way

to New Mexico in search of turquoise. "They had a stratified society with religious leaders and elaborate items," says Howard. "One of their favorite religious colors was blue; the quetzal feathers were blue. This simply could have been the Days Inn of prehistoric times, or it could have been a place where people stayed, grew corn, and conducted hand-to-hand trade," she observes. "Probably there was some of both. One of our current questions is: Did people practice corn agriculture here?" Eventually the area became too dry for human habitation, and was abandoned.

In the 19th century, settlers traveling by horseback or stagecoach stopped at this spot for water on their journey across the desert. (A cavity between the rocks in one cave held 100,000 gallons of water.) Archaeologists found spurs, buttons and pieces of plates left behind by these early travelers, who also left behind Hueco's first graffiti. Scratching their names and dates with what archaeologists believe was wagon wheel grease, they left behind such inscriptions as, "Santiago Cooper, May 16, 1893." Native peoples, particularly the Kiowa and Apache, also painted rock art at

Hueco Tanks during this period. When the Pueblo Revolt took place in 1680, the New Mexico Tiwa (usually, 'Tigua' in Texas) were displaced to the Rio Grande and began to develop ties to Hueco Tanks.

Ranching in the Hueco area began in the late 19th century. Over time, intensive grazing decimated the grasslands. "You start to see artificial reservoirs get built to contain the water running off the rocks," says Margaret Howard. "The native reservoirs were sheltered by rocks; they had very limited surface areas, so evapotranspiration was limited. These ranchers' reservoirs were open to the sun, and they were very large and fairly shallow. Today they hold water only during rare high-water events. There's a lesson that can be learned from that."

In the 1960s ranching became less profitable, and a ranching family sold the property to developers. At this point, this cultural gold mine narrowly missed becoming the Hueco Hills subdivision: a land company began to cut streets. Howard says that the developer "moved a dam and filled the area with water. The ads said, 'Get your lovely homestead right next to this lovely lake.' Again the story is water; they used water to lure people out into this area. It didn't materialize. He lost the property, and eventually it reverted to the county, which turned it into a park. If there was a loss to cultural property, it was probably the greatest during that time. I'm hearing stories of up to a thousand people going into the park on weekends, driving up these ranch roads, marking their names on the rocks. When archaeologists study the park, we see the 'pull tab' period of the '60s is well represented."

In 1969 Texas Parks and Wildlife acquired the park, and now that it is finally stabilized and protected, visitors no longer threaten to obliterate the marks that previous generations have left on its fragile and desolate beauty. For those who are thirsty, the rocks of Hueco Tanks still hold water — go and drink. ✶

MAP OF THE ART WORLD

At Hueco Tanks, scientists are using computer-age technology to unearth exciting new artistic discoveries.

Evelyn Billo and Robert Mark, the husband-and-wife team that run Rupestrian CyberServices, have been surveying rock art sites all over the world for more than 20 years. But nothing prepared them for the sheer abundance of pictographs they found at Hueco Tanks. "When we were hired to do the project, we were told there were approximately 50 sites," says Billo. "We found 180 sites — and we weren't even looking for new art."

During three weeks of intensive field work in March, they scrambled up and down mountains, braved daily afternoon sandstorms, and dragged their photographic equipment into narrow fissures in the rocks to search for pictographs hidden in shelters. Their goal was to create the first comprehensive map of Hueco Tanks' rock art sites using high-precision geographic survey instruments. The CD-ROM map — which also will contain information about the plants, animals, and archaeological deposits — will be an invaluable tool for park managers and scholars who study rock art.

As stunned as Billo and Mark were with the number of pictographs, their biggest surprise came after they returned home with 120 rolls of film and began scanning the images into their computer. Says Billo, "With rock art, lighting conditions are everything. Because the art is in a variety of pigments — black, red, white, yellow, and orange — depending on the lighting conditions, time of day, and angle of the sun, you can sometimes bring out images that are practically invisible to the eye." When Mark enhanced a photo of one painting into PhotoShop's LAB (Lightness A-B) color space, he "practically fell out of his chair," says Billo. "I've never seen

anybody so excited. He said, 'You gotta see this!'" A photo of a faded pictograph panel that had long been known as the Menstruating Woman popped out as a vivid figure on the screen — and it looks distinctly male.

Billo and Mark are also proposing a new method for cataloging sites at Hueco Tanks. "There's a Southwestern Native American tale about how the stars got placed," Mark says. "When the creators were carefully placing stars to form constellations that would have meaning to their people, the figure Coyote got impatient with the process and finally just tossed the stars up in the sky. That's why they're scattered all over the sky. As we worked out in the field, we came to the conclusion that Coyote numbered the sites at Hueco Tanks the same way." — E.R

GETTING THERE

Hueco Tanks State Historical Park is located 32 miles northeast of El Paso. Take U.S. 62/180 east, then turn left on Ranch Road 2775.

The park is open year around; winter, spring, and fall are the best times to visit. Day fee $4, children 12 and under admitted free.

Walk-ins are admitted, but reservations are suggested, especially on weekends, since access is limited to 50 people at a time. Unguided access is allowed at North Mountain. Visitors must join a guided tour to see West Mountain, East Mountain and East Spur. Rock art tours are offered Saturday and Sunday in summer at 9 a.m. and 11 a.m., in winter at 10 a.m. and 2 p.m. Reservations for tours are recommended. Other educational tours, as well as hiking, birding and rock-climbing tours, are offered on request. For reservations and information, call Hueco Tanks at 915-857-1135; Web site: www.tpwd.state.tx.us.

Top photo by TPW, bottom left photo © Laurence Parent, Bottom right photo © Wyman Meinzer. / ©Rupestrian CyberServices for TPW.

BY CHARLES LOHRMANN

RECREATIONAL KAYAKS

K AYAKS SOLVE SEVERAL PROBLEMS FOR WATERWAY USERS:
The problem of navigating shallow water in rivers, streams or coastal flats. Kayaks draw little water, and therefore can float into all kinds of interesting situations where canoes can't go. With accessories like camo covers, the more stable models of these versatile craft work well as duck blinds.

• Transporting a boat. Because kayaks are light, they're easy to transport in a pickup or on autos that are equipped with a roof racks. Because many of the affordable kayaks are molded of polyethylene, they're light enough for one person to carry and, despite this portability, durable enough to withstand sustained heavy use. These lighter kayaks range from 40 pounds for a small, one-person model like the Wilderness Systems Kaos, to 60 pounds or so for the longer versions like the Dagger Bayou II or Wilderness Systems Ride.

• Investing in your pastime. There are dozens of recreational kayaks that are reasonably priced ($500 to $800) and don't require many accessories. Though the top-of-the-line touring craft can cost $2,000 or more, prices for inflatable kayaks begin below

$200. The moderately priced "recreational kayaks" are not for whisking through churning whitewater or plummeting down a violent waterfall, but they're sufficient for fly fishing on one of the Hill Country's meandering

Poetry in motion: today's versatile and affordable kayaks glide from sunrise to sunset on Texas waterways, whether you're fishing, birding or even hunting.

rivers or gliding quietly along the shallow coastal flats.

There is an important difference in kayak models made for day touring or recreational paddling. Sit-on-top models are easy to board. But the more open cockpit models like the Dagger Bayou II (65 lbs., $695) are about as

easy to manage. Several models in both categories can be configured for either one or two seats. The Ride from Wilderness Systems is a sit-on-top model that's stable enough to serve for fly fishing or even as a dive platform. The Ride is designed to handle a load of up to 385 pounds, and features a waterproof hatch for storing camping equipment. At 13 feet 6 inches, it's long enough to track well on quiet water but it moves easily through faster water. The Ride costs about $600.

Inflatable kayaks, even with tarpaulin abrasion runners like the Stearns inflatable ($299), are fun but not designed for serious paddling. For play, I'd recommend the inflatable Sevylor Tahiti K79. It weighs only about 25 pounds when deflated and costs only $140.

A booming interest in kayaking has resulted in new breeds of hybrid kayaks — more accurately described as "paddlecraft" (or even bi-yaks) — with multiple hulls. One of these, the Stealth from Kiwi Kayak, offers the convenience of a trolling motor mount.

Recreational kayaks are perfect for Texas waterways, from the Gulf coastal flats to the Hill Country rivers. And it's easy to get started. Many outfitters offer "test drives" or classes to prospective buyers, and most carry at least a half-dozen models. You need to decide how you want to use your craft — a stable platform for fly-fishing, for example, or a seat that rides low for running the rapids. The only problem left is to choose which of these entertaining, useful, and reasonably priced boats to take out on the water.

PHOTO © RUSTY YATES

BY HENRY CHAPPELL • ILLUSTRATIONS BY NARDA LEBO

THE WHOA COMMAND

"W HOA" IS THE FUNDAMENTAL POINTING DOG COMMAND. Properly instilled, the whoa command — which means stop and be still — forms the basis for pointing and backing.

Most pups are ready for "whoa" training by 10 months of age. Older dogs can be trained as well. Rambunctious pups are more easily handled with their feet off the ground. (Think of the veterinarian's table.) The training table is useful for introducing nearly any dog, whether hunting dog or family pet, to the "whoa" command as well as other basic commands such as "sit" and "stay."

Dogs respond best to short, frequent training sessions. If a session is going badly, go back to a task that the dog can perform and end the session on a positive note. Most dogs can be reliably "whoa" trained in about six weeks.

The process for training dogs in the "whoa" command begins with attaching a six-foot lead to the dog's field collar and placing him or her on the training table. Once the dog is comfortable standing on the training table, hold its head up with the lead, restrain it and give the command whoa in a soothing, drawn-out voice. Repeat the command while stroking the dog's back. If he or she tries to sit, raise its back end, all the while

repeating whoa...whoa. If the dog moves one of its feet, repeat the command and put the foot back in position. The command should always precede the correction.

After about 15 seconds, call the dog to you with the "come" or "here" command and gently tug the lead. Praise him or her profusely.

Repeat the sequence. After a few sessions the dog should be standing for 30 seconds or so. Back away a few

Begin teaching your dog to "whoa" on a training table, with the dog at a comfortable height where you can gently correct and praise him. Once the sequence is reliable on the table, you can continue training on the ground.

feet as you repeat the command. If he or she moves, give the whoa command in a sharp voice and put it back into position.

Gradually back away until the six-foot lead is just taut. Drop the lead and walk around the dog. The dog will move its head to watch you but should not move its feet.

Once the dog's "whoa" performance is reliable on the table, repeat the training sequence on the ground.

Begin in an enclosed area such as a garage or fenced yard. Expect setbacks. Gradually increase the separation until you can walk 20-yard circles around the dog.

Gradually progress until the dog can be stopped reliably in the field and in the presence of distractions. If the dog fails to whoa on command, it must be quickly caught, and "whoaed" in a sharp voice. Early in this stage, the dog should drag a 20 foot check cord (a rope snapped to the dog's collar) so that it can be easily caught.

A pointing dog should be "whoaed" nearly every day of its career. Be creative; look for training opportunities at feeding time, on walks, when loading and unloading — the possibilities are endless.

CONTENTS

FEATURES

COVERS

Front: The sandhill crane is among the most populous species of the crane family and a winter resident of Texas. John Ford took this photo near Lubbock. To learn more about sandhills, turn to page 58. Photo © John R. Ford. Canon camera, Canon 300mm f2.8 lens, Fuji Velvia film, 1/250 second at f/3.5.

Back: Rusty Yates, while in Colorado County, made this fine study of black hickory leaves in November. Photo © Rusty Yates. Pentax 645 camera, Pentax 120mm f4.5 lens, Fuji Velvia film, 1/4 second at f/22.

For the latest and greatest parks and wildlife information, check out our Web site <http://www.tpwd.state.tx.us>.

© CHARLES L. CHRISTON H. BREWSTER CO.

Because the table of contents comes at the beginning of the magazine, the designer should think of it as a way to introduce the reader to the sensibilities of the magazine. Some magazines dedicate a single page to it, while others dedicate an entire spread. The above example takes the type treatment of the word *contents* directly from the logo treatment on the cover (see page 81). The spread is meant to impact the reader by using beautiful, full-bleed photography. The table of contents is bound in a box (in similar fashion to the cover) and the page numbers and titles are set so they can be found quickly.

The spreads on the opposite page illustrate ways in which columns, sidebars, and other short pieces of editorial text can be handled to fit the framework of the overall page design. Every magazine contains sections of editorial information that include short, newsworthy bits of information not long enough to be worthy of a feature article. These pages should be designed to be visually integrated with the rest of the book, but bold enough to highlight each separate article.

advertorial design

Many magazines offer advertisers the option to publish several pages of information in the manner of an article featuring the benefits of their product. These are often designed in a fashion similar to regular editorial design in that there is substantial body copy that is interspersed with photographs, headings and pull quotes.

As a designer you must pay heed to the specific guidelines that have been written to govern the design of advertorials. In order to clue readers visually to the fact that the information is a paid advertisement, not editorial content of the magazine, the design must use typefaces different from the magazine's editorial sections, and the word "advertorial" must appear at the top of each page. Also, advertorial pages must be numbered independently of the magazine's page numbers.

CONTENTS

The Style of Culture

Peter The Great
New Cinema's Young Monarch,
Peter Facinelli

Gore Vidal,
Eartha Kitt, and
Bobby Zarem:
Interviews and
Exclusive Portraits
by Duane Michals

Also, Momentous
Young Talent

Plus 42 pages of Extraordinary Fashion

The Second Collector's Issue

NAKED

50 Pages by the World's Greatest Photographers
Who Work With the Nude:
David LaChapelle, Ellen von Unwerth,
Sheila Metzner, Duane Michals, Ross Bleckner,
Jeff Burton, Michel Comte, Sante D'Orazio,
Joel-Peter Witkin, Karl Lagerfeld,
Gerard Malanga, Randall Mesdon,
Guzman, Paul Jasmin, Chris Verene,
Greg Gorman, and more

USA $5.95 CANADA $8.50

7 25274 83750 2 02>

Successful magazine covers combine eye-catching visuals and graphics with a strong visual hierarchy when it comes to typographic information. This example makes excellent use of a limited color palette to organize the page and create an engaging eye flow. The typography is nestled within the darker areas of the photograph, but not in an overly rigid manner. The light tonality of the top of the photograph allows the magazine's name to stand out clearly.

SAVANNAH COLLEGE OF ART AND DESIGN

the magazine

VOLUME 4, NUMBER 1

WINTER/SPRING 2000

While the majority of magazines use photography for cover illustration, the use of colorful artwork draws attention to this cover. Clever use of the unexpected—in color, graphics, or typography—can make one magazine cover stand out among the rest.

cookbooks

GROUNDWORK

MOST COOKBOOKS FEATURE A SPECIFIC THEME. THEY MAY FOCUS ON FOOD categories such as soups, sauces, muffins or desserts. They may be broken down according to geography, either with a general focus on international dishes such as Italian or Mexican, or with a more specific regional focus like seafoods of the South or Tuscan grilling. The highlight may be on a celebrity or an actual restaurant, or the cookbook may feature a specialized topic such as health foods. Determine what theme your client has in mind, then do some research. Do not wait for your client to enlighten you. Instead, come to the table (pardon the expression) with a thorough understanding of the theme, and be prepared to offer possible topic-related additions to the client's core idea.

There are two basic types of cookbook. There are the get-down-and-dirty versions that fully expect to find themselves covered with recipe ingredients, and there are the more elegant versions designed to be displayed as glossy coffee-table books. Between these two extremes lie many other choices, and the cost of production is very much a factor with each one of them. There are hardcovers and softcovers, perfect binding and spiral binding (Fig. 20 on page 95). There are glossy paper cookbooks with full-color photography, and there are one-color books printed on inexpensive paper.

Even the issue of size must be considered carefully. Each of these choices offers the client specific benefits and specific budgets. Bring a wide array of examples to your client (and price out each of them if possible) to stimulate a conversation that will narrow your range of focus from the start.

As important as photography is to catalogs, it is equally important to cookbooks. This is true for two reasons. First, a beautiful picture of food can captivate anyone's imagination and so can attract a consumer who might otherwise be browsing. Second, photographs make the steps involved in preparing a dish become visual and so contribute to the success of the cook.

If photographs are going to be used, find out who will be responsible for the photo shoot. This is a much more difficult task than shooting clothes or models; there is actual food involved, and the images must show the food in an appealing manner. They must be mouthwatering in the most literal sense.

Finally, make sure the client has considered an opening or introduction of some kind. Consumers like to know a little more about the topic of a cookbook than just the recipes, so suggest that a brief history or exposé be offered at the beginning of the book. It's one thing to cook a robust puttenesca sauce. It's quite another when you can explain to your guests the origin of such a dish.

Clarify with your client before you begin

+ **Is there a special theme for the cookbook?**
+ **Does the budget allow for full-color photography?**
+ **Is the overall aim to design a high-gloss picture book or a cookbook that is highly usable?**

A Cowboy in the Kitchen

Recipes from Reata and
Texas West of the Pecos

A Cowboy in the Kitchen

GRADY SPEARS

AND **ROBB WALSH**

Cover photography should be used to show actual dishes
or to portray the overriding theme of the recipes included in the book.
This example successfully achieves both goals.

DESIGN

Once a budget is decided upon, it must be determined where that money is best spent. If color is important, working with a three-ring spiral format would be less expensive than perfect binding, and the money saved there could go toward the cost of color printing. Or if the idea of a hardcover, perfect-bound book is too alluring to pass up for the client, perhaps he or she can save money by working with a lower-grade paper and a one-color job. In this second case, illustrations could be used in lieu of full-color photography to give the consumer an idea of the recipes' final results.

Determining the exact proportions of the book is the next design consideration. Will it be a standard vertical format? Will it be based on a square? Or will it be more horizontally oriented? A custom size may stand out nicely against other books on a bookshelf, but could the extra money involved in printing custom sizes be better spent on color images? The possibility of centralizing the color prints in a single area and printing the majority of the book in one color always is a nice economical compromise.

If the book is divided into different sections (appetizers, soups, salads, poultry, meats, fish, and so forth), devise an organizer that gives a quick visual reference to each category.

Each page of a recipe book needs to be clearly broken down between the required ingredients and the preparation process. Often the ingredients can be treated as a sidebar that is removed from the rest of the body copy by way of a separate column or a framed or filled box. The ingredient copy must be both easy to find and easy to read inasmuch as people often refer to it while their hands are busy with measuring devices, utensils or pots and pans. Isolating the numerical part of this information further can be extremely helpful. This ingredient copy should also always be presented in the same position in each of the recipes.

enchiladas

Enchilar means to coat in chiles. Some simple recipes for traditional enchiladas call for corn tortillas to be passed through a chile purée, then fried briefly, searing the purée onto the surface and rendering the tortillas pliable enough to roll. These enchiladas are served accompanied with little more than Mexican crema. More elaborate traditional recipes call for tortillas to be briefly fried, then dipped in sauce. The tortillas are then filled with cheese, warm carnitas, or any of an endless variety of other fillings and rolled into cylinders. The same sauce is usually poured over them, and a garnish is added. Although some recipes call for enchiladas to be made ahead and baked, this can yield soggy tortillas and the practice isn't recommended. These rich, hearty concoctions make satisfying casual appetizers and entrées.

And from the *Jean-Louis Meets Cowboy Bob* file come some subtle and delicate recipes that use crepes instead of tortillas. Although they are not technically enchiladas, they are lighter and do not require the heavy dosing of sauces that traditional recipes sometimes call for. Even though we have borrowed the method from our French brethren, we have replaced the cream and milk with beer and usually add chile molido or puréed poblanos for color and spice.

tortilla method

1. For tortilla-wrapped enchiladas, make the filling and sauce according to the recipe and keep them warm. Air-dry the tortillas for 3 or 4 minutes, until they are leathery but not brittle. Preheat the oven to 250°. In a shallow pan, heat 1 inch of oil to 375°, or until it sizzles but doesn't smoke. Dip the tortillas one by one into the hot oil for 1 or 2 seconds and drain them on paper towels. Dip the tortillas in the sauce and allow them to drain, leaving a light coating of sauce.

2. Working quickly, spoon a line of filling down the center of the tortilla and roll it into a tight cylinder. Put the enchilada on its serving dish seam-side down and repeat the process until all enchiladas are rolled. When ready to serve, ladle some sauce over the enchiladas and garnish as desired.

crepe method

1. For crepe-wrapped enchiladas, make the fillings and sauces according to the recipe. Unlike the tortilla-wrapped enchiladas, these can either be made with warm ingredients and served right away, or made ahead and reheated for convenience. If reheating, cover and refrigerate the filling for 1 hour to overnight before rolling or filling the crepes. Lay the crepes out on a work surface and spoon 3 to 4 tablespoons of the filling in a line down the center for rolled crepes or in a dollop in the center for folded crepes. Roll the crepes into cylinders or fold them into square parcels. If not serving them right 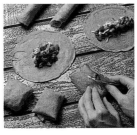 away, place them seam-side down on their serving platter and keep them warm in a preheated 250° oven. If the crepes are being made ahead, cover and refrigerate them until serving time.

2. If reheating crepe-wrapped enchiladas, place the crepes seam-side down on a buttered or parchment paper–lined baking sheet and cover them with buttered aluminum foil. When ready to serve, preheat the oven to 300° and heat the crepes for 25 to 35 minutes, or until warmed through. To microwave, place them on a microwavable plate, cover with plastic wrap, and heat on medium for 1 minute, or until hot.

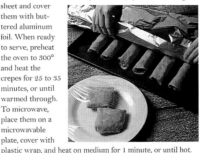

3. Sauce and garnish the crepes as desired. As with traditional enchiladas, this is usually done by saucing, then streaking them with crema and perhaps topping them with a dollop of salsa.

what not to do

1. As when making flautas, make sure that the corn tortillas are air-dried, but not to the point of being brittle. Otherwise, they may become too crisp to roll without tearing. Conversely, if they are too fresh and soft, they will take on too much oil and repel the sauce.

2. Although it is inadvisable to bake enchiladas, the filling can sometimes grow cold while you are rolling the tortillas. In a pinch, try "zapping" them in the microwave for a few seconds to get them piping hot again before serving.

Photographs of the finished dish are appetizing and pleasant to look at, but they do not illustrate the steps involved in preparation. Using additional photographs that show important—and perhaps intricate—steps in the preparation of the meal can be extremely beneficial to the reader.

Explaining food preparation can be easy enough, but some dishes are difficult to make unless the cook knows what things should be avoided. Certain nuances in cooking are learned either by trial and error or by helpful warnings, such as the example on the left. The information is neatly included in each recipe by way of a sidebar.

NINA DREYER HENSLEY, JIM HENSLEY AND PAUL LØWE

Pasta
a passion

Photography is a key element in any cookbook.
The cover is especially important because it is seen most often by potential customers. The typography on the front of such a book should play the role as a caption for the photograph that clarifies the book's content.

As seen on the example on the facing page, the photography should be prominent throughout the cookbook as a way to entice consumers and whet their appetites. The copy should be well organized and easy to read. Cooking instructions should be clearly separated from the ingredients.

Make sure the name of the actual dish is prominent. Someone leafing through the book quickly should be able to find a specific recipe without having to slow down. Present it consistently in terms of location on the page, color treatment, typeface and type size. And, as with the ingredients mentioned above, provide it with a clearly defined space.

If the book is divided into different sections (appetizers, soups, salads, poultry, meats, fish, and so forth), devise an organizer that gives a quick visual reference to each category. This can be as simple as a color band across the top or down the side. If the book is a one- or two-color job, you might devise a series of icons that can be used instead. Yet another option is simply to include the name of the category at the bottom of the page along with the page number.

One typeface can certainly do for a cookbook. If a second font is introduced, use it to clarify elements. If the directions are in a serif font, for instance, use a sans serif for the ingredients. Or simply use the second font for the recipe headings.

When it comes to paper, uncoated stocks are more inexpensive, but they will not do photographs justice, especially in the case of food. If the client is willing to pay for full-color photographs, insist on coated stock. Oddly enough, cheaper paper is often used in cookbooks that are expected to get dirty and smeared with ingredients, yet a coated stock repels stains more efficiently than these uncoated stocks.

Finally, do not neglect the cover design. This may be a small part of the overall design process, but many people do in fact judge a book by its cover. Refer to chapter 11 for a more in-depth analysis of book cover and dust jacket design.

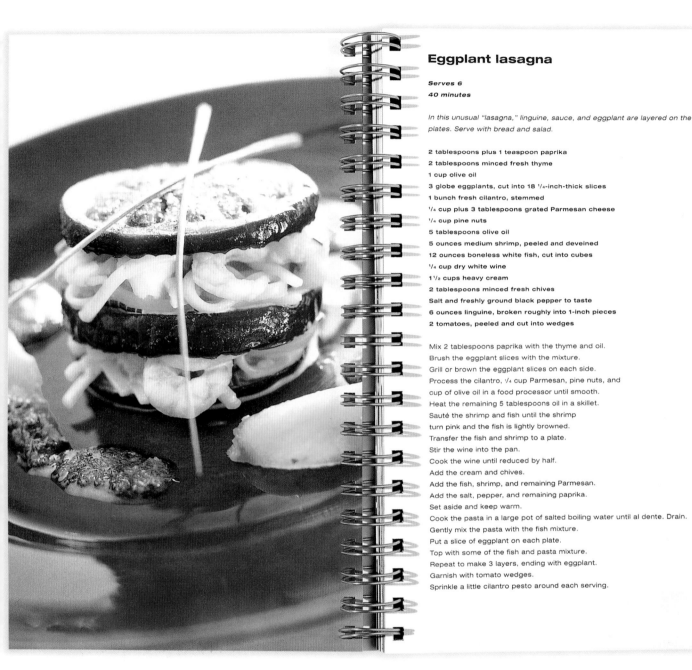

Eggplant lasagna

Serves 6
40 minutes

In this unusual "lasagna," linguine, sauce, and eggplant are layered on the plates. Serve with bread and salad.

2 tablespoons plus 1 teaspoon paprika
2 tablespoons minced fresh thyme
1 cup olive oil
3 globe eggplants, cut into 18 ¹/₄-inch-thick slices
1 bunch fresh cilantro, stemmed
¹/₄ cup plus 3 tablespoons grated Parmesan cheese
¹/₄ cup pine nuts
5 tablespoons olive oil
5 ounces medium shrimp, peeled and deveined
12 ounces boneless white fish, cut into cubes
¹/₄ cup dry white wine
1 ¹/₂ cups heavy cream
2 tablespoons minced fresh chives
Salt and freshly ground black pepper to taste
6 ounces linguine, broken roughly into 1-inch pieces
2 tomatoes, peeled and cut into wedges

Mix 2 tablespoons paprika with the thyme and oil.
Brush the eggplant slices with the mixture.
Grill or brown the eggplant slices on each side.
Process the cilantro, ¹/₄ cup Parmesan, pine nuts, and
cup of olive oil in a food processor until smooth.
Heat the remaining 5 tablespoons oil in a skillet.
Sauté the shrimp and fish until the shrimp
turn pink and the fish is lightly browned.
Transfer the fish and shrimp to a plate.
Stir the wine into the pan.
Cook the wine until reduced by half.
Add the cream and chives.
Add the fish, shrimp, and remaining Parmesan.
Add the salt, pepper, and remaining paprika.
Set aside and keep warm.
Cook the pasta in a large pot of salted boiling water until al dente. Drain.
Gently mix the pasta with the fish mixture.
Put a slice of eggplant on each plate.
Top with some of the fish and pasta mixture.
Repeat to make 3 layers, ending with eggplant.
Garnish with tomato wedges.
Sprinkle a little cilantro pesto around each serving.

17

Fig. 20

Spiral bindings are popular for cookbooks due to their ease of use. Where perfect-bound and hardcover books can be difficult to keep open on a counter top, spiral-bound books lie perfectly flat.

Common types of spiral bindings include the open spiral binding (above example), the covered spiral (on the far right), and the three-ring spiral. The three-ring spiral is more versatile because it allows pages to be added or taken out.

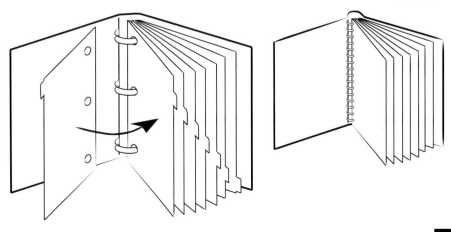

Whatever your theme may be, make sure to research it thoroughly. Take the time and effort to push your concept as far as you can, and research appropriate freelance illustrators or photographers. Of course, the boldness of your design work should be dictated by your theme. The example on this page is colorful and playful—extremely appropriate to the subject matter.

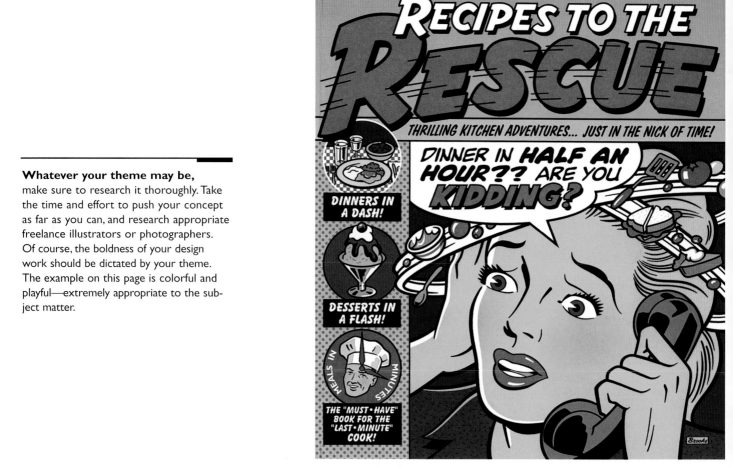

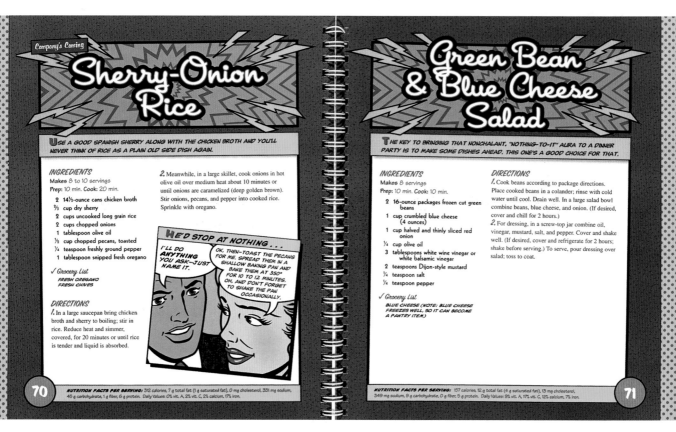

diRect MaiL

self-mailers

invitations

advertising

solicitations

self-promotion

box mailers

self-mailers

14

GROUNDWORK

A SELF-MAILER IS NOTHING MORE THAN A PIECE OF MAIL THAT DOES NOT REQUIRE an envelope; all the necessary postal information is printed on or affixed to one of the outside panels. Even catalogs that are delivered without an envelope fall into this category. A substantial amount of money can be saved by eliminating the need for envelopes, so exploring the potential of a self-mailer should be considered for any direct-mail piece you may be designing. Offer this option to your clients and make them aware of the savings possible, but also point out the potential downsides. Because the self-mailer format can be applied to most of the categories covered in this section, the specifications presented in this chapter should be referred to whenever a self-mailer is considered.

An envelope serves two basic purposes. The first is to allow for a clean area to place postage, a mailing address and a return address. The second purpose—protection—is as important, if not more important, than the first. Envelopes provide a protective barrier between the potentially rough treatment most mail is subjected to and the information held within it.

If you choose to utilize the self-mailer format, make sure you pick a paper stock that is capable of withstanding some mistreatment. Glossy stock is generally more rigid, and it is less likely to absorb any water that may come in contact with it. Just remember, if the mailer looks old and ratty when it comes out of the mailbox, the recipient's initial response will most likely be a negative one no matter how well its contents are designed.

Despite the benefits of using a self-mailer, there will be times when an envelope is necessary, not for any utilitarian purpose as much as for an aesthetic one. If the event, service or product you are advertising is somewhat exclusive or high-end, an envelope will help reinforce the upscale feel you want to exude, and the extra money for envelopes is thus well spent.

Another important issue when dealing with self-mailers is the closing mechanism. Because the mailer must travel a long distance, there must be a fail-safe way to secure it so that it does not open inadvertently. Staples are used often enough, but nothing could be more unappealing. There are miniature self-adhesives readily available in many colors, shapes and sizes. There are even self-adhesive wax seals.

Visit your local office supply store, stationery store or craft store before considering the type of closure your self-mailer will have. Also request a quote from

Clarify with your client before you begin

- ✦ **Will the delivery address be printed directly on the self-mailer, or will self-adhesive labels be used?**
- ✦ **How much written material needs to be presented in the self-mailer? This will help determine overall size.**
- ✦ **What type of closure will be used in order to assure safe passage through the mail?**

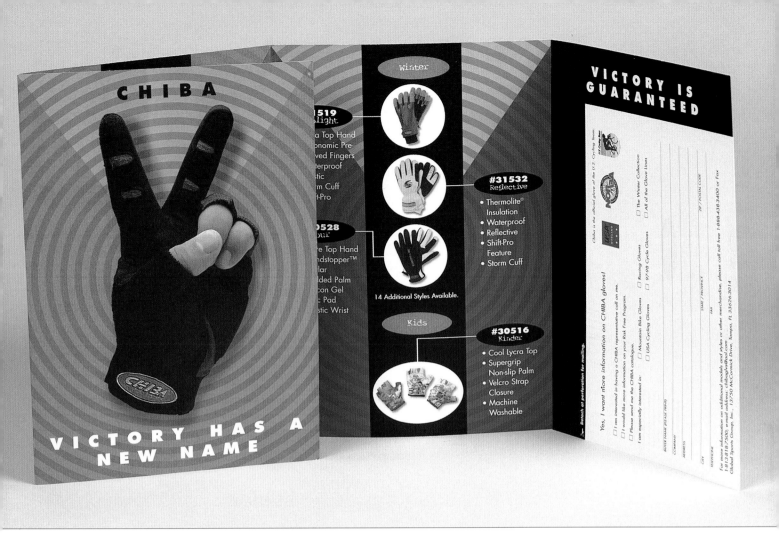

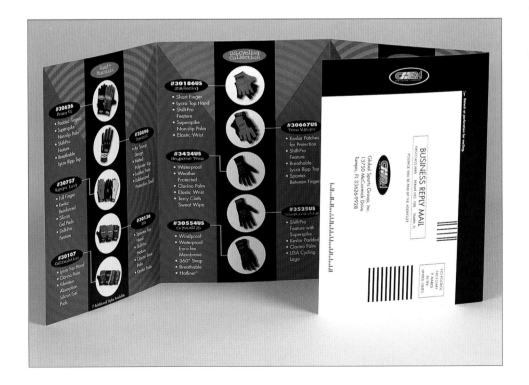

These self-mailing catalogs show how strong design elements combined with intelligent use of available space help create an efficient self-mailer that incorporates a perforated response card.

your printer that includes the addition of peel-off glue strips as part of the print job. This is a finishing process that has become much more common in recent times and so could be less expensive than you might think.

DESIGN Understanding the general guidelines that explain postal specifications for any direct mail piece—whether it be an invitation, an advertisement or a solicitation—is the designer's first priority in this project. By following these guidelines you can assure expedient delivery by the postal service.

The size of the self-mailer itself must fall within certain parameters in order to be run through the post office's machinery efficiently. It should be no smaller than 3½" high by 5" wide (8.89cm × 12.70cm). It should also be no taller than 6⅛" (15.56cm) and no longer than 11½" (29.21cm), as in Fig. 21. Anything that falls outside this range is not compatible with the post office's computer systems. The mailer should be no thinner than .007" (0.02cm) and no thicker than a quarter of an inch (0.64cm).

The post office uses what is called an Optical Character Reader (OCR) to determine the contents of a mailing address. Once the address is confirmed, the machine adheres a bar code that carries the same information in digital form. Further down the line a Barcode Sorter (BCS) is used to sort the mail to its final destination by using this barcode. Both the OCR and the BCS read information from specific areas on the front surface of each piece of mail.

No part of the delivery address should fall outside the designated OCR

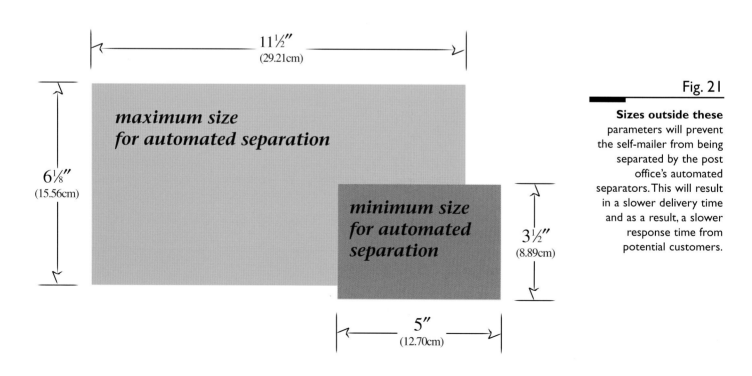

11½"
(29.21cm)

*maximum size
for automated separation*

6⅛"
(15.56cm)

*minimum size
for automated
separation*

3½"
(8.89cm)

5"
(12.70cm)

Fig. 21

Sizes outside these parameters will prevent the self-mailer from being separated by the post office's automated separators. This will result in a slower delivery time and as a result, a slower response time from potential customers.

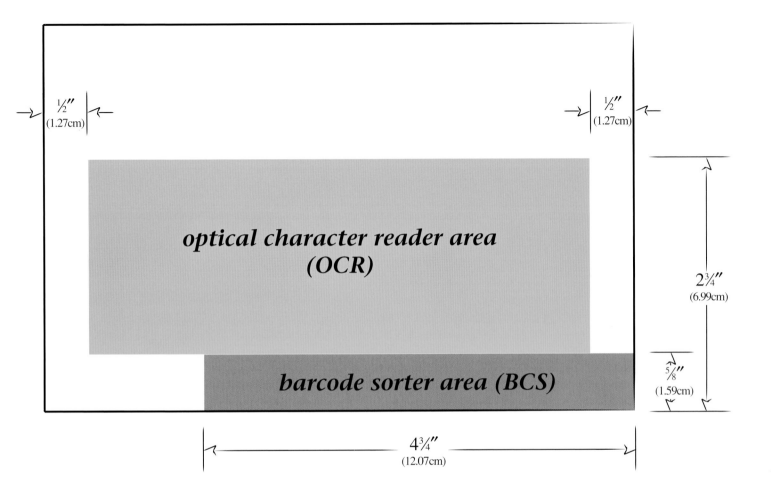

area, and any other information that falls within this area may potentially confuse the electronic reader and thus slow the delivery of your mail. This is especially true of any typography because the computer relies on type recognition.

The OCR area can be defined by drawing a rectangle that is a half inch (1.27cm) in from the left and right sides, with the bottom border ⅝″ (1.59cm) from the bottom and the upper border 2¾″ (6.99cm) from the bottom. The BCS area, or the space reserved for the barcode, measures ⅝″ (1.59cm) from the bottom and 4¾″ (12.07cm) from the right side (Fig. 22). The upper left-hand corner is traditionally reserved for a return address, and the upper right-hand corner is for the postage.

The legibility of the delivery address is also very important. There are a number of common typographic problems that occur on the outside of self-mailers that slow their delivery. First of all, allow for ample leading (white space between lines of type) and ample letter spacing (white space between each letter) in the address. If either of these is too tight, the computer is likely to misread the information.

Fig. 22

Anyone concerned with getting mail-order items through the mail in the most expedient manner possible should follow the above guidelines when applying graphics to mail delivery panels. The OCR area should carry only the delivery address, while the BCS should be left completely blank since barcodes are sometimes applied directly onto the surface.

Also allow for ample word spacing. Traditionally an em space is enough (an em space is a horizontal space that is equal to the point size of the typeface being used. A twelve point em space, for example, is twelve points wide). Inadequate word spacing also confuses the computer into thinking the address is something different from what it actually is.

The United States Postal Service recommends that you use all capital letters in the delivery address, although this is not absolutely required. At the very least make sure to use a highly legible typeface (the post office recommends a sans serif) that is large enough in point size. Script fonts can be especially difficult for the computer to dicipher. Also make sure there is sufficient color contrast between the address and the background. Ideally this would mean black type on a white background, but other color combinations that allow for enough contrast will also work.

Any nonaddress information on the outside of the self-mailer should not appear below the delivery address. Since the barcode is often laser printed directly onto the surface, the BCS area should be left clear of any markings whatsoever.

The words *machinable* and *readable* are terms used to define the mail-friendly nature of letters and self-mailers. Something that is said to be machinable is of a size and shape that is appropriate for the post office's machinery. Readable mail is mail capable of being accurately read, coded and sorted. If your self-mailer is both machinable and readable, it will be delivered expediently. If it is neither, your mail will be pushed aside for hand sorting, and, more than likely, the delivery of your mailing piece will be delayed.

Aesthetic design considerations for self-mailers are covered in greater depth in following chapters, based on the nature of their content (invitation, advertisement or solicitation).

If your self-mailer is both machinable and readable, it will be delivered expediently. If it is neither, your mail will be pushed aside for hand sorting, and, more than likely, the delivery of your mailing piece will be delayed.

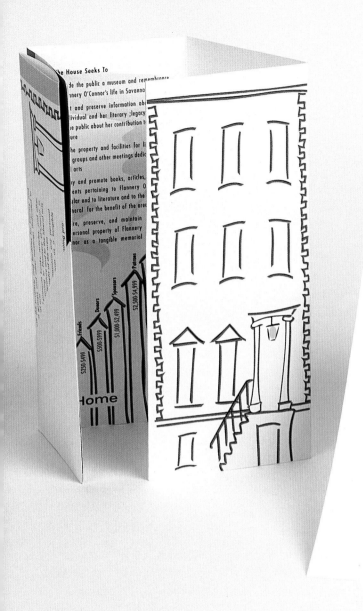

Flannery Facts

Flannery O'Conner (1925-1964)
Native of Savannah, acclaimed as one of the 20th century's greatest writers of fiction.

Two Novels

• Wise Blood
• The Violent Bear it away

Two Collections of Short Stories

• A Good Man is hard to find
• Everything That Rises Must Converge

Awards

Miss O'Conner won the O'Henry Award for best short story of the year on three occasions in the fifties and sixties. Her short stories in "The Complete Stories" won the National Book Award in 1972.

Highlighted works

Her works are available in paperback. A good place to start is with Three by O'Conner, which includes both novels and several short stories.

Wise Blood is available on film; the short story, "The Displaced Person," is also on video tape.

The Library of America published in 1989 her Complete works.

Background information

Miss O'Conner was born in Savannah on March 25, 1925, and lived in the house until March, 1938, when the family moved to Atlanta and then to Milledgeville. She completed high school and college in Milledgeville. In 1951, after an absense of several years, she returned to Milledgeville when she was diagnosed as having the the fatal disease, lipus. She spent the remainder of her life living with her mother on a farm called Andalusia outside of Milledgeville. It was there that she wrote the bulk of her fiction. She never married and died in 1964 at age 39.

The O'Conner Childhood Home
207 E. Charlton St.
on Lafayette Square
Savannah

Along with information printed directly on the self-mailer, this example includes two loose sheets that fit into sleeves of the self-mailer construction. The mailer was designed to stand upright so the resulting shape reflects the structure of the townhouse that the museum is situated in. This allows the piece to be used as a countertop display. As a cost-saving measure, only two colors have been used in the printing process.

invitations

GROUNDWORK INVITATIONS ABOUND FOR MANY DIVERSE EVENTS AND FUNCTIONS. THERE ARE personal invitations to dinners, parties, christenings and weddings. There are business invitations to annual retreats and seasonal and holiday events. There are invitations to fundraising events, invitations to black-tie affairs, and even invitations to doggy birthdays.

Find out for whom the event is being held, who will be in attendance, and what the atmosphere will be like. Ask the organizer how many items will be included within the invitation. Maps, RSVP cards, donor cards, and menu previews are just a few examples of peripheral items that can be included in an invitation. Each additional piece requires design time and extra cost in the form of paper stock and printing.

The type of function and the personality of its attendees will determine everything. If illustrations or photographs are needed, get to work finding these immediately, as they often are the centerpiece of the entire invitation. Determine whether it will be a full-color job, a one-color job or anything in between. As with any other job, do not wait too long to get the exact text for the invitation.

Paper stock is always a major issue, as are the size and format of the invitation. Invitations formatted to work within the confines of regular envelopes can be as elegant and enticing as any three-dimensional or custom-proportioned invitation, and their use can easily keep a job on budget.

Clarify with your client before you begin

+ **How many printed pieces are required for each invitation?**
+ **Is the budget large enough to consider specialty packaging or customized wrapping?**
+ **What is the basic personality or theme of the event?**

Along with paper stock, keep in mind the potential use of vellum overlays, embossing, foil stamping and even the inclusion of bows, ribbons and twine. These additions are much more cost-efficient than three-dimensional pieces and can easily add a personalized touch to an otherwise basic invitation.

If there is money available in the budget, the possibility of creating a box kit could be suggested to the client. Such an endeavor represents a substantial increase in budget owing to the additional costs of postage and materials. If the client is looking for alternatives to standard-sized envelopes,

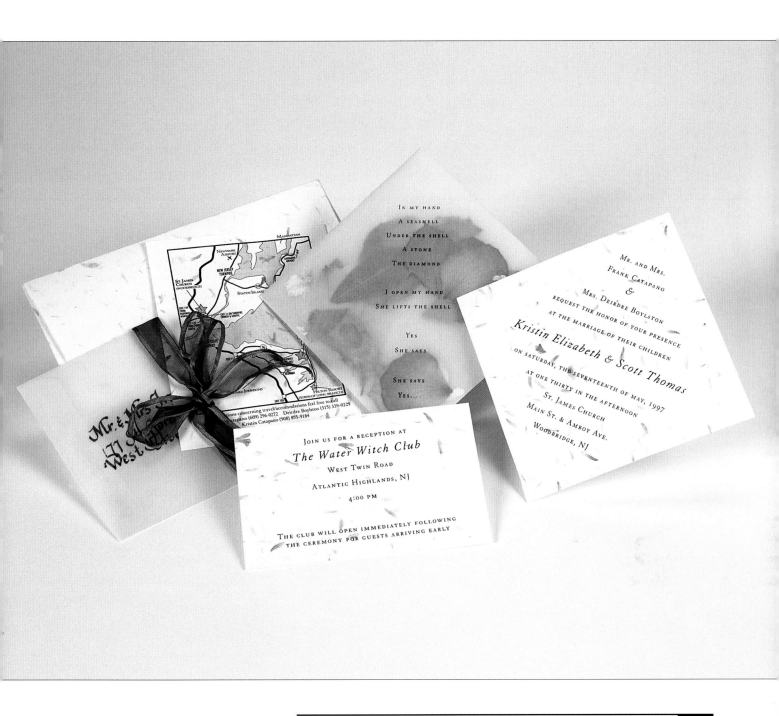

IN MY HAND
A SEASHELL
UNDER THE SHELL
A STONE
THE DIAMOND

I OPEN MY HAND
SHE LIFTS THE SHELL

YES
SHE SAYS

SHE SAYS
YES...

MR. AND MRS.
FRANK CATAPANO
&
MRS. DEIRDRE BOYLSTON
REQUEST THE HONOR OF YOUR PRESENCE
AT THE MARRIAGE OF THEIR CHILDREN

Kristin Elizabeth & Scott Thomas

ON SATURDAY, THE SEVENTEENTH OF MAY, 1997
AT ONE THIRTY IN THE AFTERNOON
ST. JAMES CHURCH
MAIN ST. & AMBOY AVE.
WOODBRIDGE, NJ

JOIN US FOR A RECEPTION AT
The Water Witch Club
WEST TWIN ROAD
ATLANTIC HIGHLANDS, NJ
4:00 PM

THE CLUB WILL OPEN IMMEDIATELY FOLLOWING
THE CEREMONY FOR GUESTS ARRIVING EARLY

Wedding invitations should reflect the personality of the couple getting married as well as the venue where the ceremony will be held. This example has made use of two vellum sheets that hold pressed flowers between them. The front is printed with a reference to the nature of the marriage proposal, while the back opens like a flower and holds the other printed materials within it. To enhance the personal nature of the invitation, the flower petals were collected and pressed by the couple, and a calligrapher addressed the RSVP envelopes.

fashion show
2000

s e e i n g i s b e l i e v i n g

Savannah College of Art and Design
P.O. Box 3146
Savannah, GA 31402-3146 U.S.A.

Nonprofit Org.
U.S. Postage
PAID
Permit No. 964
Savannah, GA

fashion show
2000

s e e i n g i s b e l i e v i n g

Saturday, May 20
Trustees Theater
216 E. Broughton St.

4 p.m. Matinee
Free, limited seating available

8 p.m. Gala Show
$10, reserved seating available

8 p.m. Live Telecast
Weston House Ballroom
231 W. Boundary St.
or visit www.scad.edu/fashionshow.com for a live Webcast.

*For ticket inquiries and reservations,
call 912.525.5050.*

All proceeds benefit the fashion department.

FRONT: Artwork by Melissa Chamberland, Kerensa Durr, Sarah Ventimiglia

K3525·4m·5/00

For an event that is open to the general public but also includes a private reception, two invitations will be required. The top example shows both sides of a self-mailer announcing the event to the public, whereas the bottom example shows an invitation intended for a more select audience. Due to its more exclusive nature, this second invitation was designed to be sent in an envelope instead of as a self-mailer. In both cases the typographic design from the front is carried over to the back for consistency in design. The bright red image for the special invitation makes it more visible and easier to see for its primary use as a ticket.

ADMIT ONE

Savannah College of Art and Design

*The President, Board of Trustees and the
Fashion Department cordially invite you to attend the*

PRESIDENT'S
r e c e p t i o n

Westin Savannah Harbor Resort
1 Resort Drive

In honor of Mr. André Leon Talley
*Recipient of the Lifetime Achievement Award for Fashion
presented by Savannah College of Art and Design*

immediately following the

fashion show **2000**

Saturday, May 20, 8 p.m.
Trustees Theater · 216 E. Broughton St.

Please present this invitation at the door
for admission to the President's Reception.

FRONT: Artwork by Melissa Chamberland, Kerensa Durr, Sarah Ventimiglia

K3528·500·5/00

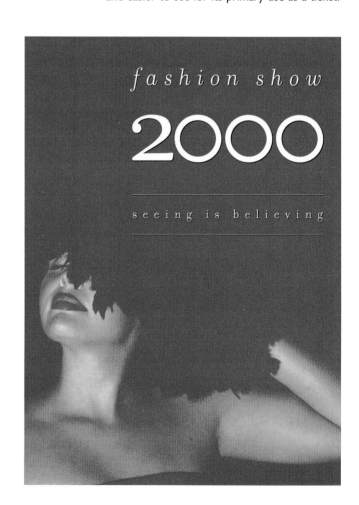

fashion show
2000

s e e i n g i s b e l i e v i n g

be prepared to offer standard three-dimensional constructions such as cardboard tubing and small mailing cartons. But also be willing to explore more unique approaches to mail packages. Always keep the budget in mind. A great idea that gets abruptly aborted because of cost overruns is no great idea at all.

DESIGN Every designer should be capable of creating an invitation within the standard mailing proportions of the U.S. Postal Service. In fact, every designer should be capable of creating an alluring invitation on nothing larger than a postcard. It is the designer's job, after all, to intrigue and entice any target audience with the creative juxtaposition of type and image. So do not despair if your client refuses to spend the extra money for what you feel would be the ideal invitation. You can always offer suggestions; just be prepared to adjust your ideas to budgetary constraints.

Once the target audience is determined, decide on the overall attitude of the invitation. Concept is as important as design here. Is humor an important element, or is a certain amount of refinement required? Once several approaches have been explored, devise various designs in the form of roughs and present these ideas to your client. Not everyone, for example, has the same sense of humor, and what you may think is witty may offend your client.

The cover of many invitations serves the same purpose as product packaging and book covers: it is designed

The cover of many invitations serves the same purpose as product packaging and book covers: it is designed to have an immediate impact on the viewer. It is your job to make sure that first impression is a good one.

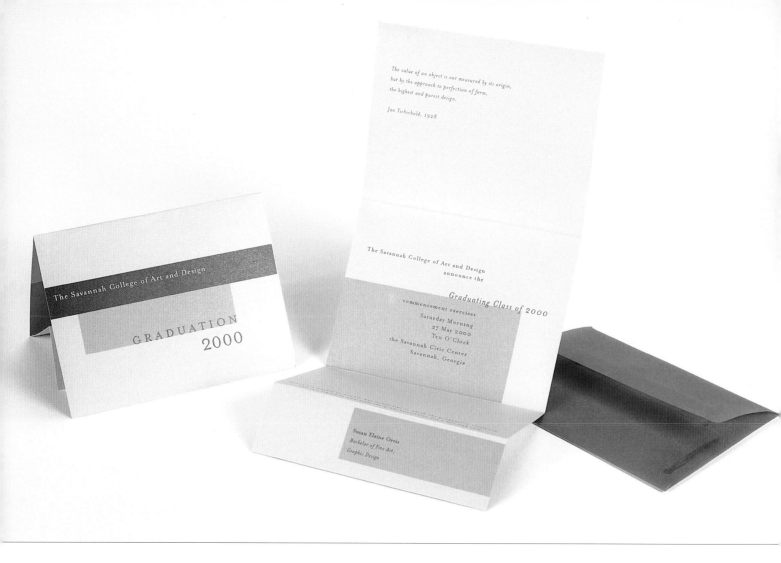

The value of an object is not measured by its origin, but by the approach to perfection of form, the highest and purest design.

Jan Tschichold, 1928

The Savannah College of Art and Design
announce the

Graduating Class of 2000

commencement exercises
Saturday Morning
27 May 2000
Ten O'Clock
the Savannah Civic Center
Savannah, Georgia

Susan Elaine Orvis
Bachelor of Fine Art,
Graphic Design

The Savannah College of Art and Design

GRADUATION
2000

The above example shows how something as simple as an extra flap can enhance the experience of opening an invitation. This also allows the designer to lay out the written information in a way that creates a progression from one idea to the next.

to have an immediate impact on the viewer. It is your job to make sure that first impression is a good one. Decisions are made quickly by people shuffling through their mail, and uninteresting items find their way into the garbage without a second thought. Beginning with the envelope, an invitation should lure the reader into the world of the event being announced.

The challenge does not end once the recipient makes the decision to open the invitation. At that point the trash can is still only inches away. With a constant bombardment of junk mail, even the most patient people are not usually willing to sort through a piece of mail that is drab, unappealing, and worst of all, unclear in its message. Many invitations come without prior notice, so the recipient will form a decision based on the overall design, even before all the information is read. Because of this, the visuals should be a treat, and any relevant information should be easily found and understood.

The delivery of the message is another consideration. If the invitation takes the form of a card that

extraordinary adornments

the jewelry of
Kathy L. Chan
JULY 7 – SEPTEMBER 23

reception
SEPTEMBER 18, 4:30 – 6:30 P.M.

**PINNACLE
GALLERY**

320
east
liberty
st.

Monday–
Friday
9 a.m.–
5:30 p.m.

Saturday
10 a.m.–
4 p.m.

the artist
will present a
lecture
SEPTEMBER 18, 7 P.M.

EX LIBRIS

third
floor
gallery
228
mlk jr.
blvd.

This folding invitation relies on simplicity and negative space on both the outside and the inside. Where the front presents an example of the jewelry featured in the show, the inside presents the typographical information in a way that mirrors the structure and the sparse elegance of the jewelry.

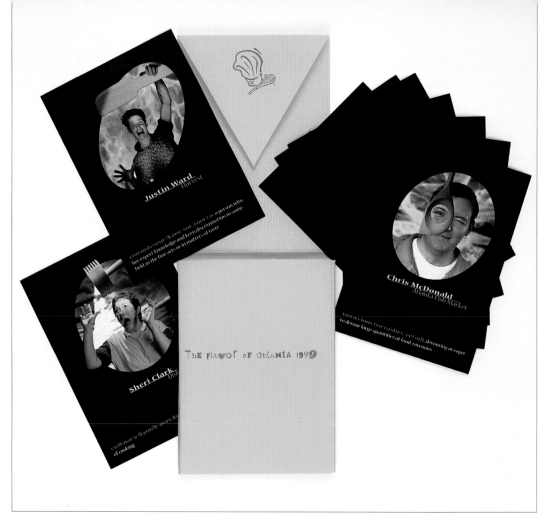

As a fundraiser for a charitable organization, chefs from critically acclaimed restaurants gathered to offer their favorite dishes. Each chef was portrayed on a separate card that was stacked with the rest of the cards. Then all the cards were placed inside a colorful mailer. The designers made use of playful photographic collages and color contrasts to create a sophisticated but humorous invitation.

Once the target audience is determined, decide on the overall attitude of the invitation. Is humor an important element, or is a certain amount of refinement required?

opens, the cover should offer a tease of some kind that prompts the recipient to open it. The simple act of opening something represents a conscious decision to become involved. This tease can be in the form of a comment or question that leaves the viewer wondering, or it can be in the form of an image that implores an explanation of one kind or another.

The creation of such a mystery is vastly different from an unclear message, so make sure that once the piece is opened, the message is succinct and comprehensible. There should be an immediate realization—an *ooh* or an *aah*—from the viewer. Pulling the viewer in is the first step, but once in, the viewer should want to stay in to investigate further.

Simple interactive formats such as innovative scoring and folding pieces are always of interest. As any package designer

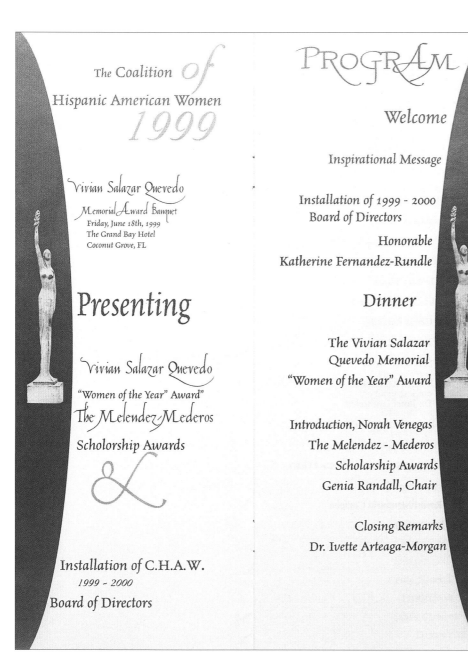

The Coalition *of*
Hispanic American Women
1999

Vivian Salazar Quevedo
Memorial Award Banquet
Friday, June 18th, 1999
The Grand Bay Hotel
Coconut Grove, FL

Presenting

Vivian Salazar Quevedo
"Women of the Year" Award"
The Melendez-Mederos
Scholorship Awards

&

Installation of C.H.A.W.
1999 - 2000
Board of Directors

PROGRAM

Welcome

Inspirational Message

Installation of 1999 - 2000
Board of Directors

Honorable
Katherine Fernandez-Rundle

Dinner

The Vivian Salazar
Quevedo Memorial
"Women of the Year" Award

Introduction, Norah Venegas
The Melendez - Mederos
Scholarship Awards
Genia Randall, Chair

Closing Remarks
Dr. Ivette Arteaga-Morgan

The use of silver inks and varnishes can lend invitations an elegant flair. In this example two ornate typefaces have been used together, along with a number of different point sizes. To prevent these variables from creating too much contrast and discord, white space has been used judiciously, and the color scheme has been kept very simple.

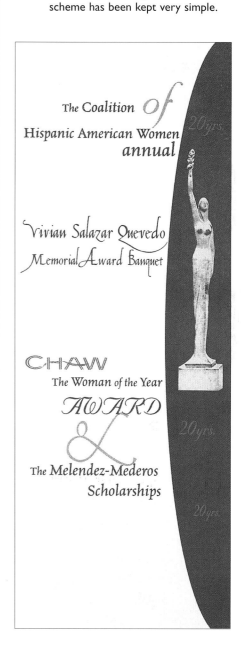

The Coalition *of*
Hispanic American Women
annual

Vivian Salazar Quevedo
Memorial Award Banquet

CHAW
The Woman of the Year
AWARD
&
The Melendez-Mederos
Scholarships

can tell you, the tactile experience of opening and leafing through something is an alluring experience we all eagerly respond to. Die cuts have a similar effect; what might be a simple circle seen through a square hole on the cover could be absolutely anything once the cover is pulled back. If there are several pieces to the invitation, make sure to devise a way to keep those pieces in the order in which they should be viewed. Ribbons, twine and other binding material work well, as do slots in the outer card.

advertising

GROUNDWORK

SOLICIT ONLY THOSE WHO MAY BE INTERESTED IN THE MERCHANDISE YOU ARE attempting to sell. This is true of any direct-mail piece. Paying for a mailing list is an efficient way to target those who would be most inclined to buy the product or service you are advertising. Although this is more a job for your client's marketing department, it would help to inquire about it early on. This information will help define your client's niche market and thus allow for a more selective design approach on your part. It also shows your client that you are astute in this regard and may ensure possibilities for a long-term relationship.

Another important consideration that is often handled by a person other than the designer is the issue of writing the advertising copy, especially the display copy that appears on the outside of the mailer or on the panel the consumer first sees. The quantity of junk mail the average person receives on a daily basis has led to the scan-and-trash response most people have with their mail. Design obviously has much to do with whether or not a person will open a piece of mail, let alone read its contents. But the wording of the sales pitch alone is enough to make or break a possible deal. Ask to see the copy, and do not be afraid to offer suggestions as to possible changes, especially when it comes to the words or phrases that should be stressed more than others.

This kind of interaction with a client requires tact and a gentle hand on the designer's part, as the copy may or may not have been through extensive revisions to begin with. Your suggestions should come only after you are sure you understand the scope of the project thoroughly. Do not begin making suggestions after only scanning the material; this will only lead to unnecessary confusion.

Ask if photographs will be used, and determine who will provide them. Determine how much money has been earmarked for printing; will it be a full-color job, and is the client open to customized processes like embossing, metallic ink, die cutting and the like? Also find out what kind of envelope, if any, will be used and how open the client is to custom formats. These are all matters of cost. The larger the client, the larger the budget and the more likely the client will be willing to spend money on such specialized processes. Make sure the printer you select is capable of performing these required production-related services, and find out the cost immediately.

Clarify with your client before you begin

+ **Is the direct-mail piece a part of a larger marketing plan?**
+ **Has the advertising copy already been written? If not, how soon can you get it in your hands?**
+ **Who is the target audience for the piece?**

A square format will stand out from the rest of the mail in your mailbox. This particular advertisement makes use of small noise-makers glued between the panels. The theme of the piece is made clear in the cover headline—the concept of hearing. This theme is cleverly carried through to the inside copy ("It Sounds Like"), where the noise-makers are positioned in the top and bottom corners. Note that they are clearly marked without being an intrusive graphic element to the design.

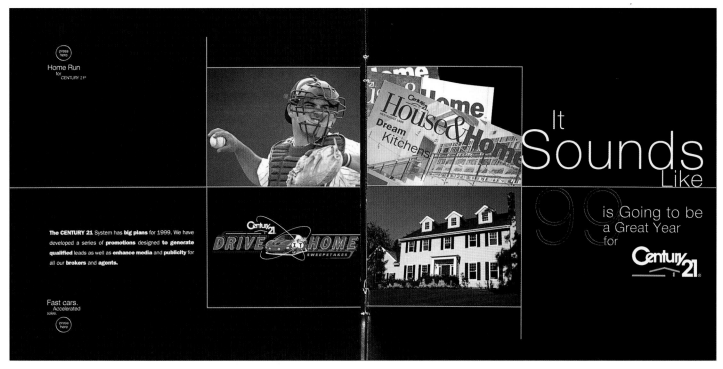

When working with the second, more subtle, approach, entice the viewer into opening the piece by presenting a mystery or a question that begs to be answered. This method is more demanding on the designer because a teaser must work in a way that takes advantage of wit, whereas the first method is a simple matter of screaming about the value of the product or service.

This is the time to work with the copy editor in order to make sure the teaser is concise and to the point. Everything should work in a way that creates a quick and easy flow from the initial pitch to the fine print. The fewer words, the better. A teaser that requires too much time to read or to comprehend will lose a potential consumer as quickly as the most poorly designed solicitation. If you decide to attempt a witty approach, the special nature of what the solicitation is offering must be made clear quickly.

Everything should work in a way that creates a quick and easy flow from the initial pitch to the fine print. The fewer words, the better. A teaser that requires too much time to read or comprehend will lose a potential consumer as quickly as the most poorly designed solicitation.

Determine what information needs to be read first, then focus your visual hierarchy on replicating that sequence. Make sure the path the eye follows through your design serves to deliver the information clearly. As with any other project, work with a tight-knit selection of typefaces, and use color not only to highlight important information but also to unify the entire piece as well. If the advertisement comes in a format that requires folding of any kind, make sure the copy and the imagery are not disrupted by the scores in the paper.

If the advertisement is for a product, the possibility of including a small sample or a coupon for the product always exists. It's one thing to advertise a special savings, but consumers often respond more readily when they have something concrete in their hands. Samples often require something more substantial than a flat envelope, so the issue of a box mailer—discussed in chapter 19—may need to be addressed.

DESIGN

There are two distinct and somewhat contradictory approaches to designing a direct-mail advertisement. The first is to make sure that the recipient can immediately assess the unique value of the product or service that is being featured. This is usually achieved by presenting the price or the special value as the most dominant element on the outside panel—so dominant, in fact, that no one could ever miss it.

This is a very common approach within the industry. The theory goes that the louder you scream, the more likely someone will hear it. This can be successful with certain people, but it can just as quickly turn away other people. When people believe that an offer is too aggressively pushed, they may dismiss it altogether and toss it into the garbage. Advertisements that fit this first description frequently disregard aesthetic issues for the sake of the loudest possible sales pitch.

The second method relies on teasing the recipient in a fashion similar to what was discussed in the chapter on invitations. This technique requires a more subtle approach, and it often works well with educated audiences who have grown tired of being screamed at by advertisers. Knowing your target audience and understanding its likes and dislikes will help determine which approach will work best for your particular advertisement.

When working with the second, more subtle, approach, entice the viewer into opening the piece by presenting a mystery or a question that begs to be answered. This method is more demanding on the designer because a teaser must work in a way that takes advantage of wit, whereas the first method is a simple matter of screaming about the value of the product or service.

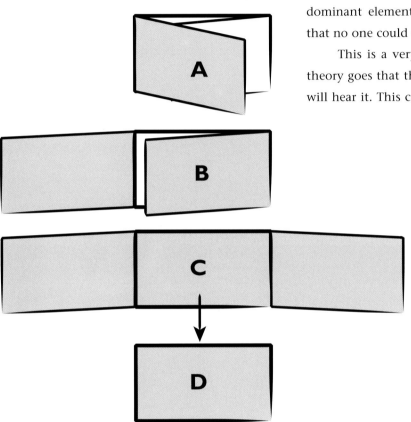

A direct-mail advertisement may make use of different folds to enhance and expand on the message inside, and to allow for a perforated return card to be part of the design. You may choose from a variety of folds including gatefolds, z-folds, and accordian folds—the names are self-explanatory. Check with your printer to see if he is able to handle the fold you choose. Both the size of the press and their off-line capability of producing the fold after the piece is printed can determine which design you choose. The example shown here illustrates one way a direct-mail piece can be designed with a separate card insert for the return piece.

Direct-mail advertising can be brash and aggressive or, as in this case, it can be more subdued. A series of holiday cards have been created as a way to invite the recipient to join the bank. Many people are looking for banks that are willing to pay more personal attention to them, and these cards, with their quaint illustrations and their textured paper, are inviting and reassuring. Creating a full series of them insures a consistent message over the course of the year and reiterates the company's sense of priority to its customers.

HAVE A SUNSATIONAL SUMMER!

. . . without having to worry about your finances.

Your NationsBank Professional & Executive Banking Team appreciates your business and the opportunity to serve you.

Please let us know if we can be of service to you today.
Please let us know if we can be of service to your friends and associates.

NationsBank®

 *THIS WINTER,
WE KNOW YOU HAVE
SWEETER THINGS ON YOUR MIND
BESIDES BANKING.*

That's why it's so important to know that you can always rely on your Premier Banking Team.
We are dedicated to seeing that all of your financial needs are met
during this season and in the seasons to come.

Thank you for giving us the opportunity to serve you.
Please don't hesitate to call on us whenever we can be of assistance.

Bank of America
Premier Banking

17

solicitations

GROUNDWORK THE DESIGN CONSIDERATIONS THAT WERE ADDRESSED IN THE PRECEDING chapter on direct-mail advertisements can also be applied to direct-mail solicitations. The one true distinction between the two is that a solicitation is more direct in its request for consumer interaction. Whereas an advertisement is often content to say its piece and then be done, a solicitation makes a direct appeal for some kind of response from the recipient. The most common solicitations come in the form of questionnaires, reply cards, coupons, rebates and free sample offers.

The reasoning is that if recipients take even an extra minute to fill something out, they are more apt to remember the product name. Packaging works in a similar fashion in that it calls out to be held and turned around in the hand. The mere act of reaching out to touch represents a willingness to consider, and in the case of a reply card the mere act of filling it out and sending it back represents that same willingness to consider. It is as close to an interactive experience a printed direct-mail piece can get.

When considering the use of a direct-mail solicitation, make sure you understand your client's objectives. Offer alternative reply card ideas, and make sure you acquire all the typographic information the reply card needs to hold. Designing these cards can be more of a challenge than one might first expect, as they are often no larger than a postcard and the client is looking to cram as much information as possible into that limited space.

Incorporating these reply cards into the original mailer is also a serious consideration. Some mail-order pieces make use of loose inserts, whereas others use a perforated edge to differentiate the reply card from the material the recipient should retain.

Odds of consumer response increase dramatically with postage-paid response cards. Find out early if this is what your client has in mind, because the client will need to pay ahead of time for a postage-paid code, and you as the designer will need to present that code clearly within a postage-paid box printed in the upper right-hand corner where stamps are usually placed.

Clarify with your client before you begin

✦ **What is the nature of the solicitation—a rebate offer, a coupon, a free sample, or something else?**

✦ **How many printed pieces will be included in the solicitation?**

✦ **Has the client considered using a self-mailer?**

Spirit *of* Living Campaign

I/we support the mission and vision of Hospice Savannah's Spirit of Living Campaign, and would like to contribute $_____ to be paid over _____ year(s).

THIS COMMITMENT WILL BE MADE BY:
(Check all that apply.)

❏ Cash
❏ Appreciated Assets: *(real estate, stocks, bonds, collectibles, etc.)*
❏ Charitable Trust
❏ Gift Annuity
❏ Life Insurance
❏ Arrangements in My Will

❏ Other: _____

ENCLOSED IS A CHECK, OR I/WE PLAN TO MAKE PLEDGE PAYMENTS.

❏ Monthly
❏ Quarterly
❏ Annually

❏ Other: _____
❏ Date of First Reminder: _____

NAME _____

ADDRESS _____

CITY _____ STATE _____ ZIP _____

PHONE _____

SIGNATURE _____ DATE _____

Through your generous support, Hospice Savannah will be able to meet the growing community needs for helping people face death with dignity, comfort and support. Gifts to Hospice Savannah, Inc., are tax deductible to the extent allowable by law.

annah, GA 31416 | 912.355.2289

HOSPICE
SAVANNAH

For solicitations of a serious nature the use of humor or intrigue is rarely appropriate. In such cases, clean elegant designs work very well. The example on this page is a two-color job printed on a textured card stock.

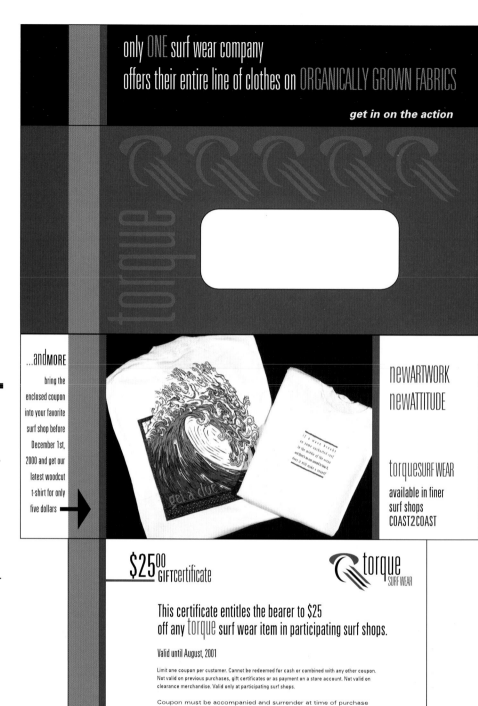

only ONE surf wear company
offers their entire line of clothes on ORGANICALLY GROWN FABRICS

get in on the action

torque

...and**MORE**

bring the
enclosed coupon
into your favorite
surf shop before
December 1st,
2000 and get our
latest woodcut
t-shirt for only
five dollars ➡

new**ARTWORK**
new**ATTITUDE**

torque**SURF WEAR**

available in finer
surf shops
COAST2COAST

$25⁰⁰ GIFT**certificate**

torque
SURF WEAR

This certificate entitles the bearer to $25
off any torque surf wear item in participating surf shops.

Valid until August, 2001

Limit one coupon per customer. Cannot be redeemed for cash or combined with any other coupon.
Not valid on previous purchases, gift certificates or as payment on a store account. Not valid on
clearance merchandise. Valid only at participating surf shops.

Coupon must be accompanied and surrender at time of purchase

The example on this spread
makes intelligent use of paper stock by
incorporating a window for a delivery
address and a detachable store coupon.
The diagram below shows how this direct-
mail solicitation can fold in on itself so the
panel that has the delivery address can be
seen through the window on the front
panel. A simple adhesive label is used for
the closure.

By placing the delivery address on the
back of the coupon, which must be surren-
dered at purchase, the company can com-
pile consumer spending information in an
efficient manner.

Notice how both the company name and
the details of the special offer are
repeated on several panels in order to
create consistency in design and product
recognition.

Only one type family has been used. The
logo makes use of Univers 39 (Thin Ultra
Condensed). Since Univers has a wide
array of condensed, extended, bold and
thin faces, it is easy to use only Univers
and still create a design that is engaging.

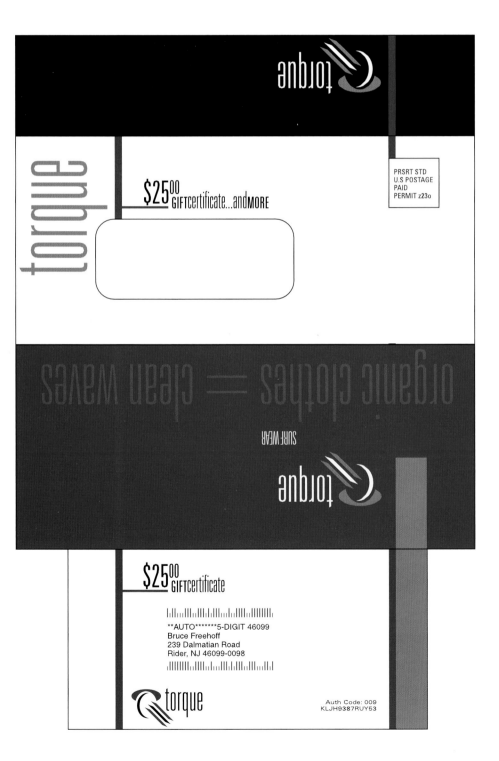

DESIGN

Since efficient use of space can save a substantial amount of money, determining the overall format of the solicitation is a high priority. Some solicitations come in the form of a personalized letter from the CEO or president of a company. These are often sent within an envelope, and they make use of a loosely inserted reply card or donor card. Although this type of solicitation may cost more money in the form of numerous sheets of paper and envelopes, it often saves money in the area of printing by using only two colors: black ink for the contents of the letter and a second ink for handwritten notes directed specifically at the recipient. If this is the kind of solicitation your client has in mind, ask the CEO or president to write the personalized information in longhand rather than use a font that simply looks handwritten.

Self-mailer solicitations require no envelope. But you must be more creative when designing the format because you do not have the luxury of an envelope to contain any extra sheets of printed material. The layout of the mailer needs to address this shortcoming, as well as the loss of an entire panel which is dedicated to delivery information. Your design must be mapped out with the use of a perforated section in mind, so that

Self-mailer solicitations require no envelope. But you must be more creative when designing the format because you do not have the luxury of an envelope to contain any extra sheets of printed material.

nothing can slip loose in the course of its journey through the mail.

As a budgetary consideration, explore standard page sizes for the solicitation. An 8½″ × 11″ (21.59cm × 27.94cm) can be folded either in half or in thirds. Both of these can then be stuffed into standard-sized envelopes or used as a self-mailer. For a solicitation that holds more information, an 11″ × 17″ (27.94cm × 43.18cm) can be folded in half and used as a booklet, which can then be folded further as described above.

Coupons can either be loose inserts or attached to the solicitation by way of a perforated score. When including a coupon, remember that it plays an important role in the entire piece, and design time is required to make sure that it works with the rest of the solicitation.

Also, coupons require legal disclaimers and expiration dates, so make sure you receive all of the typewritten information from your client early. When designing a reply card or questionnaire, allow for ample space for handwriting. Leaving small spaces will only cause problems with legibility.

Because a solicitation is straightforward in its particular request, this is another good time to sit down with the copywriter to clarify the most important part of the message. The phrase "We need your HELP," carries a message different from the same phrase with a different stress: "We need YOUR help." Be careful not to design such display copy without fully understanding your client's goals.

A tri-fold, letter-sized self-mailer is very cost efficient and easy to use. A major consideration is whether the inside of the mailer is printed reading right side up (A) so the paper simply needs to be turned from side to side, or upside down (B) so that the paper needs to be flipped vertically in order to be read properly. This can be more of a challenge than you may first think, especially, as in the example on the opposite page, a section needs to be torn off and returned. Make sure the back of the tear-off section does not contain information that the person receiving it needs.

APPLY
STAMP
HERE

SAVANNAH CIVIC CENTER
BOX 726
SAVANNAH, GEORGIA 31402

Your SAVANNAH HOST FACILITIES *invite you to join them at the*
DISTRICT V MIDDLE MANAGERS CONFERENCE
to be held JUNE 20-22 *at the* SAVANNAH CIVIC CENTER
located in the downtown, historic district.

There are EXCELLENT EDUCATIONAL SESSIONS *as well as*
NETWORKING OPPORTUNITIES
that can ONLY *be done* SAVANNAH STYLE*!*

SAVANNAH HOST FACILITIES

SAVANNAH CIVIC CENTER
SAVANNAH INTERNATIONAL CONVENTION & TRADE CENTER
THE SAVANNAH COLLEGE OF ART & DESIGN'S TRUSTEES THEATER

HOTEL REGISTRATION

A block of rooms is reserved at a special IAAM discount rate of $99 plus tax.
Check in time is after 4:00 pm

HILTON SAVANNAH DESOTO
15 EAST LIBERTY STREET
P.O. BOX 820
SAVANNAH, GEORGIA 31412
(912) 232-9000 FAX (912) 2
1-800-HILTONS

If phoning in your reservation, please indicate that you are a
the IAAM Conference. IMPORTANT: Make your reservatio
Availability and rates are only guaranteed prior to May 27th.

This example is a two-color job
that uses tints and an even dispersion of the
secondary color to make for a more interesting
design. A one-column grid is used with a wide left-
hand margin to structure the page and allow for
adequate white space. Only two fonts have been
used, with each typeface assigned a
specific organizational role.

CONFERENCE SCHEDULE

SUNDAY, JUNE 20TH

| 2PM | Registration | Hotel Lobby |
| 6PM | Opening Reception | Historic District |

MONDAY, JUNE 21ST

8AM-5PM	Registration	Savannah Civic Center
8-9AM	Breakfast	
9:15-10:30AM	Opening Session ~ Sponsorship/ Marketing	
	Matt McDonald, Mississippi Coast Coliseum	
10:30-10:45	Break	
10:45-11:45AM	Concurrent Sessions/Panel Discussions	
	A ~ Ticketing: Today & Tomorrow	
	B ~ Energy Management	
12AM-1PM	Lunch	
1:15-2:15PM	Concurrent Sessions	
	A ~ Creating an Effective Web Site	
	B ~ Preventive Maintenance	
2:15-2:45PM	Break	
2:45-3:45PM	Public/Private Partnerships	
	Mark Leahy, Savannah International Convention & Trade Center	
6PM	Buses Depart for Beach Party	

TUESDAY, JUNE 21ST

10-11AM	Maximizing Your Tech	
11-12	Tour Savannah's Theaters and Theater District	
12:30-2PM	Hard Hat Tour ~ Savannah International Convention & Trade Center	
	Part 1: Construction Safety Part 2: Working with the Architect	
	The Hard Hat Tour includes Lunch	
6PM	Buses Depart for Closing Reception	

GENERAL INFORMATION

AIR
Savannah International Airport is serviced by Delta, Air Tran, Continental Express
US Airways and United Express.

RENTAL CARS
Most major rental companies have counter service at Savannah International Airport.

DIRECTIONS
From the airport: Take I-95 South to I-16 East. I-16 East ends in downtown Savannah.
The first traffic light is the corner of Liberty and Montgomery Streets. Turn Right onto
Liberty Street at this light. The Hilton is 3 blocks on your right.

WEATHER
The average high in Savannah in June is 89& with a low of 68&.

HOW TO DRESS
All functions are casual dress, with the exception of the Monday Night Beach Party;
your ugliest Hawaiian shirt will be required. Comfortable shoes for walking and a sweater
or jacket for air-conditioned meeting rooms.

CUT ALONG DOTTED LINE AND SEND OR FAX THIS FORM TO THE BELOW ADDRESS

This example was designed vertically
so that it must be turned to be read prop-
erly from one side to the other. Thus, the
form can be torn off, filled out and sent
back without losing any important infor-
mation. Note: the back of the form section
is the address panel.

CONFERENCE
REGISTRATION FORM

SAVANNAH CIVIC CENTER
BOX 726
SAVANNAH, GA 31402
TELEPHONE: 912.651.6550
FAX: 912.651.6552

LAST NAME_____FIRST NAME_____MIDDLE INITIAL_____
FACILITY/COMPANY_____
ADDRESS_____
 STREET/P.O. BOX
TELEPHONE_____FAX_____E.MAIL_____
☐ GUEST/NAME_____ INDICATE YOUR SHIRT SIZE: M ☐L ☐XL☐
NOTE: BUSINESS ASSOCIATES DO NOT QUALIFY AS PERSONAL GUESTS.
INDICATE DISABILITY OR ANY RELIGIOUS OR DIETARY RESTRICTIONS_____

METHOD OF PAYMENT

	Early Bird Discount (if post marked before 5/20/99)	Regular Fee (if post marked after 5/20/99)	
MEMBER	$150	$175	_____
GUEST	$75	$95	_____
TOTAL REGISTRATION FEES			_____

CARD HOLDER _____
CARD NUMBER _____
EXPIRATION DATE _____
☐ VISA ☐ MASTERCARD
SIGNATURE _____

I/WE WILL PARTICIPATE IN THE FOLLOWING EVENTS

			MEMBER	GUEST
SUNDAY, JUNE 20	6PM	OPENING RECEPTION		
MONDAY, JUNE 21	NOON	LUNCHEON		N/A
	6PM	BEACH PARTY		
TUESDAY, JUNE 22	12:30	LUNCH WITH TOUR		N/A
	6PM	CLOSING RECEPTION		

Make checks payable to: IAAM District Conference. Return this
registration form and payment to the address to the left. Faxed
registrations MUST include credit card information and must be signed.
Requests for refunds must be received in writing prior to 5/20/99 for a
full refund less $30 processing fee. No refunds after 5/20/99.

123

18 self-promotion

GROUNDWORK | DESIGNING A SELF-PROMOTION MAILER COULD VERY WELL BE THE MOST FUN a designer will ever have at work in that such a piece exists for no other reason than to delight the target audience. The primary goal here is to create an immediate and visceral impact on whoever receives it. Whether it is a short run of hand-constructed pieces or a larger mass mailing, a self-promotional piece works best when it stops in his tracks anyone who picks it up. Witty presentations with wordplay or visual puns work extremely well, but that is not to say that your self-promotion piece cannot be of a serious nature.

The groundwork for such a project can be whittled down to a single word: Think. This piece is about you—who you are and what special talents and skills you can provide clients and potential clients. Determine what the essence of your professional and personal philosophies is. Then find a unique way to express those philosophies. The final piece should reflect your ingenuity, but it does not have to overstate it. In fact, if your piece comes on too much as a hard sell and not enough as an object of entertainment and amusement, it may very well end up in the trash with the rest of the junk mail.

Determine what your budget is and how many people you want to reach. If you are doing a mailing of 1,000, for example, and you are on a tight budget, the chances of your creating a three-dimensional pop-up that unfolds from a brushed metal case are pretty slim. Before you commit to any potentially bulky piece, find out how much the postage will cost. But don't worry, a simple 5″ × 7″ (12.70cm × 17.78cm) card imbued with enough wit and ingenuity will go as far as anything else.

Designers who are illustrators, photographers, or animators or who are talented in any other related field would be wise to incorporate evidence of these talents into their promotional piece. CD-ROMS are so inexpensive to buy and burn these days, it may be wise to begin with a mailer that can hold one. If the outer package is alluring, chances are the person who receives it will be excited to see what else there is. (Refer to chapter five for more information on CD packages.)

Clarify with your client before you begin

- ✦ **What kind of budget is available?**
- ✦ **Will it be primarily a print piece or a construction?**
- ✦ **How much original artwork of the artist will it feature?**
- ✦ **How many pieces will be printed?**
- ✦ **What talents and skills are you trying to convey?**

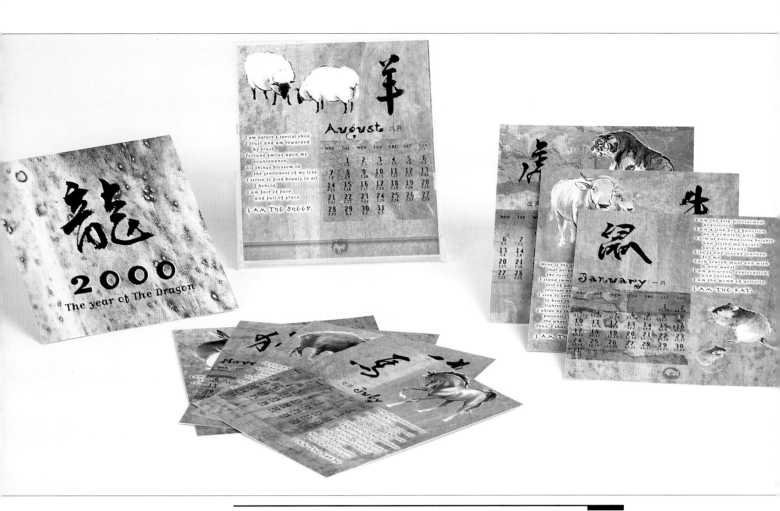

Incorporating a functional item into your self-promotional piece
as with this calendar gives your client a reason to hold on to your work and display it. If it is designed well, anyone who sees it may ask about its origins, and this in turn may have clients coming to you rather than the opposite. The designer's name and number are on the back of each card for easy reference.

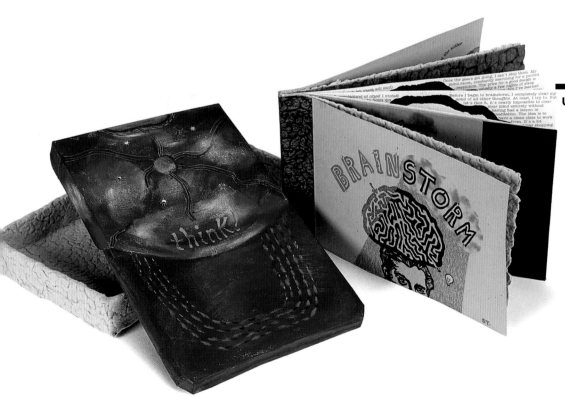

Using your own illustrations
and your own constructions and bookbinding techniques shows the individual to whom you are sending your work that your talents are not limited to simple two-dimensional design work.

Your primary goal is to design something that begs to be shown to someone else. Creating a piece that will remain in an office for a long period of time will do more for name recognition than any number of skillfully placed advertisements.

DESIGN

What would prevent you from throwing away a piece of mail that would otherwise blend in with the rest of the load of junk mail you receive on a daily basis? That's right. Your work begins with the package it is sent in. Even if it is nothing more than an envelope or a self-mailer, what is seen on the outside of the piece will determine who, if anyone, ever sees what's inside.

Your primary goal is to design something that begs to be shown to someone else. Creating a piece that will remain in an office for a long period of time will do more for name recognition than any number of skillfully placed advertisements. Think about items that are used on a daily basis in places such as your targeted client's office or studio. Even items like toys, games, calendars (spiral bound or otherwise), matchboxes or any other inexpensive piece of merchandise are all possibilities. A set of candles is a functional gift that could also be the foundation of many strong concepts. No matter what items you choose, show respect for the individuals who have received it. Subtly reiterate your name and design capabilities while offering the piece primarily as a functional item.

The item you choose to include should incorporate design work that you have done. A calendar, for instance, can easily show your ability to be creative within a somewhat standard format. It also provides you with the opportunity to show 12 pieces of your work, which—coincidentally—is an appropriate number of pieces for inclusion in a portfolio, showing a full range of your work.

design: erdodi

7 42709 10018 5

image

Designers are often talented beyond the realm of graphic design. The examples on this page are a small sampling from a book of photography by an individual who considers himself primarily a graphic designer. He has designed several self-promotional books and sends different ones according to what the client may be looking for. A book of photographs serves a dual purpose in this case. It features both photography and design work in the form of book layout.

index orders

all photographs are available by order
contact *john erdodi*
email: *uspa@aol.com*
to place an order: send request via email for mailing address and price list

erdodi 2000 ©
all rights reserved by applicable copyright laws
no reproduction or exhibition without written consent by erdodi

image

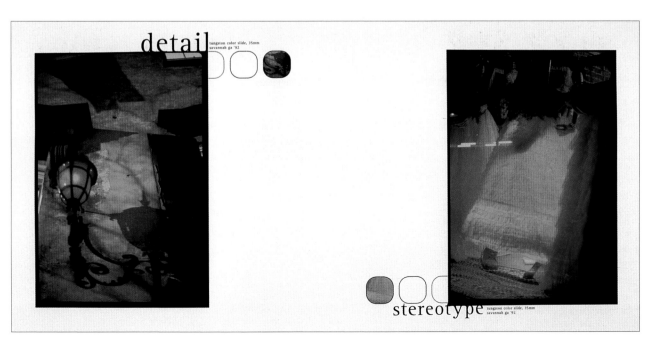

detail tungsten color slide, 35mm
savannah ga '92

stereotype tungsten color slide, 35mm
savannah ga '92

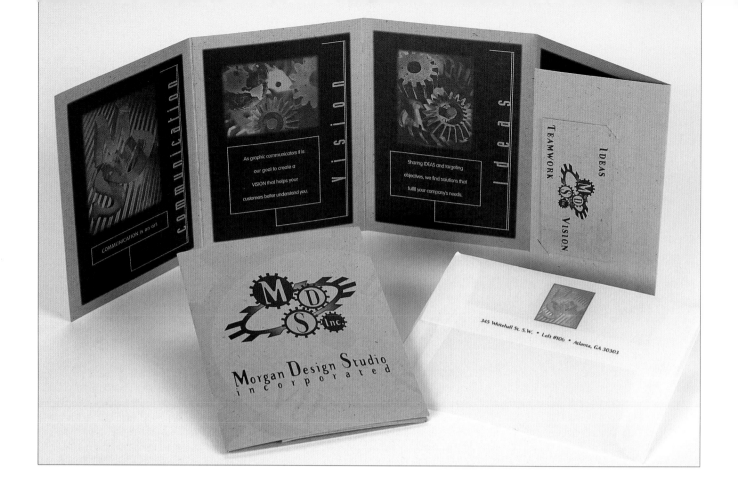

Within the image:
- communication
- COMMUNICATION is an art.
- MDS
- vision
- As graphic communicators it is our goal to create a VISION that helps your customers better understand you.
- ideas
- Sharing IDEAS and targeting objectives, we find solutions that fulfill your company's needs.
- IDEAS
- TEAMWORK
- VISION
- MDS Inc.
- MDS Inc
- Morgan Design Studio incorporated
- 345 Whitehall St. S.W. • Loft #106 • Atlanta, GA 30303

Your concept should flow through the entire piece.
This example shows how an industrial analogy for creativity begins with the logo and is carried through in a sophisticated two-color job. The paper stock is rough-hewn and textured, and the silver ink used for the second color enhances the overall concept.

Another way of keeping your name in circulation is to send a postcard that reiterates your initial concept one week after the original promotional piece. Or send a series of pieces that tell a story. Or, possibly, leave the recipient hanging with the first piece, and send the "punch line" a week later. There are many ways to create genuine interest, but a truly unique approach will not jump up and bite you. Give yourself enough time to develop an idea that will realize the full potential such a piece offers.

Promotional pieces do not need to be expensive. In no situation should creativity be limited by finances. Remember what Alexander Pope said: Brevity is the soul of wit. This philosophy can be applied to all facets of self-promotion. Doing more with less, in fact, may leave the lasting impression you are hoping for. Working within a limited budget can show resourcefulness and an unwillingness to be hindered by mitigating circumstances.

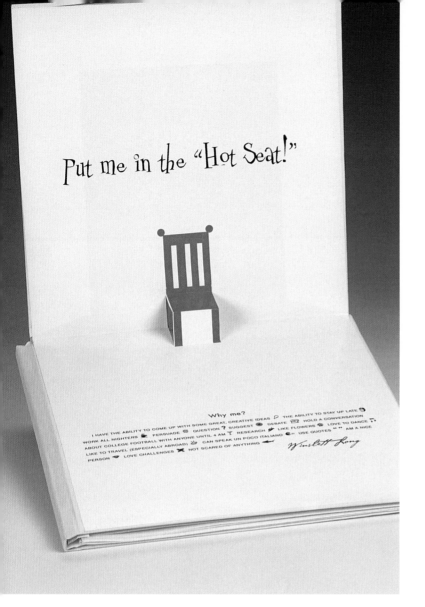

Put me in the "Hot Seat!"

Why me?

I HAVE THE ABILITY TO COME UP WITH SOME GREAT, CREATIVE IDEAS ✏ THE ABILITY TO STAY UP LATE 🌙
WORK ALL NIGHTERS ☕ PERSUADE 🗣 QUESTION ❓ SUGGEST 💬 DEBATE 📣 HOLD A CONVERSATION
ABOUT COLLEGE FOOTBALL WITH ANYONE UNTIL 4 AM 🏈 RESEARCH ✒ LIKE FLOWERS 🌸 LOVE TO DANCE 💃
LIKE TO TRAVEL (ESPECIALLY ABROAD) ✈ CAN SPEAK UN POCO ITALIANO 🇮🇹 USE QUOTES " " AM A NICE
PERSON ☺ LOVE CHALLENGES ✖ NOT SCARED OF ANYTHING ➜ *Winslett Long*

The overriding theme for a self-promotional piece should be bold in nature and consistently carried out through the entire piece. This example makes excellent use of a familiar phrase and strong visual in the form of a red chair. The table of contents is literally just that: a pop-up table. Although pop-up and novelty books are very labor intensive, they are a portfolio piece in their own right and show potential clients (or employers) that your creativity is not necessarily confined to a keyboard and a mouse.

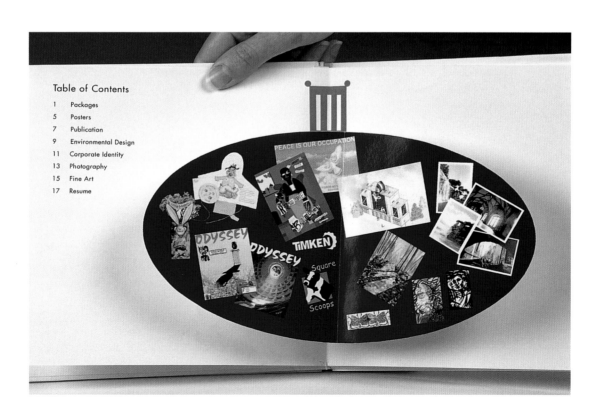

Table of Contents

Make sure that the color scheme of the packaging and any
mounting material are interesting in their own right without being so bold
or distinctive that they detract from the work itself. If there are various
sizes and shapes, make sure paper texture and color are unified throughout.

MISTY'S BOOK-1994

I created *Misty's Book* for an
experimental art class at the
University of West of Florida. This
book untilizes a variety of die cuts,
folders, sliding pieces, plus other
innovative design techniques. The
book includes self exploration and
historical references to my past. I
used several images from actual
photographs of friends and family,
magazine pictures and famous art
work xeroxes. The book is all
hand mad and bound carefully by
hole punching each page and
inserting nineteen loose leaf bind-
ing rings on the outer left edge.

What better way to flaunt your talent as a book designer than to create a book that features the books you have already designed? Each page in this example shows a photograph of a handcrafted book and a short explanation of its contents. Constructing a book that serves as a portfolio has allowed the designer to show off her craftsmanship abilities as well as her design ideas.

box mailers

GROUNDWORK

THE FIRST STEP IN THE PROCESS OF CREATING A BOX MAILER MUST INCLUDE the question: *Why?* Why go through the prohibitive expense of additional postage, materials and design work when a flat mailer is more economical? The answer should have everything to do with your concept. The research and development stage for designing a box mailer should involve an extensive assessment of what your client is trying to achieve with the package. Determine these objectives at the outset, then explore the possibilities for packaging, from standard mail tubes and cardboard boxes to wooden crates and customized constructions. There are many simple box constructions that are readily available and perfectly adequate for most jobs. But there are also some truly ingenious constructions that are a gift in their own right, and going beyond the obligatory search for materials can often pay off in unexpected ways.

Make sure you have many possible solutions to show your client in the round. A box mailer is a hands-on experience, and a client must be able to partake in this experience in order to make an informed decision. Take care to investigate the cost of postage for each sample you bring to your client, determine how many units the client will need, and investigate bulk-rate specifications.

Before the size of the package can be finalized, it is important to determine just how much room is necessary for the materials that will be enclosed. Box mailers almost always include printed material of one kind or another. Sometimes this involves nothing more than a hangtag attached to a promotional gift. Other times it may be an entire catalog or a CD-ROM kit.

Whatever the case may be, the following piece of advice should sound very familiar by this point: Get all of the required copy from your client early in the process. Using a standard box construction will save money only if its overall size is not too large in relation to its contents. Although the post office bases its rates on weight, it will add charges for oversized packages, so make sure the size of the box is appropriate for the materials being sent.

Clarify with your client before you begin

✦ **How large of a construction is required?**
✦ **How many box mailers will be sent out?**
✦ **What, other than the printed material, will be included in the box mailer?**

The designer may also be asked for input as to what additional items should be included in the box mailer. At times the box is used to hold nothing more than a sample of a product. At other times it may hold large quantities of printed materials, a unique gift, or a nondescript object that serves to take the original theme further, such as a lightbulb for a self-promotional piece or a mouse for a

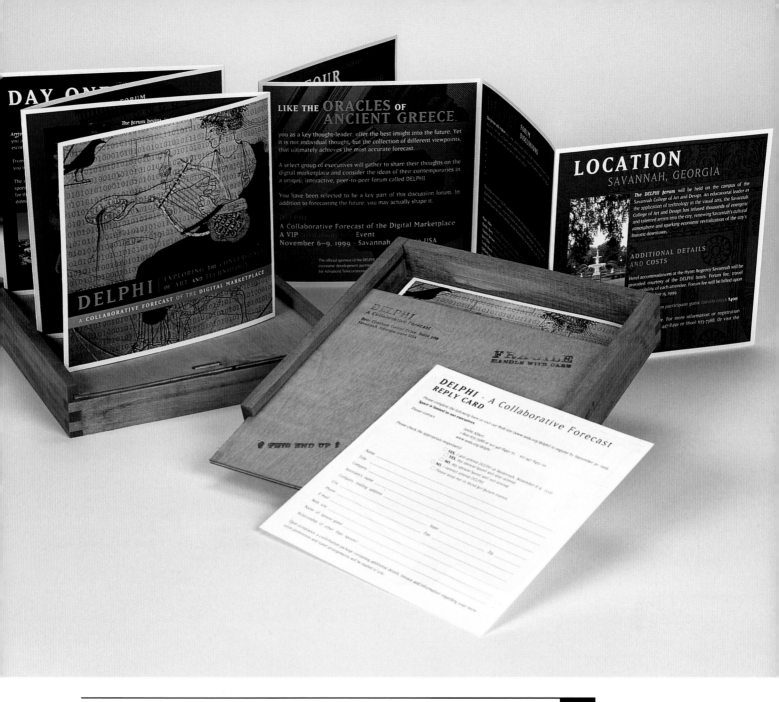

Box mailers provide the designer with many forms of creative exploration,
beginning with the box itself. As long as the client can afford it and the construction is capable of being
sent through the mail, the box can be almost anything. Once the size, proportions and materials are
defined, the format of the printed material can be custom designed to fit the specifications of the box.
In this case, the square format of the wooden box was a major influence on what the printed material
would look like.

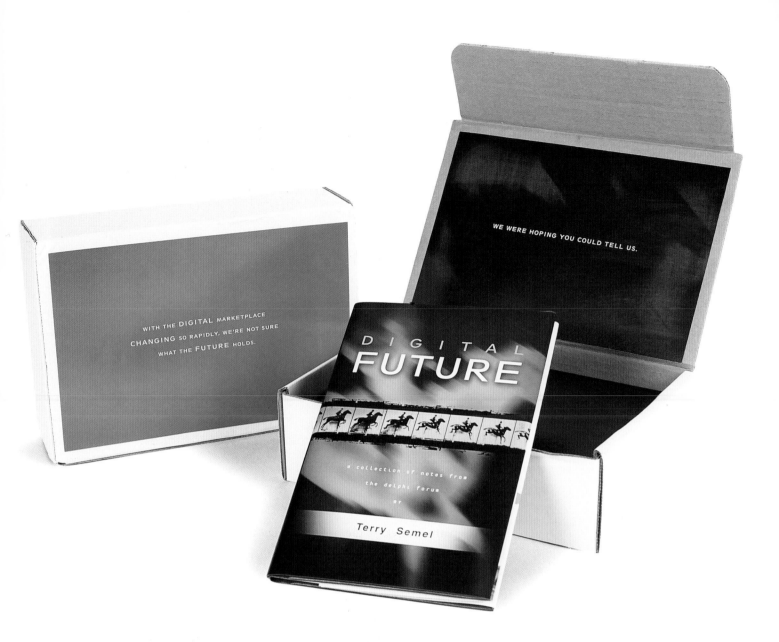

In order to make the attendees to this conference feel more personally involved (above), the entire package is geared toward soliciting the recipient's input. Along with the direct appeal on the inside cover, the box includes a blank notebook that the recipient can use while attending the conference. The notebooks have been personalized by the inclusion of each individual's name on the cover.

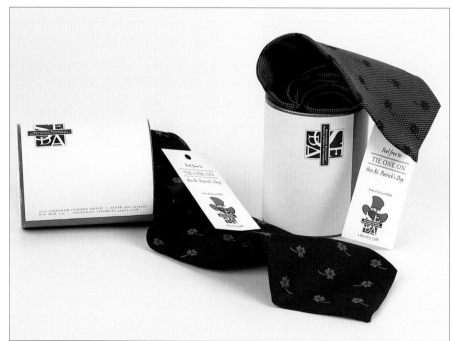

A package is always more exciting to receive than a flat envelope. It sets expectations for something more than the average piece of mail. As a designer, you must make sure that those expectations do not fall flat once the box is opened.

computer company solicitation. Whatever the case may be, the box mailer must provide adequate protection for the merchandise enclosed. This protection can come from the construction itself or from the use of bubble wrap or other wrapping material.

DESIGN

Take full advantage of the surfaces on the outside of the box. As with direct-mail advertisements and solicitations, offering a riddle or a tease of some kind on the outside will generate more interest and anticipation from the outset. If the outer package is something that cannot easily be printed on, consider using self-adhesive labels that carry the printed information.

When designing the outside of the package, also make sure you have incorporated a return address and adequate space for postage. Give ample space for the recipient's address, which is most frequently printed on a label and then adhered to the outside of the box. Few things look worse on a customized package than a label that inadvertently covers up artwork that was intended to be seen or read. Being aware of the size and proportions of the address labels will allow you to design the front of the package in a unified and well-planned manner.

A package is always more exciting to receive in the mail than a flat envelope. It sets expectations for something of more value than the average piece of mail. As a designer, you must make sure that these expectations do not fall flat once the box is opened. If the budget allows, make use of all printable surfaces, even if it means screening the inner panels of the box.

If there are several printed pieces enclosed within the box that are of different shapes or sizes, make sure this

Box mailers can take advantage of standard constructions as with the use of this truncated mail tube (opposite page). Tubes come in a set of standard colors, one of which happens to be a kelly green, so no additional costs were incurred for printing the tube.

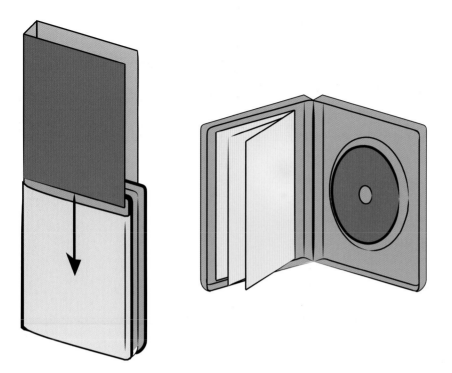

Fig. 23

CD-ROMs are an inexpensive
yet versatile way to feature any company's service or merchandise, and prefabricated box mailers for them have become common. The example above is made from rigid plastic for protection and opens up like a book. A clip is built in for a tight closure that can be used more than once. Other convenient features include a clear plastic sleeve on the outside that accommodates a sheet of paper, which can be printed by traditional means, and space on the left side of the open box for more printed material such as a catalog, brochure or instructions.

discrepancy does not detract from the overall presentation. All of the separate pieces should fit together like those in a puzzle. Be certain that the contents are secured to prevent en-route shifting that might otherwise shuffle the material. The use of a tie of some kind—as long as it goes along with the theme—or a raised platform will usually suffice.

Make sure your color scheme is consistent throughout. This may at first seem simple enough, but if the work is being printed on different stocks (on the inside of a paperboard box and on a catalog enclosed within the box, for example) the differences in absorbency, texture and finish will affect the quality of the color. What may appear blue on a shiny coated stock may look purple on an uncoated stock. Sometimes base printing white over coarse or uncoated stocks before printing the final color will prevent this from happening. Just to be sure, ask your printer about possible color matching problems if you are printing on different stocks.

When it comes to the outer construction, think of ways to make it an integral part of the gift itself. Some cartons can easily be disassembled and constructed inside out, and this could allow for collateral items such as game boards, calendars or three-dimensional posters to be printed on the inside of the carton. Of course, this can be quite a challenge, and it can also add a substantial cost to the budget, but its potential impact may be worth it. Explore other ways to ensure that the box itself has some kind of functional life after it has served its original purpose as a box mailer.

CD-ROMs have become so commonplace over the last several years that mail cases for them are easy to come by. Figure 23 shows an example of one that is especially versatile. Along with being shockproof, waterproof and inexpensive, it is also large enough to accommodate printed information other than the actual CD-ROM. A snapping mechanism assures a secure closure without need for adhesives or ties. And as a way to eliminate the cost-prohibitive process of printing directly on the package, a clear plastic sleeve acts as a window that reveals the delivery information (and plenty of advertising copy) that can be printed on paper and slipped under the sleeve.

larGe-scale projects

signage

billboards

trade show booths

signage

GROUNDWORK

SIGNAGE CAN BE BROKEN DOWN INTO TWO BASIC CATEGORIES: ADVERTISING signage and informational signage. Advertising signage plays a role similar to the role of billboards, only on a smaller scale. It can take the form of backlit posters in airports, malls or bus stops. It can include banners in stores and flea markets, or metal or wood store signs. It can also incorporate the use of point-of-purchase displays, posters, awnings, canopies, marquees, roofs signs, reader boards and billboards (a more in-depth look at billboards can be found in the following chapter).

Informational signage is different from advertising signage in that its primary purpose is to aid people in their maneuvering through a specific space or place. More so than with any other large-scale projects, the primary objective of informational signage systems is the quick and unambiguous dissemination of information. This type of signage is not meant to entertain and amuse; it is designed strictly with clarity of message in mind. Unlike advertising signage, informational signage is more often permanent. It can take the form of placards affixed to walls, hanging signs, ground or pole-based metal signs, or architectural artifices.

Regardless of whether its purpose is to advertise or to inform, designers must make note of the immediate surroundings of the sign they have been called upon to design. For outdoor signage, determine whether the information will be read from a fast-moving car, a slow-moving car or by a pedestrian. Pay careful attention to the surrounding color schemes and the amount of direct sunlight the sign receives.

Indoor signage must take into account the overall height of the sign in relation to a person standing, but it also needs to consider the height of the ceiling directly above as well as the lighting around it, whether ambient or direct.

Determine the duration of time the client plans to have the signage up, and familiarize yourself with potential materials. Talk to your printer about the client's specific needs. Consider whether printing is the best possible solution, or whether cut vinyl, etching, carving or even stone cutting would be more appropriate. Contact as many sign shops as possible. There are countless possibilities with plastics today. There are also backlit signs as well as neon signs to consider.

If lighting is an issue, the cost of maintenance and energy consumption should be determined early so that the client understands the total cost of the

Clarify with your client before you begin

✦ **In what environment will the sign(s) be placed?**
✦ **What materials are the clients interested in using?**
✦ **Will the sign(s) be primarily for foot traffic or road traffic?**

THE
MODEL
OF THE
PROPOSED NEW
BUILDING
IS HERE!

HAVE YOU
SEEN IT YET?

FREE ADMISSION
Monday – Saturday ~ 11 am to 1 pm
Sunday ~ 1 pm to 5 pm

Signage must always be designed with its final setting in mind. Choices of materials, proportions, color, typography and visuals can only be made after visiting the site. It should be visited at different times of day in order to discern atmospheric changes. Distance from the viewer, and the speed at which the viewer is moving are two additional concerns that must be addressed. In the example on this page, the photograph has been taken on site so that the stonework in the background of the photograph reflects the stonework on the Corinthian columns. The message is short and to the point, the colors provide strong contrast, and the composition is broken up in a way that clarifies the message.

sign. Inasmuch as a sign that appears old and run down will reflect poorly on the business, maintenance is an important issue even if lighting is not necessary. Outdoor signage must be capable of withstanding the weathering effects of natural elements. Finally, do not fail to check for specific sign codes for the municipality the sign will be placed in. Local sign shops are usually well acquainted with these local matters.

DESIGN No matter what type of sign you are designing, it must inform the viewer and identify the type of business it is representing in a quick and forthright manner. Signs are often seen from cars, and so the information must be capable of being read and comprehended in a matter of seconds. Ideas should be distilled to their essence. There is an old rule of thumb in the signage business that anything more than seven words (or a total of seven elements) will confuse passing viewers and will thus turn attention away from the sign.

Signs can either be on-site or off-site. While on-site considerations include size in relation to the building, placement on or in front of the building, and placement of the sign in relation to the general flow of traffic, off-site signs must consider the problem of identifying the location of the store itself. This can be done simply with an address, or if it is aimed toward a more out-of-town market, a small (but clear!) map may help. The design of a sign should be distinct enough to stand out from its immediate surroundings while retaining a certain amount of harmony with them.

All capitals can make the message seem more urgent, but lowercase letters are usually easier to identify since they include ascenders and descenders. These elements break the copy up into more distinct forms than the smooth-edged bar that results from using all capitals.

Typography should be bold and simple in design and concise in message. All capitals can make the message seem more urgent, but it is important to note that lowercase letters

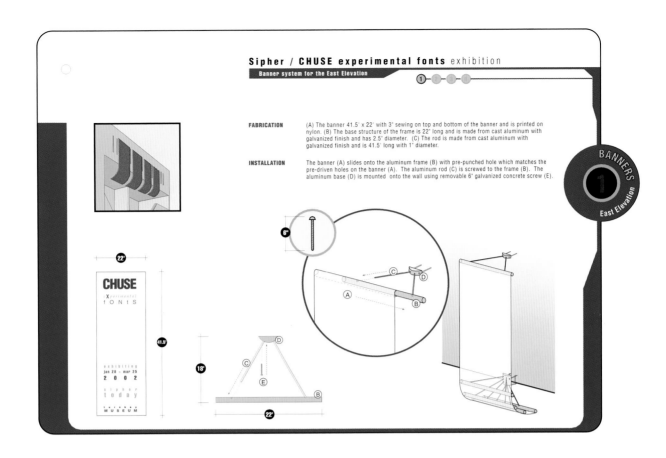

FABRICATION (A) The banner 41.5' x 22' with 3" sewing on top and bottom of the banner and is printed on nylon. (B) The base structure of the frame is 22" long and is made from cast aluminum with galvanized finish and has 2.5" diameter. (C) The rod is made from cast aluminum with galvanized finish and is 41.5' long with 1" diameter.

INSTALLATION The banner (A) slides onto the aluminum frame (B) with pre-punched hole which matches the pre-driven holes on the banner (A). The aluminum rod (C) is screwed to the frame (B). The aluminum base (D) is mounted onto the wall using removable 6" galvanized concrete screw (E).

When dealing with more involved signage systems that function as environmental design, your job may entail more than the graphic design itself. The examples on this page are from a manual for a signage system that includes the design work but also goes into detail concerning the structure of the signage and the building details. A little research on your part can help with this, or you can take your work to a specialist and let that person work out such details. If a manual such as this is required, substantial design time should be allowed for the work.

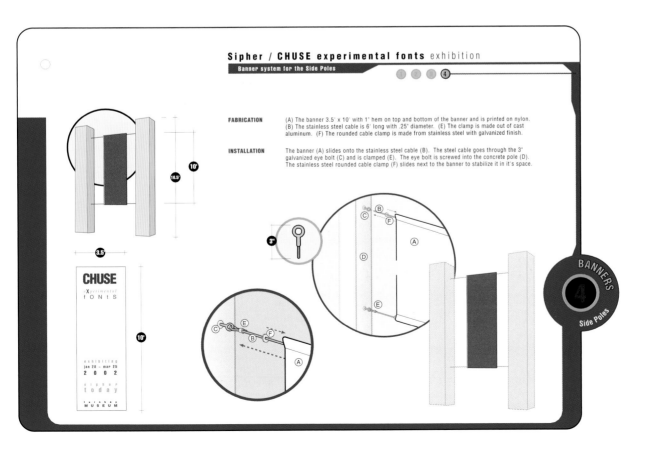

FABRICATION (A) The banner 3.5' x 10' with 1" hem on top and bottom of the banner and is printed on nylon. (B) The stainless steel cable is 6' long with .25" diameter. (E) The clamp is made out of cast aluminum. (F) The rounded cable clamp is made from stainless steel with galvanized finish.

INSTALLATION The banner (A) slides onto the stainless steel cable (B). The steel cable goes through the 3" galvanized eye bolt (C) and is clamped (E). The eye bolt is screwed into the concrete pole (D). The stainless steel rounded cable clamp (F) slides next to the banner to stabilize it in it's space.

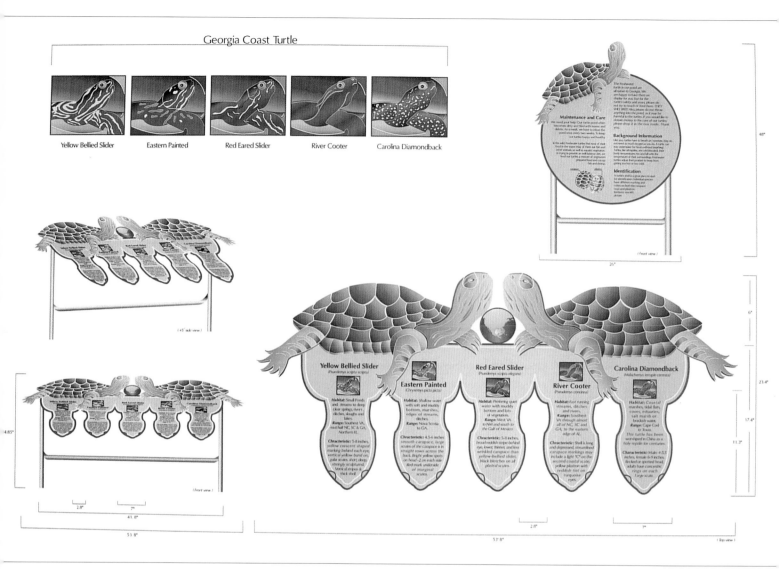

Signage for a nature trail must work on several levels. It must visually fit in with its natural surroundings at the same time it attracts attention. Because such trails are usually for young and old alike, the visuals must be especially appealing to younger people in order to make them want to look closer. They must also supply enough information to interest older hikers.

are usually easier to identify because they include ascenders and descenders. These elements break the copy into more distinct forms than the smooth-edged bar that results from using all capitals.

When it comes to type size, an industry minimum can be determined by allowing for one inch (2.54cm) of letter height for every twenty-five feet (7m 62cm) of distance between the viewer and the sign. In fact, anyone interested in more exact information on sign legibility as it applies to viewer distances, speeds and reaction times should take a look at *The Sign User's Guide* by Karen E. and R. James Claus (ST Publications, Cincinnati, Ohio).

Color scheme ideally should work well in bright sunlight as well as at night. Always allow for maximum value contrast between colors. The eye generally responds more quickly to imagery than to the written word, but if you plan to use symbols of any kind, make sure they are symbols that are easily understood by a public majority.

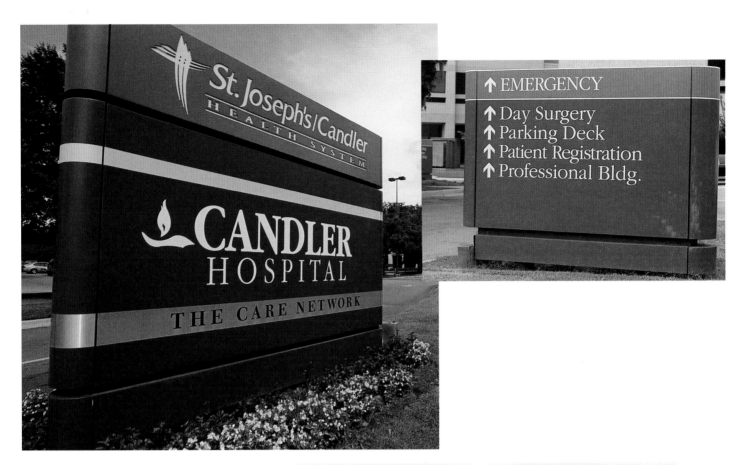

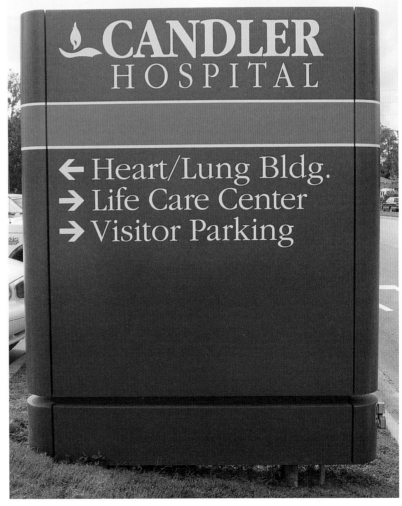

The inclusion of a readerboard or a digital read-out that allows a company to change information on a regular basis catches the attention of viewers, especially if the viewer is a local who might otherwise have become accustomed to the sign due to overexposure. A sign should be versatile enough and intriguing enough to attract new customers while reassuring old ones.

For informational signs, make use of a bold visual break between any corporate symbol or name and the informational content of the sign. This can be done by using multiple typefaces or a simple graphic element. Color choices must provide enough contrast for optimum legibility. Many countries have designed special sans serif typefaces for the sole use on informational signage systems. Whatever your choice of typeface, they must be bold and clean, without unnecessary ornamentation.

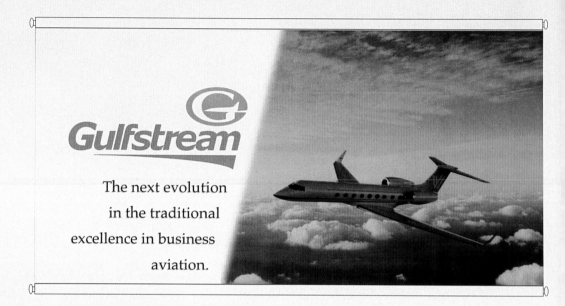

Gulfstream

The next evolution
in the traditional
excellence in business
aviation.

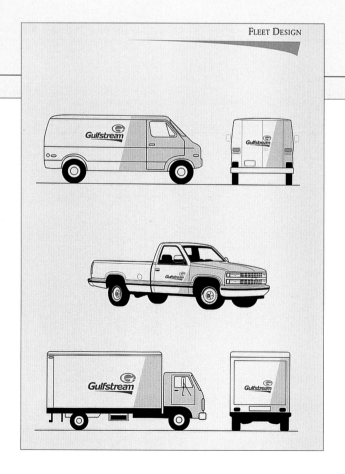

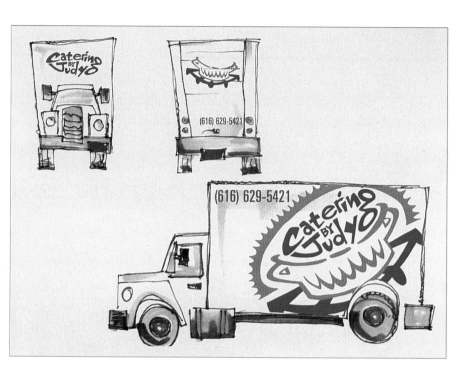

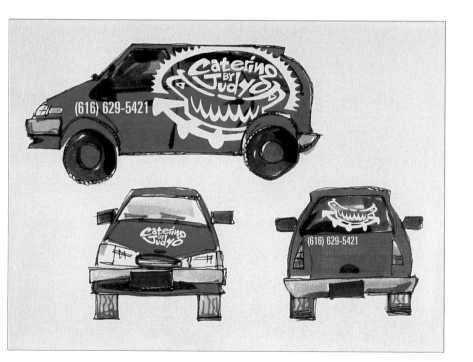

Manufacturing the final sign(s) before the client gets an accurate feel for the design is not a recommended procedure—the client may not be as satisfied as they envisioned. Because of this, it is common to present a scaled rendering of the work as it will appear in the final setting. Traditionally, this has called for an architectural rendering that features both the sign and its surroundings, with the inclusion of at least one human figure. Hand renderings of this nature, when done well, go a long way in making the proposed signage appealing. Computer renderings can also do a fine job, especially as a three-dimensional interactive space that allows the clients to "step into" the computer-generated world. Determine which the clients would prefer, then if you are not capable of such work, contact a freelancer in that field and forward the price estimates to your clients.

billboards

GROUNDWORK

LIKE POLYBAGS, BILLBOARDS ARE A VERY SPECIALIZED BUSINESS, AND IT IS POSSIBLE that your local printer is not equipped for such a job. If this is the case, an Internet search or a call to the Outdoor Advertising Association of America will surely help you in your quest for a company that can handle a print job of this magnitude.

A billboard must be direct in its message and bold in its design. The above example has reduced its message to two words and one image, and the color scheme is bold. The best billboards also find a way to acknowledge the viewers' environment in a humorous manner. In this case, the design plays off the idea of a road sign which is a common enough sight to people in cars. Messages that work on more than one level or make witty use of clichés can be very effective.

Billboards can be offset printed or screen printed. The smaller formats, which include ground-level billboards for sidewalks rather than roadways, are usually silkscreened on paper stock for short print runs. Uncoated stocks have a tendency to flatten or dull colors, especially when bright colors are part of the design, so go with coated stocks. Silkscreening is usually of very high quality, but the process can sometimes have difficulty replicating vignettes and subtle gradients, so make sure you see sample work from the printer with whom you choose to work.

Large format billboards are quite a marvel. Recent technology allows for large banners of vinyl to be offset printed on a huge spinning drum. This one-piece billboard is then stretched on a metal frame and ratcheted tightly down like the skin of a drum. The printers who offer this technology are somewhat

hard to come by. Because the results are wonderful, however, contacting these select companies for an estimate is an important first step.

As a cost-saving alternative, there are still companies that print on panels of self-adhesive vinyl that are then adhered side by side to the billboard to give the appearance of a single sheet.

Ask your printer about the durability of the light-fast inks, which are usually good for up to six weeks without any fade and can often stand up to the elements for at least a year. Metallic inks may need to be varnished for protection against the elements. Printing costs will vary, but as with any other job, the more billboards you print, the cheaper your cost per unit. Call the company that is providing the billboard space and get the exact size and proportions. The most common billboard proportion ratios are $1 \times 2\frac{1}{4}$ and $1 \times 3\frac{1}{2}$, but there are always exceptions. Check with your billboard company first.

Determine whether your clients have given any thought to the placement of the billboard. If they have already selected a number of actual sites, visit them and study the surroundings. Pay careful attention to the amount and direction of sunlight that hits the surface, the average speed of the vehicles that pass it, and the environmental surroundings. Observe the colors that exist in the setting, and mind the color schemes and designs of any other billboards or man-made objects in the vicinity. Suggest to your clients a color palette that will provide enough contrast with all of these variables.

Optical illusions and word play are two ways of attracting attention. Also consider breaking out of the rectangular format. Although this adds a significant cost to the project (the additional pieces must literally be built onto the billboard frame), the eye-catching results may be worth it.

DESIGN

The statement that a billboard must stop traffic in order to be successful should not be taken literally, and it should apply to the underlying concept rather than to the legibility. In fact, if someone has to stop the car in order to read the message on a billboard, the designer of that billboard has failed. The primary objective for such work is to convey a message immediately and unambiguously. There should be very few words, and those words should be large and extremely easy to understand.

Serif fonts can certainly be used, but sans serif fonts are much more effective in this respect. Avoid any intricate typefaces, since the extra visual information in them will only hinder recognition. Keep the message simple and direct. The central idea is important enough to repeat: Stop traffic in a cerebral sense, not in a physical sense.

Clarify with your client before you begin

+ **Where will the billboard(s) be placed?**
+ **If there will be more than one billboard, will they be the same proportion?**
+ **How long will the billboards remain up?**

f peeling?

BLUE SUN HOTSUNCOOLSKIN

Drivers should not have to brake their cars, but they should pause mentally and reflect on the idea that was just presented to them. You want to burn a message into their minds in the few seconds you have their attention (seven seconds is the average time a driver will be exposed to any one billboard). Success in billboard design is often measured by how well observers retain the gist of a message to which they have been exposed for only a short period of time.

When creating your visual hierarchy on a billboard, work with standard, time-tested compositional arrangements. Use bright colors to call attention to the eye. Use contrast in size to clarify primary from secondary elements. And begin the message in the upper left-hand corner, working your way to the right and downward.

Avoid color schemes that may be difficult to read in different light levels. Contrast is extremely important when choosing color because colors of the same intensity will look very similar in certain light levels, adversely affecting readability.

Success in billboard design is often measured by how well observers retain the gist of a message to which they have been exposed for only a short period of time.

149

C O A S T A L

A GREAT

FOR THE KID

When creating your visual hierarchy on a billboard, work with standard, time-tested compositional arrangements. Use bright colors to call attention to the eye. Use contrast in size to clarify primary from secondary elements. And begin the message in the upper left-hand corner, working your way to the right and downward.

As with many other formats in graphic design, the intelligent use of wit when designing billboards can be very successful. The focal point can be an amusing photograph that catches the eye or a short tag line that puts word play into effective use.

A call-and-answer format works well where the primary element (either a visual or a line of type) puts forth the first half of the idea while a second, somewhat less prominent, element answers the first part.

Because wit often plays with preconceived notions, taking advantage of a well-known cliché—or twisting the idea behind that cliché—provides the designer with something that is quickly recognizable to a vast majority of the target audience. Absurd juxtapositions or observations can also grab the eye quickly.

If wit and absurdity are not appropriate for the nature of the product you have been asked to design a billboard for, just remember that simplicity is key. Large type, a dramatic photograph, and bold colors should always be used. Just as a logo must say so much with so little, so should any billboard. Speak loud and clear even if your subject matter is subtle.

Billboards do not always need to be geared toward the direct sell.
These two billboards call attention to the environmental concerns of the company,
showing their community pride and involvement. They also illustrate how to maintain
a specific feel for an advertising campaign, despite alterations in size and proportions.

trade show booths

GROUNDWORK

Trade show regulations are relatively standard throughout the country and abroad, but before any design work can be considered it is important to get a copy of the specs and guidelines for the specific trade show in which your booth will be featured. Among many other things, the guidelines will provide the booth's square footage and the maximum allowable height of any constructions within it. A single booth space is most often 10' × 10' (3.05m × 3.05m), but larger companies prefer to build their booths on two spaces or more for the visibility provided.

The construction of the booth itself is a demanding process as it must be built in a way that allows for easy shipping and on-site construction. Some booths are built for only one show, but others are built for an entire circuit of shows, so durability is always an important consideration. Lightweight but strong materials must be used in the construction. Some convention halls require that local union members do any on-site building. Because of this, the construction should not be overly complex, and a thorough and easily understandable set of step-by-step instructions should be drawn up and presented as a manual.

Determine whether your clients are investing in on-site electricity for the exhibition booth. All convention halls provide some kind of overhead lighting, but it is usually unflattering if not downright insufficient. If they are willing to pay the extra fee for electricity, your job has become that much more complex because the effects of dramatic lighting can work for you only with a well-thought-out set design.

Keep in mind that a trade show booth is indeed a set design. If your client does not recommend someone who is well versed in construction, environmental design, production design or even architecture, find someone yourself. Focus on creating a team and making sure that that team works together with clearly defined goals and deadlines. There is an amazingly diverse array of prefabricated trade show booths available. A quick Internet check will provide a more than sufficient list of possibilities. These companies specialize in lightweight and compactible structures, but they also provide specialty printing for large banners. Always keep these alternatives in mind.

Your job may not entail anything more than simple two-dimensional design. If the set has already been designed and the clients are looking for two-

Clarify with your client before you begin

+ **Will the booth be a prefabricated construction or custom built?**
+ **How much signage will be used in the booth?**
+ **What is the main focus or theme of the trade show?**
+ **Will the both be used for more than one trade show?**

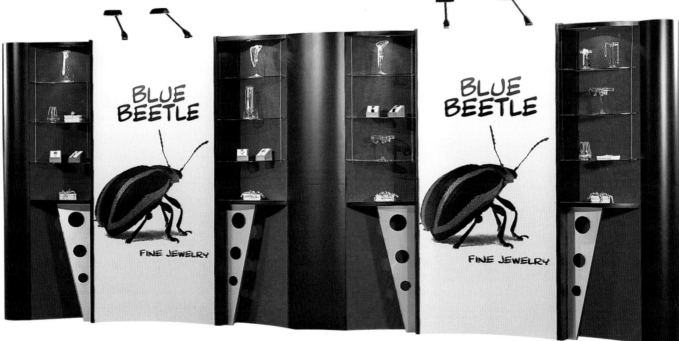

The construction of the actual booth will have a major impact on the signage you create. The two examples on this page show how the relatively basic graphic design work can be changed in order to accommodate different booth proportions while remaining loyal to the overall feel of the work. As has been done here, try to keep the color scheme consistent throughout, even if it means painting the backdrop or special ordering it. Regardless of the construction, keep your graphics large, bold, and imaginative.

Make sure some signage can be seen from both sides of the booth. Signage that faces directly outward from the booth is always important, but it cannot always be seen and so should be complemented by other signage. The above example shows a freestanding column that can be placed near the front of the booth so that people walking down the aisle can see it without too much trouble.

dimensional design work only to finish it off, talk to the booth designers to pick their brains on how they see their space being used. Ask to see the layout of the convention hall to determine from which direction the majority of the convention attendees will be approaching. Clarify which parts of the construction, if any, are capable of bearing heavy loads in terms of lighting or weighty signage.

DESIGN

There are two main objectives when designing a trade show booth. The first is to attract attention from afar. Your design work should be large enough and prominently displayed so that an attendee walking down your aisle sees your work from a distance and is immediately intrigued by it. Decide what should be seen first, whether it is the company's logo, slogan, or a dramatic image that mesmerizes onlookers. Then make sure there is a way to place this element high enough to be seen and in a position that is visible to the largest segment of attendees. It should go without saying that color will always play an important role in this facet.

The second objective is to lure the attendees into the booth once they have been visually led to it. This is as much a function of the set design as it is the surface design. Attendees should want to come in to

Fig. 24
pop-up panels

Fig. 25
modular panels

Fig. 26
towers & stands

Fig. 27
arches & trusses

Trade show booths have benefitted from a recent boom in lightweight and inexpensive prefabricated displays. A quick search on the Internet will result in a wide array of companies dedicated to selling and renting these. They work within the standard booth size of eight feet (2.50m) high by ten feet (3.05m) wide and are collapsible and freestanding units. Many of them also include lightweight lighting systems. Once the client has decided on a booth, it is your job to determine where you can apply graphics and how large and what proportions they should be. Signage adheres to the surface either by way of magnets or velcro. Note: The dark yellow areas represent panels for design graphics.

Fig. 24 Pop-up panels with a cloth skin and a header for company names and logos. Where this example shows the lower section dedicated to merchandise display, there is also the option to use the space for an eye-catching photograph or illustration.

Fig. 25 Panel systems are modular for custom requests. They usually incorporate a large overhead marquee for artwork, and side panels that can also carry graphics. These marquees can be backlit or, as in this example, lit from the front.

Fig. 26 There are countless freestanding tower and stand options.

Fig. 27 The example to the left shows how such a structure can get your graphics in a very prominent position. This also allows for other graphics to be placed along the back wall.

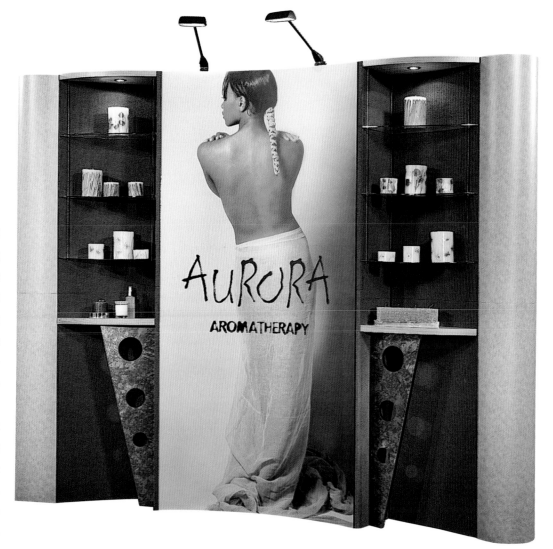

investigate. They should be enticed into stepping into the world you have created. Make them feel at home, offer them comfortable chairs, free giveaways, or an interactive experience to encourage participation.

Determine how most people will be entering the booth—from the front and center, the front and to the side, or in the case of a corner booth, possibly the corner in its entirety—and focus on leading them further into the booth.

In the closing section of this book (called *General Design Considerations*) there is mention of the designer's need to become a guide. It explains how the designer must structure a composition so that it works as a map capable of taking the viewers by the hand and leading them from the most important element to the least important element in a clear and interesting manner. The designer must approach designing a trade show booth with the very same challenge in mind.

Talk to signage stores to find out what materials they use and how lightweight they are. Foam core can be molded and carved, then airbrushed or hand

Dramatic imagery is a must for trade show booths. The trade show hall will be cluttered with competing visuals of all kinds. Finding an image that will call attention to itself, and then isolating that image from any outside visual interference, is important. The shelving units on either side of this graphic panel act as a frame of sorts that highlights and calls attention to the visual.

There are two main objectives when designing a trade show booth. The first is to attract attention from afar, the second is to lure the attendees into the booth once they have been visually led to it.

painted for a handsome but lightweight sign. Brushed sheet metal and painted plywood can also offer relatively lightweight options for signage, providing they are not too large or cumbersome.

Vinyl banners are another possibility. Dowels running across the top and bottom work nicely because they rely only on gravity to ensure that the surface is smooth and taut. But if you plan to use grommets in the corners for wire or rope to hold a banner taut, make sure you understand what it takes to do so.

The backdrops that the convention halls offer are often no more than fabric hung along a metal pole with metal poles on either side that are not built into the floor. Instead, they are held upright by way of a metal stand at their base, and they will topple over if too heavy a load is placed on them.

If the booth will contain pedestals or columns, make sure they are strong enough and heavy enough around the base—you

Designing trade show banners is similar to any signage project in that the work must be uncluttered and legible from a distance. Vibrant colors will call attention to themselves, even from a distance. Make sure the typefaces you choose are bold and easily readable—not too complex or overly ornate.

will not be allowed to glue or screw them into the floor—to support the weights and stresses inherent in the banners you design.

Determine whether the company's products will be featured in the booth and exactly how many products there will be. A table in the front of the booth that allows casual observers the opportunity to handle the merchandise works well as long as it does not block the entrance, making attendees feel as if they are making too much of a commitment by stepping around that table.

If the merchandise is not placed on a freestanding pedestal, a back wall or structure will need to be built to either hang the merchandise or shelve it. Regardless of the approach, ask the client how much instructional and display information needs to be provided, and make sure that any small informational cards, posters or displays are designed consistently with the overall theme of the booth.

Decide what should be seen first, whether it be the company's logo, their slogan, or a dramatic image that mesmerizes onlookers. Then make sure there is a way to place this element high enough to be seen and in a position that is visible to the largest segment of attendees.

Island shelving units like this one are very versatile. They can be used toward the back of the booth or along the front of it. They can be placed parallel to the front or perpendicular to it. If used in front, it is important to make sure they do not create too much clutter which may result in people being unwilling to walk further into the booth. They are mostly used to show the products themselves and do not offer too much space for graphics, so they are best used in tandem with other forms of signage in a double booth.

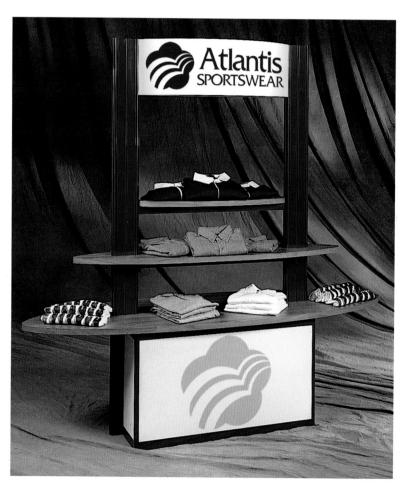

miscellaneous

awards

forms

buttons

tickets

23 *awards*

GROUNDWORK MOST AWARDS ARE DESIGNED TO FIT WITHIN AN 8½" × 11" (21.59cm × 27.94cm) frame. Many also include gold stamping or embossing as a way to embellish the award and give it a more dignified appearance. There are two basic categories of awards. The first kind is somewhat generic and leaves specific information blank so it can be filled in at a later date. These are extremely common and come in many styles. Chances are that if you have been asked to design an award, it will be of the second kind which will involve a more customized approach.

Customized awards are not usually mass produced. Because of this, the cost-saving benefits of printing a thousand units simply do not apply. This can be especially daunting when gold stamping or embossing—two finishing line procedures that can be expensive enough on long print runs—is requested by the client. Luckily, there are other options. Stores that cater specifically to people in search of such short runs can be found in most towns. These are usually the same shops that offer engraving for trophies and plaques. They can take your design work and produce high-quality prints at a low cost even if you only need three or four of them.

Visit your local award shop before you sit down with your client so that you have a solid idea of what can and cannot be achieved and at what costs. Ask about embossing and gold stamping, but also determine whether there are any restrictions as far as paper stock and typefaces are concerned. These shops are very specialized, and they have restrictions that may surprise you. Ask to see samples (and ask if you can take samples to show to your client), and determine what kind of software they use.

Often the software issue can be a stumbling block in these situations, especially if you are in the habit of using high-end design software. These shops are accustomed to designing their own awards on software that is concerned less with finesse and high-quality design than with functions. At the very least you may need to change typographic information into outlines and then save your file in a low-end format. You may even need to rely on the software the store has on its computers.

Clarify with your client before you begin

✦ **Are your clients interested in gold stamping or embossing?**
✦ **Will a particular logo or emblem be used as a design element?**
✦ **How many awards will be needed, and how frequently are they awarded?**

INTUITION·INSPIRATION·INTELLIGENCE
1925 2001

THE
JOINT ACADEMY
OF CREATIVE
WRITING

Presents

THE
JOANNA SIT AWARD
IN POETRY

TO

MICHAEL SCHMIDT

THIS 29TH DAY OF SEPTEMBER, 2001

Director of Creative Writing

Executive Director

1 2 3 4 5 6 7 8 9
regular (lining) figures

1 2 3 4 5 6 7 8 9
text (oldstyle) figures

Script fonts and swash fonts are frequently used for awards, but a classic Roman font can be just as effective. In the above example, small capitals have been used rather than lowercase. A secondary typeface has been introduced to mimic the typeface within the seal. To highlight the recipient's name, a slightly bold version of the typeface was used, and it is the only information set flush left. For numbers, the use of text figures (oldstyle figures) lends the work a classic elegance. (Text figures are named so because the numbers have ascenders and descenders as in lowercase text. See example to the left.)

Attention to kerning is especially important with script fonts because they should give the appearance of the same steady flow from one letter to the next that occurs in natural handwriting.

Craft shops carry specialized kits for metallic printing on a small scale if you are wiling to do most of the work yourself. Embellishments that could replace gold stamping and embossing altogether include wax seals or small ribbons affixed with self-adhesive gold seals. Finally, if the design is for awards that are presented to recipients every year, there is always the possibility of printing a larger run of embossed or gold-stamped blanks that can then be printed in the future.

DESIGN Determine if your client has a logo that must be featured as the emblem at the top of the award, then determine whether this logo is in digital form and if it is compatible with your software. Cross-platform software (software that can work on PCs and on Macs) is the norm, but do not assume that your client's file will translate without complications. If you need to recreate the logo on your own computer, make sure you compensate for that time in your estimate.

Typeface is always an important consideration. Be selective in your choice, and resist the temptation to use just any script font. Many digital script fonts are difficult to read, and some do not have adequate kerning tables programmed into them, so the ligatures (the physical connection between two letters) are erratic or downright sloppy. Attention to kerning is especially important with script fonts because they should give the appearance of the same steady flow from one letter to the next that occurs in natural handwriting. Resist the urge to commit to script fonts in the first place. Other options include swash typefaces (faces that include curvilinear endings to particular strokes) and classic Roman fonts. Certain in-line fonts (fonts that have small sections of white space carved out of them) also exude a dignified feeling.

When distinguishing between the general typographic information and the highlighted information, such as the recipient's name and the name of the award, do not get carried away. As mentioned earlier in the section on typography, you should avoid using too many methods when distinguishing certain information. Above all, make sure that your typography is unified.

Determine whose signature needs to be added to the bottom of the award. Also consider the use of decorative brackets and borders, but do not overuse them. When considering paper, look beyond the color and texture of the paper. The lasting quality of the paper should be considered. Acid-free, fade-resistant paper will look as good in ten years as it does today, so in the case of an award, the extra money for the highest-quality paper is more than worth it. If the work is not framed when presented, consider presentation folders as an option.

An award should be something a person would be proud to frame and hang on a wall. Design such work with elegance, sophistication and grace in mind.

1 9 8 6

A U S T I N

G R A P H I C

A R T S

S O C I E T Y

A W A R D S

S H O W

B R O N Z E

Larry McEnt

President

Ki

Show Chairperson

24 *forms*

GROUNDWORK FORMS COME IN ALL SHAPES AND SIZES. THE CONTENT PRESENTED ON the form has a major influence on the shape and size, but so does the end use of the form. Forms can be mailed in conjunction with other printed material, or they can be designed for interoffice use, for use at sales booths or for a conference. They can be intended for employees, for applicants or for people interested in knowing more about a service or product.

As with any other project, acquire all the necessary copy as quickly as you can, including any and all legal disclaimers, then begin offering your client options as far as the format is concerned. Pay careful attention to how many questions are being asked on the form, but also pay careful attention to how those questions are posed. Five questions that require full-sentence answers will take up more room than twenty questions that require one-word answers.

Many of the considerations mentioned in this chapter echo the information presented in chapter two on order forms because the two categories have many features in common. Paper stock is a good place to save a little money on your printing costs. Forms travel through the hands of consumers rather quickly, so high-end stocks are not always necessary. In fact, coated stocks are often best avoided because the form must be easy to write on with a pen or a pencil. Also ask about the need for carbon copies. The most common sizes for carbon copy forms are 5" × 7" (12.70cm × 17.78cm) and 8½" × 11" (21.59cm × 27.94cm). If these standard sizes are used, the client can save money.

Wherever possible, incorporate the form into the material it will accompany. If the form supplements any additional information or merchandise, consider the possibility of printing it directly onto a sleeve that can contain everything rather than onto a loose sheet of paper. Forms, of course, can also be printed as reply cards or as perforated panels that are included in brochures, catalogs or direct-mail solicitations.

Clarify with your client before you begin

✦ **Will the form be more than one color?**
✦ **What overall size will the form be?**
✦ **Will the form need to have carbon copies?**
✦ **How much legal information will be included, and can that information go on the back of the form or does it need to be on the front?**

BRIDGECOM DISCOUNT (All BridgeCom business customers receive these discounts)

VOLUME DISCOUNT:		LOYALTY DISCOUNT:	
$0-85	2%	6-12 months	2%
$85.01-330	5%	12-18 months	4%
$330.01-1170	8%	18-24 months	6%
$1170.01-2500	10%	24+ months	8%
$2500.01-5000	12%		
$5000.01+	15%		

IN ADDITION, TERM BONUS CUSTOMERS WILL RECEIVE:

TERM COMMITMENT BONUS CREDITS

Customers earn Term Commitment Bonus Credits that accumulate and can be redeemed at the end of each term. These points can be redeemed for credit on an invoice or for other promotional offerings.

- ◯ 1 year 5% of all toll
- ◯ 2 years 10% of all toll

MOST FAVORED CUSTOMER STATEMENT:

A customer who executes a term agreement with BridgeCom achieves "Most Favored Customer" status. If the customer receives a competitive offer for an equivalent package of services, BridgeCom will waive any termination penalties if the customer first gives BridgeCom the opportunity to match the competing offer.

SERVICE REQUESTED*

- ◯ LOCAL
- ◯ LONG DISTANCE
- ◯ INTRALATA TOLL

- ◯ VOICEMAIL
- ◯ CENTREX
- ◯ ACCOUNT CODES
- ◯ PAGING
- ◯ CONFERENCE CALLING
- ◯ DIAL-UP INTERNET
- ◯ WEB DEVELOPMENT TOLL FREE
- ◯ 800/888/877
- ◯ CALLING CARD
- ◯ DEDICATED LONG DISTANCE
- ◯ ISDN
- ◯ DEDICATED INTERNET
- ◯ BRIDGELINK
- ◯ OTHER

*additional information may be required.

- ◯ ASSUME AS IS ◯ NEW INSTALL ◯ TOTAL NUMBER OF LOCATIONS

LOCAL

If Customer transfers local telephone service to BridgeCom:
Attach the Remittance, Current Charges, Local Usage Charges and Calling Services pages of each LEC bill
DOES CUSTOMER CHOOSE TO TRANSFER LOCAL SERVICE TO BRIDGECOM AS SOON AS AVAILABLE? ◯ YES ◯ NO

LONG DISTANCE

If Customer transfers long distance telephone service to BridgeCom:
Attach the Summary of Charges page of each long distance bill

PIC

PRIMARY INTER-EXCHANGE CARRIER—Prevent unauthorized changes to Customer's long distance selection? ◯ YES ◯ NO

TAX EXEMPT STATUS

◯ FEDERAL ◯ STATE ◯ LOCAL ◯ OTHER (PLEASE ATTACH TAX EXEMPT CERTIFICATES)

COMPANY INFORMATION

OWNERSHIP TYPE: Ownership Information (Required of ALL Partnerships, Proprietorships and Small Businesses)
◯ CORPORATION ◯ SOLE PROPRIETORSHIP ◯ PARTNERSHIP ◯ OTHER

Estimated Monthly Billing $_____ Years in Business_____ Bank Name:_____
Federal Tax ID#_____ Bank Account #_____
SS# (Small Business Only) _____Industry_____ Bank Phone #:_____

Reference Names	City/County/State	Phone #	Account #
_____	_____	()_____	_____
_____	_____	()_____	_____
_____	_____	()_____	_____

Services ordered hereunder are subject to credit approval. The signature below authorizes BridgeCom to contact the credit references listed above, to obtain credit reports through credit bureaus and to undertake such investigation as shall be reasonable necessary to verify my/our credit history.

Authorized Signature_____ Date_____
Name/Title of person authorized to sign (please print)_____
Company Name _____
Street Address_____ City_____
State_____ Zip_____ Main Phone # ()_____

Take advantage of negative space when it is available in order to break up the composition into clearly marked sections. Also, try to make use of the company's logo and color scheme. In this example, the crescent shape from the logo is used throughout the piece as a box to be marked off by the applicant.

Forms need to be read but they also need to be written on, so take care to leave enough room for even the sloppiest writer.

DESIGN When designing a form, focus on the traditional means of creating an organized composition. A form is a functional piece of design work, and the intended progression of filling it out should be clear to all. Confusion on the part of any person who happens to be filling it out constitutes a failure on the part of the designer. Your creativity should be focused on clarity of message. In every case, you should be designing to accommodate the least capable person. This applies to the amount of space allowed for handwriting as much as it does for the aforementioned visual structure.

When picking typefaces, work with the font the client uses on his or her letterhead. This will ensure a consistent presentation. For secondary fonts, straightforward typefaces are the best solution. Keep the type at a highly readable point size, and avoid overly extended, overly condensed, or ornate typefaces because they hinder legibility. The company logo and address should always be prominent.

As with order forms, many regular forms are designed to work as a one-color print job for economical purposes. Use tints of the one color in a way that helps define the visual hierarchy. Medium tints (40–70 percent) in bands can efficiently divide the page into clearly defined areas without being too obtrusive and discordant.

Also take advantage of rules (graphic lines) to break up your page into different areas. Using more than one weight for these rules can help organize information further.

Forms need to be read, but they also need to be written upon, so take care to leave enough room

Just because a form must be cleanly structured and easy to understand, it does not mean you cannot have a little fun designing it. Your design should capture the spirit of the company, and if the company happens to enjoy whimsy, you should do everything you can to embody that in your design.

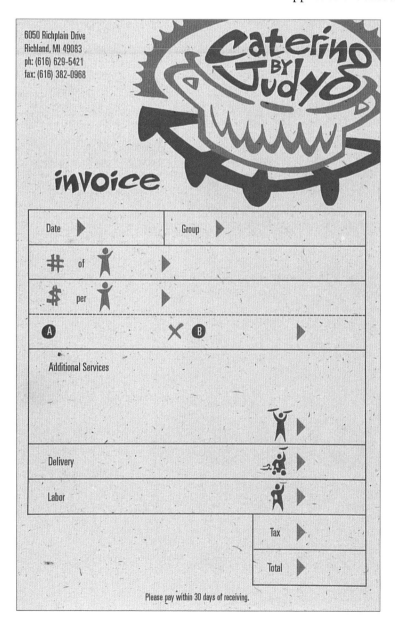

DRIVE IT HOME SWEEPSTAKES
Century 21

YOU COULD BE DRIVING HOME IN THE
▼PONTIAC (NHRA) **PACE CAR!**

IT'S A CHANCE TO WIN A ONE-OF-A-KIND CUSTOM TRANS AM CONVERTIBLE!

COMPLETE ALL THE INFORMATION ON THIS FORM.

PREFERRED TITLE: ❑ Mr. ❑ Mrs. ❑ Ms.

*FIRST NAME *LAST NAME *DAYTIME PHONE

*ADDRESS *EVENING PHONE

*CITY *STATE *ZIP CODE *E-MAIL

PLEASE ANSWER THE FOLLOWING QUESTIONS:

PLEASE SEND ME INFORMATION ON THE FOLLOWING PONTIAC MODEL(S):

❑ Aztek® ❑ Grand Prix® ❑ Montana® ❑ Bonneville® ❑ Firebird® ❑ Grand Am® ❑ Sunfire®

1. WOULD YOU LIKE TO RECEIVE INFORMATION ON ANY OTHER VEHICLE IN THE GM® FAMILY? (CHEVROLET®, OLDSMOBILE®, BUICK®, CADILLAC®, GMC®)

*Make Model *Make Model

2. ARE YOU PLANNING TO PURCHASE OR LEASE A NEW VEHICLE?
 ❑ Purchase ❑ Lease ❑ Undecided

3. WHEN DO YOU EXPECT TO PURCHASE OR LEASE A NEW VEHICLE?
 ❑ Within 1 month ❑ 1-3 months
 ❑ 4-6 months ❑ 7-12 months
 ❑ More than 1 year

4. HOW MANY MAKES AND MODELS ARE YOU CURRENTLY CONSIDERING?
 ❑ 1-4 ❑ 4 or more ❑ Not sure yet

5. ARE YOU PLANNING TO VISIT A DEALER IN THE NEXT MONTH?
 ❑ Yes ❑ No ❑ Have already visited a dealer

PLEASE TELL US IF YOU HAVE A PREFERRED GM DEALER?

*Dealer Name *City State

6. WHAT VEHICLES ARE CURRENTLY IN YOUR HOUSEHOLD?

*Make Model *Make Model

1.800.2PONTIAC **www.pontiac.com**

7. ARE YOU LOOKING TO BUY A (CHECK ALL THAT APPLY)
 ❑ HOME
 ❑ LUXURY HOME
 ❑ SECOND HOME IN ❑ 6 MO.
 ❑ VACATION PROPERTY ❑ 6 MO.-1 YR.
 ❑ INVESTMENT PROPERTY ❑ MORE THAN 1 YR.

8. ARE YOU LOOKING TO SELL A HOME?
 ❑ Yes ❑ No
 IN ❑ 6 MO.
 ❑ 6 MO.-1 YR.
 ❑ MORE THAN 1 YR.

9. ARE YOU INTERESTED IN LEARNING MORE ABOUT A CAREER IN REAL ESTATE?
 ❑ Yes ❑ No

10. WOULD YOU LIKE TO RECEIVE A FREE HOME MARKET ANALYSIS?
 ❑ Yes ❑ No

▼PONTIAC®
Part of the **move.com** network.

www.century21.com
FIND OUT MORE ABOUT CAREER OPPORTUNITIES WITH CENTURY 21.
CALL 1.888.21CAREER, OR YOUR LOCAL CENTURY 21 OFFICE.
SOME RESTRICTIONS MAY APPLY. SEE OFFICIAL RULES ON BACK FOR DETAILS.

Century 21®
Real Estate for the Real World™

EC1000135

The main goal of any form must be the organization. The example on this page shows how a lot of information can be placed into a small space without becoming too confusing. Simple gray bars break the page into clearly defined areas, and although the type is a small size the large x-height makes the letterforms clearly visible.

for even the sloppiest writer. If the spaces are too small for people to write in, things will get messy quickly. When things get messy, you have done more than simply make the form a frustrating experience for the person filling it out; you have also made the job of the person who must read the information that much more difficult.

Always allow ample space for the information requested. If the question can be worded to solicit a yes-or-no answer, there is no need for two full lines for the answer. Instead, present the words yes and no with a box next to each word and ample space between them in order to prevent confusion. If the question requires a longer answer, provide more space than you think necessary.

If you are using small boxes that will be checked off, be consistent with their placement in relation to the specific question.

Legal disclaimers often accompany forms. They can be presented on the front if spatial constraints allow. If not, they are often printed on the back in a straightforward manner. Make sure to highlight the more important information to eliminate potential misunderstandings.

25 *buttons*

GROUNDWORK

THE FIRST THING TO DETERMINE WHEN DESIGNING BUTTONS IS WHO WILL be wearing them. A button that is meant to be worn by an employee or a staff member at a function must serve an informational purpose, whereas a button that is meant to be sold to a consumer must first attract attention and entice. These buttons must be bright enough to stand out, both on the counter from which they are sold and on the shirt to which they end up pinned.

As a promotional giveaway, a button should be something memorable that could be hung in a visible place at home or in the office. Political buttons are common, but they remain true to a somewhat standard format in that the color scheme rarely strays from red, white and blue—possibly with a grayscale image of the candidate—and the typography consists mainly of the candidate's name and a few identifying words.

Buttons are often used in conjunction with an entire line of peripheral items, from hats and t-shirts to banners and other signage. Find out if there is an already existing color scheme, logo or typeface you need to work with. If the button is an individual piece in a wide array of promotional pieces, it should be nothing more than a miniature replication of the central image of that promotion.

If the button is a stand-alone piece, however, get to the heart of the matter with your client; what is it exactly that must be conveyed? Is the client intent on imparting specific information, or is he or she more concerned with a visceral impact? There is not that much room to work with on a button, so getting to the essence of the idea is very important.

Bring examples of successful and unsuccessful buttons. Your client may stubbornly insist on including large amounts of copy. He or she may feel that the button needs to "say" a lot. Let the client see that the small, clogged letters that result from attempting to cram too much information into a tight space is counterproductive and aesthetically unappealing.

As far as the process itself is concerned, find out if it is financially

Clarify with your client before you begin

+ **What is the general spirit of the message being conveyed on the button?**
+ **Is the button a part of a larger marketing scheme that already has been designed?**
+ **How many buttons will be needed?**

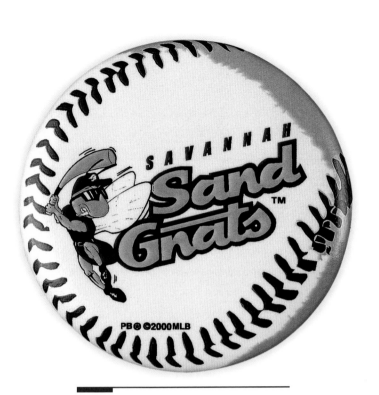

Choose a button shape that further enhances the design concept. In this example, the addition of the baseball seams give the button a feeling of an actual baseball.

Try to reduce your design to its bare minimum. Each of the examples on this page makes use of a single image coupled with only a few words. As with billboards, your button design must communicate its idea quickly and from a distance.

Because the typography will be small and the printing procedure is relatively crude for buttons, work with a typeface that has a large x-height.

feasible to buy a button machine and do all the work yourself. It may cost a little more to begin with, but the machine will be yours to keep for future use with other clients. Of course, if the client is looking for a very large run, it may be better to have the work done by someone else, as it would be quite time consuming to do so many by hand.

DESIGN It's no coincidence that the important considerations involved with designing a button are more or less the same as those with designing its opposite in terms of size: the billboard. Both formats must attract attention quickly, and both must present the information in a straightforward manner. Any typography must be large enough to read from a distance and brief enough to communicate directly.

Once you and your client have reduced the amount of copy to its barest minimum, it is time to pick a typeface. Because the typography will be small and the printing procedure is relatively crude for buttons, work with a typeface that has a large x-height. Make sure the smaller counters (negative spaces within a letter form) do not clog up. Serif typefaces can be dangerous because the serifs and the thinner strokes of the letters themselves are liable to disintegrate without proper attention (adding a thin stroke to such faces can help; a 0.1 or 0.2 stroke is sometimes all that is required). Sans serif fonts will hold up much better.

Photography is used less frequently than illustrations for good reason. Continuous-tone images reproduce poorly at small sizes, and they tend to lose their impact, whereas illustrations are more likely to stand out clearly. Also, a four-color photographic job is more expensive than a two- or three-color illustration. Find an illustrator who is capable of creating a bold and bright image while using a minimum of colors, or illustrate the image yourself.

The most common shape is circular, and a square format is not far behind. An added incentive to use these basic shapes is that they do not necessarily infringe upon your design work. Instead, they provide a crisp frame for it.

Other shapes, such as ovals, rectangles and triangles, are not only more expensive but also more restrictive in that your design work needs to address the overall shape as a dominant design element. Offer such a custom shape to your client only if it contributes directly to his or her concept.

26 *tickets*

DETERMINE FROM THE OUTSET WHETHER THE TICKET YOU WILL BE DESIGNING is for a one-time event, a seasonal event or a series of events that reoccurs from year to year. This will help clarify important matters such as overall quantity and frequency of use.

GROUNDWORK

Also ask if the event has assigned seating or general seating. Numbering tickets is usually not a problem for local printers, but if there are other variables, such as mezzanine and orchestra designations as well as exact seats, rows and sections, printers dedicated specifically to ticket production may be better equipped for the job. They have software that can assure an accurate print run no matter how complex the seating arrangement of the event facility. Call some of these specialty printers for size specifications, standard quantities and price estimates.

There are many types of tickets. There are small one-color tickets that come on a roll, there are full-color tickets that offer a perforated edge for the stub to be easily removed and there are more high-end tickets for expensive fundraising events and the like. This last type of ticket is often customized to work directly with an enclosed invitation, but the other formats may also be sent through the mail to the purchaser. Because of this, you may want to consider limitations in size that account for standard envelope lengths. Even consider the size of a man's wallet because tickets often end up there on the way to the event. At the very least, offer these observations to your client.

Inquire whether your client has considered the option of including a coupon for a local store or a national chain of stores on the back of the ticket. This can defray the cost of printing, and it presents a valuable promotional opportunity for the client's sponsors. Also make sure the client provides the exact wording of any legal disclaimers that may need to be printed on the back.

Determine how much money has been put aside for production. This will narrow the possibilities as far as the ticket size and the number of colors. Regardless of budgetary constraints, resist the temptation to skimp on paper stock. A ticket should be printed on cover stock that is thick enough to stand up to any mishandling it may encounter, and coated stocks will always allow for a sharper, more professional appearance.

Clarify with your client before you begin

✦ **What is the general spirit of the event?**
✦ **How many colors do the clients want to use, and how large would they like the tickets to be?**
✦ **Will the tickets need to be numbered or organized by row, section or area?**

As with any promotional material, a ticket should exude the nature and spirit of the event it is representing in a clear, unambiguous manner.

DESIGN Be clear on the exact nature of the event from the beginning. The theme for a fundraiser could be solemn, but it could also be comical. Likewise, a musical event could be for young adults, mature adults or children.

Tickets are often small, but that does not mean there is no room for elaboration in your design. Font choice will play a critical role, to be sure, but an image or illustration that is printed lightly in the background can add a dramatic flare. As with any promotional material, a ticket should exude the nature and spirit of the event it is representing in a clear, unambiguous manner.

With tickets that include a tear-off section, the perforated edge is usually printed with a dotted line so that the ticket takers have no problem identifying the edge they must tear. Make sure both the ticket and the ticket stub are printed with all of the necessary information so that the customer can find the seat once the stub has been removed. Also keep in mind

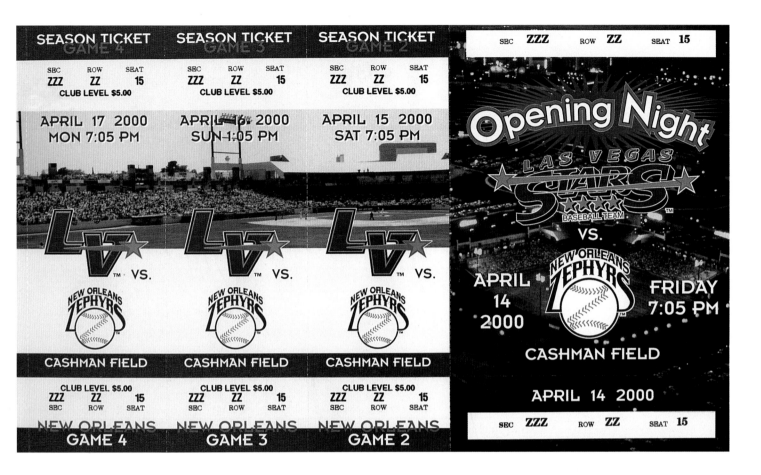

that many people like to save their tickets as memorabilia, so the design should work nicely even with the stub removed.

Tickets often include legal disclaimers. This information can be printed on the back as small as possible while still retaining legibility. Account for the design time required for this in your estimate, as it can often be more a matter of squeezing too much information in a tight space than the comparatively selective design approach to the front of a ticket; if a photo does not fit on the front, you can always remove it, but this is not so with legal information.

In order to prepare your work for the printer, design a single ticket with a blank area that is designated for the specific seating information. The printer will then tile that artwork to best suit the sheet-fed press.

An easy way to allow for some diversity in the background design for the sake of variety is to provide the printer with a block of two or four tickets with each ticket featuring a different image. The printer can then use that block as the tiling artwork instead of a single ticket. Make sure to approve this through your printer first—in fact, never begin the design process until your printer has explained the specific requirements and preferences thoroughly.

Seasons tickets should be designed with a booklet format in mind. Speaking with the printer or specialty service provider first is necessary to determine the exact proportions and specifications. Booklets like the one above provide the designer with many possibilities, including using large background photographs that run across a full section of tickets, and specialty event tickets such as the one dedicated to Opening Night.

ANATOMY AND TERMINOLOGY

A DESIGNER MUST RESPECT TWO THINGS WHEN DEALING WITH TYPOGRAPHY: type as words that can be read and understood, and type as a pure design element.

This chapter is a synopsis of a topic that every designer should be intimately familiar with. Like any other profession, graphic design exists within a world of its own terminology. Recognizing and understanding this terminology is important to successful design.

The basic lowercase letter form is broken down into several sections. *Ascenders* and *descenders* are parts of lowercase letters that break away from the main body, which exists within the *x-height* (Fig. 28). An ascender rises above this x-height (so named because a lowercase x defines the space best). Examples of ascenders are the upper parts of the letters *b,d,f,h,k,l* and *t*. Descenders are the parts of lowercase letter forms that fall below the *baseline* (or the imaginary line on which all letters sit). Examples of descenders are the lower part of the letters *g,j,p,q* and *y*.

The *point size* of a typeface is the total height of a letter form (from the top of a capital letter to the lowest part of a descender). This is measured in *points*, a system of measure used by designers. There are twelve points in a single *pica*, and a pica is approximately one sixth of an inch (0.43cm). Most, if not all, designers still measure with points and picas rather than inches or centimeters.

Although the practice of using points when designing and setting type is universal throughout the industry, all point sizes are not necessarily the same. Ten point type in different fonts will not always be the same height. On the opposite page are three examples of this variance (Fig. 29). It is plainly visible that both the x-height and the overall height of these typefaces vary. Although it is a good rule to keep body copy between eight and twelve points, always be aware of the variance in size when considering typefaces for a design.

The amount of *leading* given to a column of type (the vertical space between each line) must allow for a clean visual jump from one line to the next. The standard leading is 120 percent of the point size (10-point type would be given 12 points of leading), but many factors come into play here; bold and condensed typefaces require more leading than standard typefaces, as do longer column widths (*measures*) and—as mentioned above—typefaces with large x-heights. The use of open leading can lend a classy feeling to a design if the visual gap between lines is not too great.

X-height varies from font to font. Because the relationship of the x-height to the total height of a font has a dramatic effect on the appearance of a typeface, choosing a font with a relatively small x-height as opposed to one with a relatively large one (or vice versa) will alter the perception of both body copy and display copy.

Novel**ty** **Fonts**

Since the computer has made it much easier to manipulate typography, the last decade has seen new typefaces emerge on the scene at a dizzying pace. Many of these are respectful interpretations of existing typefaces, some use an existing type style as a departure point, while others are so specialized in form it is impossible to categorize them, except to call them all novelty fonts.

There are two things to remember about novelty fonts: First, many of them rely on either omissions from or additions to the standard letter form and are difficult to read at small sizes so should be used only for display purposes. Second, a good designer should develop the ability to create certain moods without the need to rely on decorative typefaces.

In most situations fonts that have a larger overall x-height should be allowed more leading to grant more visual space between each line. The legibility of type has everything to do with how easy the eye can flow from one line of copy to the next, and a certain amount of white space can be helpful with this transition.

However, when it is necessary to fit a lot of type in a small space (as is often the case with compact discs and other small format pieces), it can be helpful to use a typeface that has a large x-height in order to insure readability. This will prevent the *counters* (or negative spaces) from closing up at small point sizes.

Kerning and tracking are also important factors in your design. Kerning means adjusting the space between two specific letters so that the space is consistent with other spaces within a word. This is especially important in display copy. All headings should be intensively scrutinized in order to ensure balance and consistency between all letter pairings. This caveat also applies to pull quotes, subheads, captions and even body copy. Most digital fonts come with kerning tables built into them to account for pairs of letters that tend to leave too much space between them, but even inspect those.

Tracking refers to the adjustment of space between letters within an entire line or paragraph of text. Although this can be mainly an aesthetic choice, open letterspacing within text copy can be hard to read. However, there are times when increased tracking will be beneficial. For sans serif fonts, especially condensed or bold sans serif faces, a moderate increase in tracking may enhance legibility and elegance.

Fig. 28

The length of ascenders and descenders varies from font to font: Both of these share the same x-height, yet the overall height is very different.

Fig. 29

Point sizes vary from typeface to typeface: All these samples have been set at the very same point size.

Every industry has a list of things to avoid, and typographic design is no exception. Following is a short list for graphic designers.

JUST DON'T DO IT

Avoid artificially condensing or extending a typeface. A lot of care is required to design a font, and special attention is paid to all spatial aspects. *Squeezing or extending a font distorts these proportions, and such manipulation is a sure sign of an amateur.* These things can be done in more experimental work to create a specific effect, but they should never be done to fill spaces or to fit words.

Avoid leaving single words or very short lines of type at the end of any paragraph. These stubby endings (referred to as *widows*) create abrupt visual breaks in the texture of body copy.

Avoid using all caps in long sections of copy. Ascenders and descenders create visual cues and aid in legibility. Long stretches of capital letters do not offer this visual recognition, and such paragraphs hinder readability.

Avoid opening the tracking (letterspacing) on lowercase letters without a clear reason. Doing so in long stretches of body copy introduces too much white space between letters and significantly hinders legibility. Opening the tracking in headings, subheads and open paragraphs can work very nicely.

grids

IN THEIR MOST BASIC FORM, GRIDS ARE USED TO CREATE MARGINS AROUND the area you are designing. Whether you are designing a brochure, a poster or a magazine spread, allowing for a specific distance on the outside edges for elements that will not bleed (run off the sides of the page) is one of the first steps that you should take. These margins can be consistent along all four edges, or they may vary from top to bottom or side to side. This decision is influenced by any number of factors (type size, overall page size, the necessity for wide margins due to gutters, areas for the reader to turn the page, and so forth).

Grids do not need to be complex in order to be successful. A single vertical line may be enough to bring the needed structure to a layout. For more complex layouts, imagine your grid as a wire frame that you will use to "hang" your design elements on. Elements can align on vertical or horizontal lines of the grid, or they may hang on the intersections. Try varying approaches. Be imaginative in your layout, and avoid too much predictability. The grid should allow you to create a sense of consistency, and it will most certainly allow you to create well-proportioned intervals of space that will balance out with other open spaces. But always remember that there is a big difference between creating a consistent design and creating a boring and predictable design.

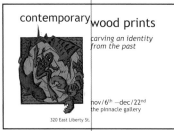

Fig. 30

A grid can be as simple as one or two axes used to structure the typography. The top two examples make use of a single vertical alignment. The bottom vertical example utilizes flush left and centered (the center of the heading aligns with the edge of the image). When using more than two alignments there is always a danger of creating visual chaos, so try to avoid it if possible.

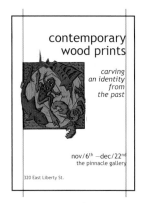

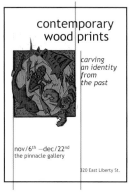

LAYOUTS WITH SMALL AMOUNTS OF BODY COPY

When dealing with a design that has minimal body copy, work with several axes that divide the live area into workable quadrants. These lines can be used to create visual alignments with your design elements. The potential of these secondary alignments must be explored in the form of extensive thumbnails at the outset of the design process. Even with small amounts of display type, the varying impact of type alignments will be readily evident (Fig. 30). These quick studies allow the designer to see the strengths and weaknesses of each layout, and once this exploratory stage is complete, the most successful one must be refined and developed further in the form of roughs.

If you are working with a lot of body copy in your design, the column structure of the page needs to be addressed. As with any project, research here is paramount. Look. Find examples of layouts you feel are successful in their column treatment, and determine how they utilized their grid.

The first consideration should be your ***margins***, or the outside areas that separate the body copy from the edge of the page. In designs that involve a score or a binding, the inner margin that falls into those areas is called a ***gutter***. Margins are too often neglected by designers as they move on to the so-called more important elements of the page such as typefaces and photographs. Their importance, however, cannot be overstated. Think of your margins as a frame that protects and highlights your work; they should provide ample space so that your design can be seen as a work of art in its own right. Decide whether or not you want symmetrical margins (the same width on both sides of the page) or asymmetrical (thicker on one side or the other) (Fig. 31). Decide how open the top and the bottom of the page should be. Do not minimize the importance of such a decision—if your margins are too thin, your page will feel cramped.

The next consideration is the number of columns. Will you be designing with two columns, three columns or more? Each option should be explored in extensive thumbnails before committing to it. The important thing to remember when making this decision is the flexibility you expect from your grid. This is especially true with multipaged documents. Why use a one-column grid when a two-column grid by design allows for a single column? A four-column grid can be used as such or as an amazingly wide array of column combinations (Fig. 32). A six-column grid, which is what this book is based on (Fig. 33), offers still more possibilities.

When determining your column structure, make sure to figure in the point size of your type. This will affect the

LAYOUTS WITH A LOT OF BODY COPY

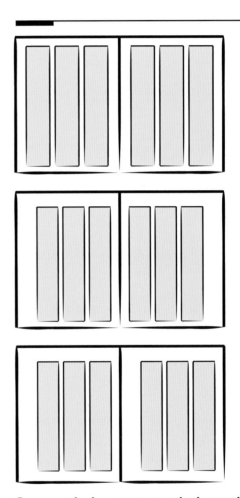

Fig. 31

Symmetrical or asymmetrical margins?
Margins that are too small and too even like the first example often give the page a cramped feeling. The second example shows how the introduction of some white space helps let the page breathe. Each single page is asymmetrical, but the overall spread is symmetrical. The third example shows how the opposite page, rather than being a mirror image of the first, is an exact duplicate of the first. Although not frequently used, it can provide a nice alternative to the standard symmetrical spread.

Fig. 32

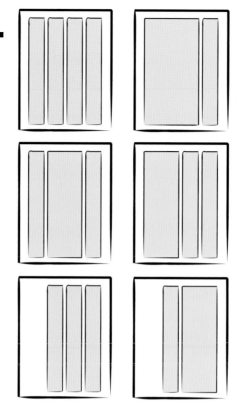

A four-column grid can be used in a wide variety of ways. The first example shows the grid as it has been designed to be used, while the one beside it offers a wide, three-column type box beside a narrow type box.

Both middle samples use a two-column type box along with two single-column type boxes, one as a symmetrical layout and the other as an asymmetrical layout.

The bottom two examples show how the spatial feeling of a four-column grid can be opened up by reserving an outside column for elements other than body copy.

Fig. 33

character count per line, which was discussed in the last section. The columns should not be so thin the reader is constantly jumping from one line to the next. In fact, many six-column grids use the outermost columns as areas to plug in design elements other than body copy (the book you are reading is a case in point; the outer columns are reserved for captions, pull quotes and other visual elements).

Like the outside margins, *alleys*, or the inner margins that separate columns of copy, have quite an impact on the overall layout. As with any occurrence of white space, they are an integral design element in their own right. Of course they serve a practical purpose; they must be wide enough to clearly break one column of type from the one beside it (one pica is a standard alley width). But making them

A six-column grid is even more versatile. The top two bands of color show how such a grid can be used in very symmetrical ways—either with two or three equal columns. The third shows an asymetrical layout. The bottom two are asymmetrical, but they allow more white space to flow through the page since they confine the body copy to less than the total six columns.

wider may create a compositional element you never expected. The choice of alignment will have a large impact on how your alleys are perceived. They become a much more rigid element with justified type, whereas with flush left alignment they are soft and amorphic and call less attention to themselves.

Working with a grid is neither as simple nor as tedious as it may at first seem. It is the most basic and most important building block the designer ever uses. It provides the designer with an underlying structure on which to "build" a design. It creates an opportunity to develop a visual rhythm for the many diverse elements that must be incorporated into a complex page design. If used properly, the grid will create a sense of unity, balance and consistency that will warmly welcome the reader from one page to the next. If you blindly use the grid without ever breaking it, however, or if you use the grid in the exact same fashion page after page after page, you will soon find that you have not used the grid at all. Instead, it has used you.

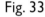

successful composition

ALL DESIGNERS MUST KEEP IN MIND THE IMPORTANCE OF VISUAL STRUCTURE and how it affects the perception of the viewer. When applied to the visual arts, the term **Gestalt** refers in part to the ability of the human eye to gather visual information quickly by creating an elaborate set of groupings. What this means is that we actively group objects by association. If a design presents three orange dots scattered across a page that is filled with many other elements, the eye attempts to group them together regardless of how far apart they may be from each other. This process occurs when the eye is confronted with similar shapes, textures, fonts, and line weights as well. This also occurs with objects that may be substantially different from each other but that are proximate. Because most compositions include many colors and shapes, the eye is often grouping elements on many levels at once. To make matters more complex, the human eye also has the ability to perceive certain alignments in a composition and perceive subtle spatial associations.

> *If a design presents three orange dots scattered across a page that is filled with many other elements, the eye attempts to group them together regardless of how far apart they may be from each other.*

THE DESIGNER AS GUIDE You must be aware of these innate tendencies; understand that this is how the majority of people experience a composition. With this in mind, look over your work carefully. Make sure that any grouping or alignment that exists, whether its creation was intentional or unintentional, enhances the experience of viewing rather than detracts from it. Each grouping and each alignment should provide the viewer with a sense of structure and order. As mentioned in the last section, the use of a grid is a basic building block designers use to address these matters.

As a designer you must consider yourself a guide. First clarify with your client the relative importance of each element in the design in question. Then, with this hierarchy of importance in mind, create a composition that visually recreates that hierarchy. Take the viewer by the hand and bring him through your design. Tell him—give him the visual cues required—where he should begin; this is your *focal point*. Then reveal the next most important piece of infor-

mation, then the next, and so on. Create a clear flow through the piece, always remaining conscious of the groupings the elements in your design may be creating. Do not accidentally create a focal point by put-

> *Do not accidentally create a focal point by putting too many unimportant elements too close to one another, thus creating a visual grouping.*

ting too many unimportant elements too close to one another, thus creating a visual grouping.

Use *contrast* to your advantage. A page that is too evenly weighted with elements can be unstimulating. The introduction of some contrast—whether it occurs as a contrast in color, size or shape—creates a more dynamic and appealing composition. When working with contrast, however, you must be careful to avoid disharmony. There is a thin line between successful contrast and the loss of *unity*. Without an overriding sense of unity, a design will quickly fall apart. The use of a single typeface is just one way to retain a sense of unity in an otherwise busy composition.

Also, once contrast has been introduced, make sure your work has not lost its sense of balance. There should be an equal distribution of elements so that one does not feel as if the composition is pushing the eye too hard in one direction or another. The most important thing to remember when working with visual balance is that an object on one side of a composition does not necessarily need to be balanced out by an exact replica on the other. *Symmetry* (creating a mirror image) is a surefire way to create balance, but it also runs the risk of being too predictable and boring. *Asymmetry* (the use of different elements of equal weight to balance a composition) is more of a challenge for the designer, but it often provides a more interesting and more dynamic design. A pull quote may be enough to balance a photograph. Even white space can be used as a way to balance out dominant objects.

Rhythm in a design is like rhythm in music. Objects that are spaced in a way that takes advantage of a consistent rhythm feel more orderly than objects that are randomly spaced. Once again, creative use of a grid goes a long way in creating a sense of rhythm. The repeated use of spatial intervals is as effective as the repeated use of actual objects.

Finally, do not be afraid to introduce graphic rules and shapes to provide smooth eye flow, unity and rhythm. Although it is important not to rely too much on such elements, judicial use of them can enhance any design.

working with illustrators

THERE ARE MANY VARIABLES TO CONSIDER WHEN SEARCHING FOR AN ILLUSTRATOR, but the issue of style is almost always the determining factor. Your client may be looking for something bold and colorful, or something subtle, elegant, abstract, or linear in nature. Determine whether the medium used (pen and ink, woodblock, pastel, watercolor, computer illustration, etc.) is an important matter to your client. Matching an illustrator to a client with very specific needs can be a time-consuming task.

Because the scope of illustration can be so diverse, it is worthwhile to catalog the work of any illustrator you may have come in contact with in the past. Present this library in a binder so that your clients can see what kind of work is available. Persuade them to commit to a style early so that you, in turn, can track down the appropriate illustrator and get him or her working. This type of catalog can be very helpful during the early stages, but do not bring it back to your clients once they have made a decision. This will only tempt them to change directions in midstream, and nothing good can come of such indecisiveness. For clients on a small budget, suggest the possibility of black-and-white illustrations, or illustrations with a bolder style, since a lower quality printing job will never do justice to illustrations that feature fine detail and subtle tonal changes.

COMMUNICATION IS KEY Make sure you spend enough time with your illustrator to discuss the finer points thoroughly. This meeting should be an open dialogue that enlightens and informs both parties. Bring any written descriptions of the project that your client might have given you, and if the illustration is being used as a visual representation of a specific body of written work, bring a copy of the text so the illustrator can read it. Communicate any special requests from the client such as color preferences or subject matter or even particular dislikes the client may have. Avoid the temptation to enforce your own view of how the final illustration should look. Instead, allow the illustrator room to attack the problem. You have come to the illustrator, after all, and your job is to be an art director; guide your illustrator gently toward a piece that satisfies the general demands of your client.

The business end of the relationship can be broken down into three categories: copyrights, pricing and deadlines. The deadline is the most clear-cut of the three. Give the illustrator ample time to do the job you ask, and always leave some time between the due date you give your illustrator and the due date your client has given you. Along with the final deadline, set several interme-

diate deadlines to assure steady progress. Ask for a number of roughs to begin with to make sure the illustrator is moving in the appropriate direction. The relationship between illustrator and designer should be focused on a long-term collaboration rather than a one-shot deal, and accordingly, everything should be candid and mutually beneficial.

The issues of pricing and rights are somewhat intertwined. The most common agreement is for one-time rights, in which the work remains the ownership of the illustrator, and it can be used only in the one instance it is originally intended for. If the work is printed again in another format by your client, the illustrator should be paid extra for each use. If the client is interested in exclusive rights, this means that the work is owned by the client, who is free to use it at will. An exclusive agreement frequently demands a higher fee. Ask the illustrator how much the job is worth. This is determined by any number of variables, including the overall exposure of the work (how wide the market is—regional, national, etc.), the notoriety of the illustrator, and the degree of complexity of the work. Some haggling may ensue, but as long as both parties are reasonable, a suitable compromise can be found.

working with photographers

THE TWO MAIN CATEGORIES OF PHOTOGRAPHERS ARE STUDIO AND ON-SITE, or location, photographers. Although photographers work in styles as diverse as illustrators, clients are most often looking for photographs that present their merchandise—from tomatoes to shoes to hotels—in a true-to-life manner. In other words, while an illustrator is often asked for whimsical interpretations of specific themes, the photographer's job is usually more direct and literal. A photographer must shoot something or someone rather than create a visual depiction of an idea. Because of this, your job as an art director is more demanding, and it is necessary to develop a healthy, ongoing collaboration. Along with describing the specific needs of your client thoroughly, it is a good idea to accompany the photographer on the shoot.

If it is a location shoot, issues of angles, lighting and time of day should be scouted prior to the shoot. Outside shoots can be unpredictable owing to weather, so the photographer needs to be flexible and open-minded as well as capable of thinking on his toes. Studio shoots are more predictable but can be as time consuming, depending on the subject of the shoot. Sketch out your ideas to prevent miscommunication. If models are required, the coordination of the shoot becomes even more crucial because these models will be on the clock. Shooting food also presents unique problems. You must be meticulous in your planning and your cost estimation as there are so many variables involved.

The business end of a working relationship with a photographer differs from that of one with an illustrator. To begin with, supplies are more expensive for a photographer. The cost of film and studio time must be considered, as well as any additional costs in the way of props, backdrops and models. Developing costs also should be considered; do your clients want to see the work in slide form or print form? Medium format film offers finer resolution, but it also requires special cameras and more expense in developing. And unlike illustration, the issue of rights almost always allows the client to retain nonexclusive rights to photography for future usage, as the imagery is often client specific. Work out a long-term arrangement for who will retain the negatives or original chromes. One thing that does not differ between working with a photographer and working with an illustrator is the need to create a long-lasting relationship, based on honest communication and mutual respect, that will allow both parties to prosper.

YOUR CLIENTS MAY LOVE HOW YOUR WORK LOOKS ON A COMPUTER SCREEN, and they may adore your **hand-built comp**. But none of that means anything (and none of that will pay the bills) unless your job has made it successfully through the gauntlet of the production line. Do your research on local printers. Find out who is capable of running what kinds of jobs. Visit each one of them and ask to see samples of their work. Ask for references. Call those references.

Ask the printers you plan to work with for a tour of their press so you are familiar with the entire operation. As a designer you do not necessarily need to know the finer details of the printing business, but you should know enough to carry on an intelligent conversation with a printer. If you understand the physical parameters of the printing process, and if you are familiar with the terminology used in the industry, you will impress upon your printer your seriousness as a professional. This goes a very long way, as a printer who respects you is much more likely to help you out in a pinch than a printer who senses that you view him as nothing more than a necessary evil. Get your hands dirty; learn as much as you can about the finer points of production.

COMMUNICATION IS KEY

The printer you choose to work with should be someone you feel comfortable talking to on a daily basis. Communication and understanding each other's basic needs are paramount. Find out if the printer is capable of performing all the **finishing line** requirements of your project beyond the standard trimming, folding and binding, such as die cutting, laminating, embossing or any other specialized requests. Find out what computer programs the printing house uses, and make sure you know what version of the program it has. Ask if the printer is outputting the films in-house, if he is sending them out, or, as is more often the case today, if he is going direct to plate or even direct to print (**plateless printing**).

If there are any special needs in terms of inks or paper stock, let the printer know from the beginning. Be familiar with the quality and cost of specialty inks such as fluorescent, metallics and varnishes, as well as scratch-resistant and UV-resistant inks. The issue of paper stock is addressed in more detail in the following section. Determine the overall cost of the print run per unit. After the initial cost of the setup (referred to as the **makeready**) has been covered, the per-unit cost is often ridiculously small. Usually the cost of a print run will remain the same anywhere up to 1,000 units, because as much of the cost of such a job is derived from the makeready expense. After this initial cost, the price per unit falls dramatically. If your client requests 2,000 units, get a quote for that amount. Then request a quote for 2,500 units, 3,000 units or even more to determine what kind of per-unit cost savings your client can take advantage of.

If you understand the physical parameters of the printing process, and if you are familiar with the terminology used in the industry, you will impress upon your printer your seriousness as a professional.

PRINTING METHODS

The most common printing process is *offset lithography*. In this process, ink is applied to a metal plate that is ink repellent in areas that should not print. The plate is placed on a cylinder that transfers (offsets) the ink to a rubber blanket cylinder which in turn offsets the ink to paper. The use of the intermediate rubber blanket is beneficial in two ways: it is durable for long runs, and it is flexible enough to allow ink transfer to paper stocks of various thicknesses and textures, as well as to other nonpaper stocks. Offset lithography can be used in short runs and long runs.

A *sheetfed* press, as the name implies, prints on sheets of paper stock, whereas a *webfed* press prints on rolls of paper. Often the choice of which process to use comes down to the quantity needed; because a webfed press relies on long rolls of paper, it is more often used for longer runs.

Flexography is a form of relief printing that has been improved recently and is capable of very fine results. This process is often used for printing packages and more unique materials, such as plastics, foils and mail cartons. Other common printing procedures are *screen printing*, which uses a screen to filter ink into the areas that will print, and *thermography,* which uses heat to fuse ink with a fine powder to give the feel of an embossed, or raised, printed surface.

PREPRESS

There will come a point when the design work is completed and you need to prepare for production. This stage is often called *prepress* or *preflighting*. This is yet another opportunity to pick up the phone for a friendly chat with your printer. Find out exactly how much of this he would prefer you to do and how much of it he would prefer done in-house. Many printers would rather do the majority of this themselves to prevent any potential miscommunication or oversights. Because getting any job half-completed can lead to trouble down the line, this is usually a wise decision.

If you are using photography, make sure they are of high-enough quality. Many printers have drum scanners, and as they will be the ones printing the work, they are more familiar with the specifics of what they need from their scanned images. Of course, assigning them to do the *high-resolution scans* can be an expensive proposition, so make sure to take this into account at the outset in order to include the cost in your original estimate.

Address the issue of *font usage* at this stage. Make sure any fonts you have used are supplied to the printer. When it comes to *trapping* your work, many design programs do in fact have trapping functions, but they are usually rather primitive. Unless you are experienced in such matters, it is better to allow the printers to trap the artwork because they often have software designed for just such things.

The work must then be *paginated* properly to coincide with the specifications of the printing press, while the *imposition* will most surely be handled by the printer. Once all of this has been attended to, be sure to be available to check the *color proofs*. If a mistake somehow finds its way through all of the prepress operations, or more importantly, if the color of the print job is off, checking the color proofs is the only way to determine that before the job runs. Once it runs, the cost of printing is irrevocably incurred.

High gloss, although very refined, has a tendency to reveal every fingerprint.

THE ISSUE OF PAPER STOCK SHOULD BE AN INTEGRAL PART OF THE ONGOING conversation with your printer. Most print houses will provide you with sample books of either their own papers or—more commonly—sample books from the paper manufacturers themselves. Any major paper manufacturer would be more than willing to send along sample books directly to you if you find your local printer lacking. These books come in handy when choosing a stock with your client, and your printer can order any of them directly from the manufacturer as soon as your client has approved one. As stated earlier, the more production knowledge you have, the easier your job will be in the long run. Your client will be impressed, and your printer will happy to work with you.

Paper is made from wood fiber. These fibers are stewed in various ways and then are run along a wire mesh channel (think of a conveyor belt) that smoothes and drys the fibrous material. As the fibers move along this mesh, they align themselves in the same direction the belt is moving. This results in a specific *grain*, and all paper folds easier and tears straighter along this grain. Paper also expands or contracts more easily against the grain. In most cases the grain of a paper should run parallel to any binding or fold.

Uncoated stocks work nicely for stationery purposes or text-heavy projects, but any project that features photography will benefit from a coated stock. *Coated stocks* provide a less absorbent and smoother surface that can hold a fine halftone much better than uncoated stocks. They are available coated on one side for use on packages, folders and labels or coated on both sides for use on any publication that will be printed front and back. The type of coating varies from dull (matte) to high gloss. High gloss, although very refined, has a tendency to reveal every fingerprint. *Finishes* refer to the smoothness of a specific coating, and they also come in a wide range.

There are numerous standard paper *grades,* which are named for their most common usage. Each of these grades comes in a particular trim size, and the *weight* (in pounds) of a paper is determined by the weight of a ream of that grade in its standard trim size. Some of the standard grades are *newsprint* (newspapers, cheap publications), *bond* (letterhead, business forms), *coated* (brochures, catalogs), *text* (invitations, announcements), and *cover* (book covers, folders). Each of these has unique characteristics and comes in varying weights. Because weight is determined by the ream in a different size for different grades (as mentioned above), comparing weights between grades can sometimes be confusing. When in doubt, check with your sample books and with your printer.

glossary

ADVERTORIAL *A multipaged advertisement that is designed to look like a feature article in a magazine.*

ALLEY *The inner margins within a grid that separate one column of copy from another.*

ASCENDER *The part of a lowercase letter that rises above the x-height. The upper strokes of the letters b, d, f, h, k, l, and t are ascenders.*

ASYMMETRICAL *A layout that does not rely on a mirror image for balance.*

BASELINE *The imaginary line that all letterforms rest on. Letters with curves along their bottom are set slightly below this line to give the appearance of an even resting point for all letters.*

CANT *The slight angle or diagonal stress in letterforms that can be determined by aligning the thinner parts of a stoke in a curved letterform.*

COUNTER *Any negative space that surrounds a letterform.*

DESCENDER *The part of a lowercase letter that falls below the baseline. The lower strokes of the letters g, j, p, q, and y are descenders.*

DIE-CUTTING *The process of cutting away custom curves or shapes from a printed piece of work.*

EMBOSSING *The process of raising parts of a printed surface to create a subtle three-dimensional design element. Debossing is similar, only the paper is pushed downward in the debossed areas.*

EM SPACE *A horizontal distance equal to the point size of a type space (An em space in 12 point type is a distance of 12 points). One half of that distance is called an en space.*

FLEXOGRAPHY *A form of relief printing that makes use of a flexible plate in order to respond to various printing surfaces.*

FINISHING LINE *The end of a print run that includes special procedures such as die-cutting, laminating and embossing.*

GESTALT *As it applies to design, the innate capacity of the human eye to visually group similar elements.*

GUTTER *The margin in any page layout that separates the columns of copy from the binding.*

IMPOSITION *The positioning of digital pages in proper sequence for printing and binding.*

KERNING (LETTERSPACING) *Adjusting the space between two specific letters so that the space is consistent with other spaces within a word.*

LEADING *The vertical space between lines of type in a column.*

LINING FIGURES *Figures (numerals) that are designed so they align with the baseline and the cap height of a typeface.*

MAKEREADY *The physical work required to set up a printing press for a print job.*

MARGIN *The outside areas of space that define columns of body copy.*

MEASURE *The total length of a line of copy.*

OFFSET LITHOGRAPHY *The most common form of printing. Offsetting the design work to an intermediate blanket cylinder in order to transfer it to the paper.*

ORPHAN *In typography, any first sentence in a paragraph that is left at the bottom of the page.*

OVERPRINTING *The process of running ink of one color under ink of another in order to prevent any signs of misregistration.*

PERFECT BINDING *Using flexible adhesive to hold a binding together (as with a paperback book).*

PICA *A unit of measure used by designers that is approximately one sixth of an inch.*

POINT *A sub unit of a pica. There are twelve points in a pica.*

PREPRESS/PREFLIGHTING *Preparing digital files so that they are ready to go to print.*

PULL-QUOTE *A quote that is pulled directly from the text and enlarged to stress its importance to the reader.*

SADDLE STITCH *A form of binding that uses staples punched through the spine.*

SANS SERIF *A font that does not have serifs.*

SCREEN PRINTING *A form of printing that makes use of a fine screen to filter ink onto a surface area.*

SERIF *A small stroke, or lip, added to the end of a letterform.*

SHEETFED PRESS *A press that uses sheets of paper in the printing process.*

SPOT COLOR *A color that is not created by the standard, four-color printing process*

SYMMETRICAL *A composition that makes use of a mirror image in order to create balance.*

TEXT FIGURES *Figures (numerals) that reflect lowercase letters in that certain strokes are ascenders and descenders.*

TERMINAL *The ending of certain strokes in letterforms that do not have serifs.*

THERMOGRAPHY *A printing process that makes use of heating the ink, and results in a slightly raised printing surface.*

TRACKING *The adjustment of space between letters within an entire line or paragraph of text.*

TRAPPING *Expanding the reach of one color in printing into another.*

TYPE COLOR *The value (lightness or darkness) of a particular typeface.*

TYPE TEXTURE *The pattern of positive and negative shapes a typeface creates.*

VERSAL CAP *A large capital used at the beginning of a paragraph to create visual emphasis. (Also called an initial cap.)*

VISUAL HIERARCHY *Creating a focal point in a composition, then order the subsequent elements according to their importance.*

WEBFED PRESS *A press that uses a roll of paper in the printing process.*

WIDOW *In typography, a single word left on a line at the end of a paragraph.*

X-HEIGHT *The height of lowercase letters that do not have an ascender.*

index

permissions

P. 9 (top left) © Rubin Postaer & Associates, San Francisco, CA; (top right) © Yuliana; (lower right) © Hauser Group

P. 10 (top) © Jason Yeo; (bottom) © Ten Speed Press

P. 13–15 © Savannah College of Art and Design

P. 16–17 © Scott Boylston

P. 18–21 © Savannah College of Art and Design

P. 23 © Scott Boylston

P. 25 © Carl Hoppman/Hauswerks

P. 27 © Michael Morgan, CEO, Creative Director of Morgan Design Studio, Inc.

P. 28 © Kevin Dvorscak

P. 31 © Kevin Dvorscak, Kiyomi Yoshimoto, Justin Miller

P. 32 © Cindy, Wing Han Lau

P. 33 © 2000 Scott Boylston

P. 35 © Skipping Stones Design

P. 37 © Hauser Group

P. 38 © Michael Morgan, CEO, Creative Director of Morgan Design Studio, Inc.

P. 40–41 © Hauser Group

P. 42 © Alissa D. Ash

P. 45–46 © Scott Boylston

P. 48 © Tammy Smith

P. 49 © Durwin Talon

P. 51 © 2000 Scott Boylston

P. 52 © Yuliana

P. 53 © Meghana Kishore

P. 55 (top) © Tamaryn Byrne; (bottom) © Jason Yeo, Savannah College of Art and Design

P. 56 (top) © Aaron Taylor; (bottom) © Scott Boylston

P. 58 (left) © Hugo Brioso; (right) © Shannon Deane Tudyk

P. 61 © Rubin Postaer & Associates, San Francisco, CA

P. 62 © Old Navy, In House Agency, San Francisco, CA

P. 63 © 2000 Waxing Moon Communications

P. 65–69 © 2000 Scott Boylston

P. 73 © Reprinted with permission from "Pike Place Seafood Cookbook" by Braiden Rex-Johnson. Copyright 2000 Ten Speed Press, Berkeley, California.

P. 75 © Reproduced with permission from Cedca Publishing, San Rafael, CA (Design Press)

P. 76–77 © 2000 Scott Boylston

P. 78–79 © Meredith Corporation

P. 81 © Texas Parks and Wildlife/Stefanay C. Allen

P. 83 © 2000 Waxing Moon Communications

P. 84 © Rodale's Scuba Diving magazine

P. 85 © Atlanta magazine

P. 86–87 © Texas Parks and Wildlife/Stefanay C. Allen

P. 88 © 2000 Waxing Moon Communications

P. 89 © 2000 Savannah College of Art and Design

P. 91 © Reprinted with permission from "A Cowboy in the Kitchen" by Grady Spears and Robb Walsh. Copyright 2000 Ten Speed Press, Berkley, California.

P. 93 © Reprinted with permission from "!Cocina!" by Leland Atkinson. Copyright 2000 Ten Speed Press, Berkeley, California.

P. 94–95 © Reprinted with permission from "Pasta!" by Jim Hendley and Paul Lowe. Copyright 2001 Jennifer Barry Design. Published 2001 by Ten Speed Press, Berkely, California.

P. 96 © Meredith Corporation

P. 99 © Skipping Stones Design

P. 103 © Tammy Smith

P. 105 © Scott Boylston

P. 106 © 2000 Jennifer Walker, Savannah College of Art and Design

P. 108 © 2000 Susan Orvis

P. 109 © Savannah College of Art and Design

P. 110–111 © Michael Morgan, CEO, Creative Director of Morgan Design Studio, Inc.

P. 113 © BFG Communications

P. 116–119 © Hauser Group

P. 120–123 © 2000 Scott Boylston

P. 125 (top) © 2000 Chia-wen Chang; (bottom) © Shannon Deane Tudyk

P. 127 © John Erdodi, Savannah College of Art and Design

P. 128 © Michael Morgan, CEO, Creative Director of Morgan Design Studio, Inc.

P. 129 © 2000 Winslett Long

P. 130 © Nanyi Oh

P. 131 © Misty Howell

P. 133 © Campus Printing, Savannah College of Art and Design

P. 134 © Hauser Group

P. 139 © 2000 Hauser Group

P. 141 © Eliot Bae, Savannah College of Art and Design

P. 142 © Jennifer Walker

P. 143 © Richard W. Rodriguez

P. 144 © Alejandro Soria

P. 145 © Thaddeus S. Nowak III

P. 146 © Meyer & Wallis; St. Joseph's/Candler

P. 148–149 © Scott Boylston

P. 150–151 © Hauser Group

P. 153–158 © Nimlok Display and Exhibit Solutions Worldwide

P. 161 © 2000 Scott Boylston

P. 163 © 1980 Janice Shay

P. 165 © BFG Communications

P. 166 © Thaddeus S. Nowak III

P. 167 © BFG Communications

P. 169 (top left) © Ticket Craft; (top right) © BFG Communications, © Hauser Group; (lower left) © Thomas Duane

P. 172–173 © 2000 Ticket Craft

P. 176 © 2000 Scott Boylston

P. 181 © 2000 Savannah College of Art and Design, Lin Wang

P. 182 © 2000 Savannah College of Art and Design, Julie Mueller-Brown; © 2000 Savannah College of Art and Design, Catherine Myler Fruisen

P. 183 (top) © Richard W. Rodriguez; (bottom) © 1997 Winslett Long